KIENHOLZ

ON A SCALE THAT COMPETES WITH THE WORLD
THE ART OF EDWARD AND NANCY REDDIN
KIENHOLZ

ROBERT L. PINCUS

UNIVERSITY OF CALIFORNIA PRESS
BERKELEY LOS ANGELES LONDON

University of California Press
Berkeley and Los Angeles, California

University of California Press
London, England

First Paperback Printing 1994

Library of Congress Cataloging-in-Publication Data

Pincus, Robert L.
 On a scale that competes with the world: the art of Edward and
Nancy Reddin Kienholz/Robert L. Pincus.
 p. cm.
 Includes bibliographical references.
 ISBN 0–520–08446–2
 1. Kienholz, Edward, 1927– —Criticism and interpretation.
 2. Reddin-Kienholz, Nancy, 1943– —Criticism and interpretation.
 I. Title.
 N6537.K48P56 1990
 700'.92'2—dc20 90–35430
 CIP

Printed in the United States of America

1 2 3 4 5 6 7 8 9

To my mother and father,
whose love of books and marvelous library quietly taught me to
revere the craft of writing.

And to my wife Georgianna,
who believed in me from the first word to the last.

CONTENTS

LIST OF ILLUSTRATIONS

Plates

1. Edward Kienholz, Partial view of *Roxy's* (1961), with *Ben Brown* (at left) and *Diana Poole, Miss Universal* (at right). Mixed media environment. Collection of Rinehard Onnasch, Berlin. Photograph: J. Littkemann.

2. Edward Kienholz, Partial view of *Roxy's,* with *Five Dollar Billy* (at center in foreground), *Cockeyed Jenny* (at center in background), and *Miss Cherry Delight* (at left in background). Photograph: J. Littkemann.

3. Edward Kienholz, *John Doe* (1959). Mixed media assemblage. Courtesy of the The Menil Collection, Houston. Photograph: Susan Einstein.

4. Edward Kienholz, *The Illegal Operation* (1962). Mixed media tableau. Collection of Monte and Betty Factor, Santa Monica.

5. Edward Kienholz, *The Birthday* (1964). Mixed media tableau. Collection of the Staatsgalerie Stuttgart.

6. Edward Kienholz, *The Back Seat Dodge '38* (1964). Mixed media tableau. Collection of the Los Angeles County Museum of Art; purchased with funds provided by the Art Museum Council.

7. Edward Kienholz, *The Wait* (1964–1965). Mixed media tableau. Collection of the Whitney Museum of American Art, New York; gift of the Howard and Jean Lipman Foundation, Inc.

8. Edward Kienholz, Partial view of the interior of *The Beanery* (1965). Mixed media environment. Collection of the Stedelijk Museum, Amsterdam.

9. Edward Kienholz. Interior of *The State Hospital* (1966). Mixed media tableau. Collection of the Moderna Museet (National-museum), Stockholm. Photograph: Statens Konstmuseer.

10. Edward Kienholz, *The Portable War Memorial* (1968). Mixed media tableau. Collection of the Museum Ludwig, Museen der Stadt Köln.

11. Edward Kienholz and Nancy Reddin Kienholz, *Sollie 17* (1979–1980). Mixed media tableau. Private collection, Los Angeles.

12. Edward Kienholz and Nancy Reddin Kienholz, *The Night Clerk at the Young Hotel* (1982–1983). Mixed media tableau. Collection of the San Francisco Museum of Modern Art; purchased through a gift of Mrs. Henry Potter Russell.

13. Edward Kienholz and Nancy Reddin Kienholz, Interior of *The Pedicord Apts.* (1982–1983). Mixed media environment. Collection of the Frederick R. Weisman Foundation, Los Angeles.

14. Edward Kienholz and Nancy Reddin Kienholz, *Portrait of a Mother With Past Affixed Also* (1980–1981). Mixed media tableau. Collection of the Walker Art Center, Minneapolis; Walker Special Purchase Fund, 1985.

15. Edward Kienholz and Nancy Reddin Kienholz, Detail of *The Hoerengracht* (1984–1988). Mixed media tableau. Collection of the artists. Photograph: Angelika Weidling.

16. Edward Kienholz and Nancy Reddin Kienholz, *Holding the Dog* (1986). Mixed media tableau. Collection of the Museum of Contemporary Art, Los Angeles; partial gift of Mandy and Cliff Einstein.

PREFACE TO THE PAPERBACK EDITION

It is an occupational hazard for enduring artists to be remembered for breakthrough works. Edward Kienholz and Nancy Reddin Kienholz haven't eluded this fate, as I have been reminded on many occasions since the publication of the hardcover edition of this book in 1990. Apart from those who follow post-1945 art history closely, people usually know Kienholz for two or three key works of the 1960s.

A primary reason, then, for writing this first full-length study of the Kienholzes' art was to illuminate their major contribution to the history of sculpture and of art in general. For all of the considerable recognition they have received, the Kienholzes' work still has not been given its due, in full measure. My book offers reasons, both aesthetic and circumstantial, as to why this has been the case. If the hardcover edition persuaded some portion of the audience for art that Edward and Nancy Reddin Kienholz deserve a larger spot in the history books, then it has fulfilled one of its major ambitions. Its appearance in a paperbound edition makes this aim seem all the more realizable.

Meanwhile, the Kienholzes have been productive in the years since the hardcover edition appeared, so an update is in order. Works they have created since 1989 (the cutoff date for inclusion in the earlier edition) continue to affirm the fruitful nature of their collaboration and the vitality of their oeuvre.

In an October 1989 exhibition at Louver Gallery, Kienholz's first gallery exhibition in New York in 22 years, the human-scale tableaux were compact, at least by the art-ists' expansive standards. But the urgency and power of their social commentary persists in these works, while the rich pictorial qualities of their sculptures were never more apparent than in two works in that exhibition.

The Potlatch (1988), with its strong frontal orientation, is as much a carefully staged picture as a sculptural construction. It is an elegaic portrait of Chief Joseph of the Nez Percé, a tribe uprooted from its territory (which spanned portions of Oregon, Idaho, and Washington) by the U.S. government during the gold rush of the 1860s and 1870s. With the cast body of a man and the head of a stag, the freestanding figure of Chief Joseph in the tableau projects the air of a dignified nature spirit. Photographs of Chief Joseph grace a music stand and the wood plank floor of the piece.

Its title refers to a common practice among Indian tribes of the Northwest. As a sign of the tribe's status, a chief would bestow gifts upon the leader of a rival tribe. If the enemy couldn't surpass those gifts with his own he would be humiliated, suffering a loss of prestige in the community. In *The Potlatch,* Chief Joseph can boast only a few worthless trinkets, scattered on the table beside him. It is a scene resonant with pathos; gazing out over our heads, he is something of an apparition, haunting us with the memory of his tribe's genocide at the hands of rapacious nineteenth-century settlers in the region.

Septet (1987–88), also included in that exhibition, was equally poignant but understated in its use of objects. The point of departure for the piece was a found photograph of seven German girls, taken during World

War II. An enlarged version of this image, set into a wooden wall, becomes the central version of the composition. On the floor-mounted platform extending from that wall are seven dressmaker's dummies of female torsos, arranged precisely to echo the positions of the figures within the photograph.

The dressmaker's dummies project the identity of the girls into maturity, and at the same time transform the girls in the photograph into archetypal figures, participants in an allegorical group portrait. The implicit subject of *Septet,* as in so much of the Kienholzes' work, is mortality. Youth and maturity are counterposed. In the photograph the girls remain girls forever, but we know it isn't so and inevitably ponder the fate of the people pictured there. In *Septet,* the gap between time stopped and time in flux is economically and eerily heightened by the presence of the fragmentary mannequins.

The consistent appearance of works as strong as *The Potlatch* and *Septet* makes it clear the Kienholzes have remained genuine masters of the assemblage form, able to return to perennial themes with continuously renewed vigor and a remarkable variety of approaches. Consider *Mine Camp* (1991), their first outdoor tableau and their first work in bronze. (It was commissioned by their longtime collectors Klaus and Gisele Groenke.) In medium and setting, it is a departure. And yet it is of a piece with their oeuvre. The artists employ bronze in a fashion consistent with their narrative approach to artmaking. Cast objects create a sculptural scenario that hovers close to life itself—a perennial quality of the Kienholzes' work.

The setting is Hope, Idaho, where the artists have long had a home. The name of the tableau is that of the hunting camp the Kienholzes own in the mountains above Hope, and the set-up is much the same as it would be at a camp on the site. A 1956 International pickup truck, once owned by the artist's father, Lawrence Kienholz, is cast in bronze, as is the figure of Edward Kienholz himself, seated on a stump and staring at a campfire pit in bronze. A deer carcass (strung between a real tree and a cast armature of branches and rope) is sculpture; sculpted pine cones are scattered among real ones. A host of other objects too, from crates to milk bottles to a shaving kit, are in bronze. They date from the 1940's and 1950s, when Kienholz's father introduced the artist to this area during early hunting and fishing excursions.

Mine Camp, as the only self-portrait of Kienholz, discloses much about his sensibility. He is deeply connected to this area in rural Idaho, as is Nancy Reddin Kienholz. In mood, the tableau evokes a famous sentence from Henry David Thoreau's *Walden, or Life in the Woods* (1854): "I had three chairs in my house; one for solitude, two for friendship and three for society." The figure of Kienholz seems an emblem of the virtues of solitude, inviting the passerby to enjoy the palpable stillness of the landscape in which it resides. The work implicitly argues for communion with this landscape, for the virtue of living within it and the value of passing on an appreciation of it from generation to generation.

Yet the Kienholzes have remained deeply committed participants in a moral dialogue about the human condition. *The Merry-Go-World or Begat by Chance and the Wonder Horse Trigger* (1988–1992), conceived by Reddin Kienholz, is epic proof of a continuing interest in this dimension of their oeuvre. It is a large carousel that

houses eight compact human scale tableaux, each repre-
senting a different spot on the globe, each assembled
from items collected during trips to disparate parts of the
world. In a sense, this piece is a three-dimensional wheel
of fortune. The viewer spins a circle on the outside and
one of the scenes within is illuminated. The sweet face of
an African girl stares back at us from one, surrounded by
tho furnishings of the hut she shares with many relatives.
Another scene portrays an equally attractive child, one
of the many poor inhabitants of the hillsides of Rio de
Janeiro, crucifix on her wall and tile shard floor beneath
her feet. The logic of the piece emphasizes scarcity. As
Kienhholz writes in the catalog for its premiere showing
in September and October 1992 at the L.A. Louver Gal-
lery in Venice, California, "We determined that if you
divided the world into eights by monetary considerations,
you would end up with one section wealthy, two parts
middle class and five sections poor or extremely poor."

A few spins of the wheel of *The Merry-Go-World or
Begat by Chance and the Wonder Horse Trigger* dramatize
just how staggeringly random it is that each of us makes
an appearance on this planet at any given locale. A few
trips inside this environment make this idea, so simple
and complex at once, vivid and accessible. The ability to
take a theme as basic as this one and give it a compelling
sculptural form has been Kienholz's gift as an artist for
nearly four decades. His collaboration with Reddin Kien-
holz since 1972 has served to enrich and deepen the artists
vision he established in earlier works. Together, his solo
efforts and their collaborative projects are an indelible
body of work and this new edition of my book will, I hope,
produce an even wider appreciation of their remarkable
sculptures, tableaux, and environments.

ACKNOWLEDGMENTS

The generous assistance of others has been vital to this book. I note these contributions with a deep sense of gratitude.

Edward Kienholz and Nancy Reddin Kienholz have endured my many interviews with them as well as my numerous written queries with graciousness, patience, and warmth. They opened their studio and archives to me, providing me with insights and material I could not have otherwise brought to this essay. Their great generosity of character has been an inspiration throughout the creation of this book, and I hope that some of their vitality and integrity manifests itself in this essay on their art.

Three eminent scholars, Susan C. Larsen, Jay Martin, and Marjorie Perloff, offered encouragement and helpful direction as my research took shape as a doctoral dissertation. Their editing of and observations concerning my manuscript were astute, sensitive, and constructively critical. The inspired teaching of all three of these professors had a profound, if less tangible, impact on this essay as well; so, too, did the instruction and insights of Dickran Tashjian and Victoria Kogan at an earlier stage in my thinking about art, art criticism, art history, and the relationship of all three to that even broader topic: culture.

Others gave their time freely too, at different stages in my research; they shared their remembrances of the past, as they pertain to this study. The late Robert Alexander, Billy Al Bengston, Elizabeth Asher, Patricia Faure, Monty and Betty Factor, Pontus Hulten, Richard Jackson, Paul Kantor, David Meltzer, Lyn Kienholz, Seymour Rosen, and Maurice Tuchman all provided valuable insights into Kienholz's and the Kienholzes art and milieu.

The contributions of many individuals and institutions to the accompanying visual material in this book are duly acknowledged in the list of illustrations, but I want to single out L. A. Louver Gallery, the artists' American dealer, for its large contribution to the images that accompany my text. In this and other ways, the assistance of gallery owner Peter Goulds and staff members Kimberly Davis and Jon Sorensen was invaluable.

Stanley Holwitz, assistant director of the University of California Press, was enthusiastic about and supportive of this project from the moment I brought the idea to him eight years ago. Scott Mahler, my sponsoring editor at the Press, has been a sensitive and intelligent reader of my book, not to mention its enthusiastic champion. In the final stages of editing, Paula Cizmar gave it a judicious, meticulous, and appreciative reading, as did Shirley Warren. Robert Ross added that other vital component of a book about art: an intelligent and elegant design.

A final thanks to my son Matthew, who was such a congenial baby during the penultimate stages of this book that I actually found time to assemble its many photographs and give the text a conscientious last reading without losing too much sleep.

San Diego, California Robert L. Pincus
January 1990

A THEORETICAL PREFACE

History of art, . . . instructs us that art, every art,
constantly strives to break through the
limitations provided by its material, inclining at
one time toward this one, at another time
toward that one of the other arts.

—Jan Mukarovsky, "The Essence of the Visual
Arts" (1966)

The art of Edward Kienholz has engaged me as both
critic and scholar for more than a decade now. It was
during the writing of my first essay on his work, in
1978, that I became convinced that Kienholz had
created some of the most significant and underrated
sculpture of the post-1945 era. And more than a decade
later I remain unswayed in my estimation of the
importance of the work that he forged on his own until
1972, and thereafter with his wife, Nancy Reddin
Kienholz, as an official collaborator.[1]

Yet in an era that saw the Abstract Expressionist
sculpture of David Smith give way to the Minimalist
objects of Donald Judd or Tony Smith, Edward
Kienholz's large scale narrative tableaux seemed to be
something of an anomaly. Barbara Rose articulated the
dilemma that his work posed in a 1963 review of his
first environmental work, Roxy's (1961): "Kienholz
obviously has something to say, but why has he
chosen to express himself visually and not verbally?"
("New York Letter," 65).

Both the work created by Kienholz alone and with
Reddin Kienholz aspires, in some part, to the condition
of literature. Yet in its sheer physicality, its human
scale, and its use of detail, the Kienholzes' assem-
blages and tableaux have an effect quite different from
literature. We "read" these works differently than we
would a short story, a play, or a novel since we must
piece together a tale from the figures and their
surrounding environments. Only in the earliest
tableaux are there explicitly literary clues, such as the
letters in Roxy's and The Birthday (1964), placed in half
concealed locales so that the viewer became a voyeur
while reading them. We also interpret these tableaux

differently than we would a narrative painting, for when the tableaux consist of entire rooms we are enveloped by them; they surround us as any room would and so we experience them by piecing together a sequence of visual perceptions and physical sensations rather than viewing them simply as pictorial scenes. Even when a tableau's presentation is predominantly frontal and we view the constructed scene as if the space it occupied were a stage, its physical nature parallels that of the everyday environment. It is not a window on the world but is akin to an altered chunk of the larger environment that once existed—a place that is preserved, entombed, and reconstructed. We are physically inside "the story" or standing in front of it as it were.

Craig Owens, in his essay, "The Allegorical Impulse: Toward a Theory of Postmodernism," aptly asserts that one of the prominent "strategies" in the visual arts of our moment is "hybridization."[2] The Kienholzes oeuvre firmly demonstrates the validity of this particular strategy. In turn, their art demands that one employ the skills of the literary critic as much as those of the art critic; to be as cognizant of literary history as art history. The insistent confrontation of their art with problematic aspects of the social arena also asks that one view these works as part of a larger tradition of cultural criticism. Ultimately, then, their art insists on an interdisciplinary approach, and I have tried to fulfill that demand in both the overarching framework of my essay and in the individual analyses of selected major works.

This essay—divided into an introduction and four chapters—focuses largely on the work rather than the

artists' lives, attempting to illuminate its development: its formal advances, its persistent thematic concern, and its cultural context. Moreover, I have focused on the development of their American work, with much less attention to the art created in Germany. Although there is an overarching unity to their entire output, in both its sensitivity to the cultural resonance of found objects and its formal structure, the work made in and about the United States offers a thoroughgoing critique of life in America which, to my mind, was deserving of a book unto itself. Taken together, the introduction and chapters are an interpretation of this major portion of their oeuvre.

Preceeding each chapter is an interchapter that touches on aspects of both Kienholz's and Reddin Kienholz's lives. This information seemed largely out of place within the sequence of the longer chapters, but valuable nonetheless to highlight events surrounding the public dissemination and reception of their art. The chronology of a given interchapter loosely corresponds to that of the chapter that follows it. (Moreover, I have provided a standard chronology at the close of my essay.) Ultimately, however, this study is a biography of their American work. I have aspired to trace the development of this oeuvre as it has taken place over the last three decades and more so we can better understand its marked contribution to both American art and art in general.

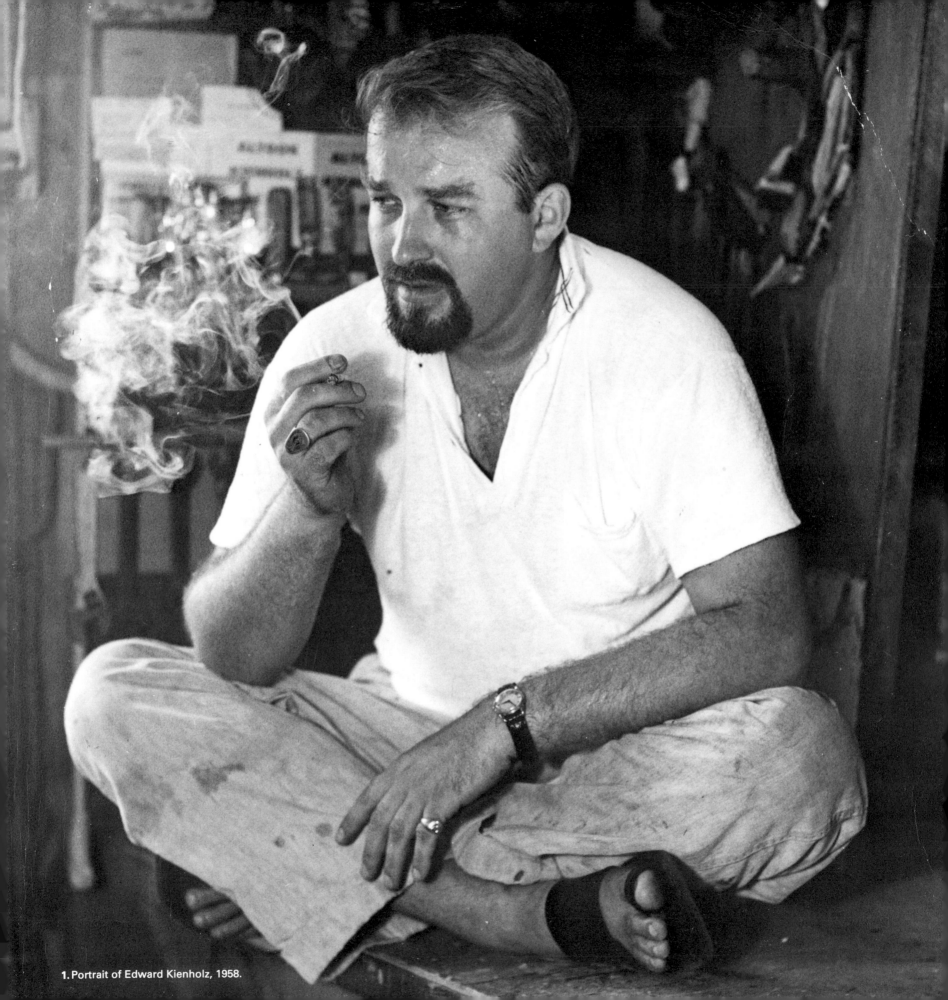

1. Portrait of Edward Kienholz, 1958.

INTRODUCTION

Theory and history were of little concern to Edward Kienholz when he constructed his first environmental sculpture, *Roxy's* (plates 1 and 2). Its form, he recalls, evolved from the folk tableaux and stop-action scenes he had witnessed in the churches and grange halls of his native Fairfield, Washington, whereas its subject emanated from his own memories of a visit to a brothel in Idaho as a teenager.[1] Kienholz constructed human-scale rooms in which he employed props such as a picture of General McArthur, a June 1943 calendar, and magazines of the time to evoke the era of his adolescence. He filled these rooms with grotesque interpretations of "prostitutes" created from skulls, dolls, boxes, and other found objects. In retrospect, it is clear that *Roxy's* is also the pivotal work of his career, for it was to provide the basic formats for all of Kienholz's subsequent tableaux: scenes that one views frontally, much like a stage in a theater; or environments that one can enter and experience much like the architectural spaces of our cultural landscape.

Working in Los Angeles with only the most cursory knowledge of precedents or contemporary parallels, Kienholz forged a powerful West Coast counterpart to environmental developments that were taking place on the East coast (fig. 1). Working from a decidedly more theoretical and historically informed vantage point, Jim Dine, Allan Kaprow, Claes Oldenburg, Robert Whitman, and others were creating collage environments that functioned as works in and of themselves and as "places" in which their fragmented theatrical pieces— commonly termed "happenings"—were enacted. As early as 1958, Kaprow, an art historian then teaching at Rutgers University, had constructed the first of his

environments; it was structured like a maze out of suspended strips of fabric, plastic sheets, cellophane, and lights and played electronic sounds at approximately one-hour intervals. In the very same year, Robert Rauschenberg exhibited the first of his wall-mounted hybrids of painting and assemblage— "combines," as he called them—at the Leo Castelli Gallery.[2]

Rauschenberg pinpointed the assemblage aesthetic when he declared, "I think a picture is more like the real world when it's made out of the real world" (Tomkins, 193–194). But it was Kaprow, with his essay, "The Legacy of Jackson Pollock" (1957) and later with the book into which that essay was subsumed, *Assemblage, Environments & Happenings* (1966), who became the most prominent theoretician for all three genres. As one sifts through both of these writings Kaprow's overarching theme becomes evident: that expanding the scale of art serves to blur the distinction between the arena of life and that of art. Although Kaprow recognized the importance of early twentieth-century Cubist, Dada, and Surrealist experiments with collage and assemblage, he argued that Pollock had pointed the way for the post-1945 American assemblagists "by utilizing gestures, scribblings, large scales with no frame, which suggest to the viewer that both the physical and metaphysical substance of the work continue indefinitely in all directions beyond the canvas" (154). Kaprow went so far as to assert that the more traditional formats of painting or drawing would become obsolete, though we can now see that his prognosis of the death of picture-making was greatly exaggerated. "The ro-

mance of the atelier, like that of the gallery and museum, will disappear in time," he speculated. "But meanwhile, the rest of the world has become endlessly available" (Kaprow, 183). For Kaprow, as well as Oldenburg, Dine, Red Grooms, George Segal, and others of that milieu and generation of artists, art was to become integrated more fully into the world by embracing more and more of its materials.

It is important to note here that Kienholz's tableaux are the only strong and sustained West Coast manifestation of this environmentalist aesthetic in American art of the late 1950s and 1960s. Wallace Berman had earlier exhibited a couple of human-scale assemblages at the Ferus Gallery in 1957—the Los Angeles-based gallery that Kienholz then co-owned with Walter Hopps—but he soon abandoned this format to create sculptures of painted stones and wall works with serial arrangements of photographic imagery; both these sculptures and wall works used Hebrew characters and words which alluded to the Jewish mystical texts of the Kabbala. Neither of the other two major West Coast assemblagists—Bruce Conner, who worked primarily in the San Francisco Bay Area, or George Herms, who divided his time between Southern California and the Bay Area—worked on this scale, either at the time Kienholz created *Roxy's* or during the remainder of the 1960s (fig. 2).[3]

Yet if he created work on a scale that matched that of his East Coast counterparts, Kienholz had different ends in mind for his art. He used discarded objects to reconstruct everyday environments and in turn to make us see the workings of contemporary culture more lucidly and startlingly. As one tableaux after another followed *Roxy's,* it became clear that Kienholz's art was predominantly a socially critical art—that it confronted us with the darker aspects of contemporary American life. Its subjects were society's victims and the methods of their victimization: the loneliness of death, furtive sex, violent acts motivated by racism. Indeed, Kienholz focused on these and other troubling aspects of everyday life in Western culture that were generally excluded from art of the 1950s and 1960s—including other assemblages and environmental work.

He employed similar means to those of his East Coast counterparts, using discards on a grand scale. To paraphrase Kaprow, Kienholz was willing to relinquish the goal of picture-making (159). Like Kaprow and Rauschenberg, he wanted to create an art that was more like the real world than any art that came before it. Yet the underlying impulse of these other artists' work was to subsume more of the real world into the arena of art; in their varied ways, they strived to aestheticize more of the world. Oldenburg makes that point vividly in a poetic catalog from his memoir and working notes for that period, *Store Days*:

> I am for art that is smoked, like a cigarette, smells, like a pair of shoes.
> I am for art that flaps, like a flag, or helps blow noses, like a handkerchief.
> I am for art that is put on and taken off, like pants, which develops holes, like socks, which is eaten, like a piece of shit.
> I am for the blinking arts, lighting up the night.
> I am for art falling, splashing, wiggling, jumping going on and off. (Henri, 27)

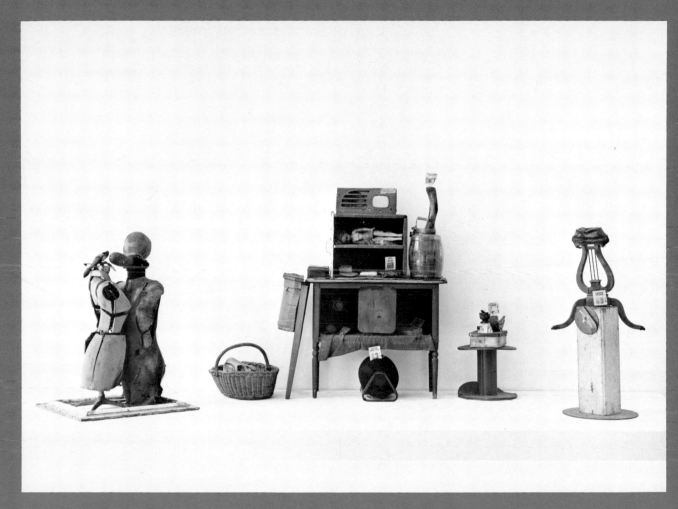

2. George Herms, *The Meat Market* (1960–1961). Tableau arrangement of five mixed media assemblages. Collection of the artist.

For Oldenburg, art was to take the things of reality and create a universe of sensory experience which paralleled and transformed that of the ordinary physical world. For instance, the commonplace clothespin was an appropriate form for an immense monument, as he so vividly illustrated by creating a giant version of one that today sits in downtown Philadelphia (fig. 3); or common forms, such as a toilet or a drum set could be made out of soft, stuffed vinyl, altering our physical experience of them in the everyday world of mass manufactured items.

For all of its use of both the materials and imagery of contemporary American society, the work of these artists offered a different sort of realism than Kienholz's. His art wasn't so much about extending the space of action painting into three dimensions, as were Kaprow's environments of that time: or blurring the boundaries between detritus and a painting, in the fashion of Rauschenberg's combines; or playfully transforming the technological world, as Oldenburg's sculptures did; or making segments of the everyday world serve as the setting for cast figures that evoked Classical and neo-Classical sources, which is the achievement of George Segal's tableaux. Instead, Kienholz's art provides an intensified version of the given social world. It forces us to think about the darker, troubling, and more covert aspects of contemporary Western culture—with a decided emphasis on American society—by giving it back to us in a distorted form that strives to reveal its underlying cruelties.

This is the aesthetic that has unfolded in the more than a quarter century of art that has followed *Roxy's*:

first in the work that bears only his name and in the subsequent art that displays his name and that of his wife, Nancy Reddin Kienholz. It is an oeuvre, as I have begun to suggest, which seems fairly idiosyncratic amongst other notable environmental work of the late 1950s and the early 1960s. Moreover, as this kind of environmental art waned and the room-scale geometric forms of Minimal sculpture waxed dominant throughout much of the rest of the 1960s, Kienholz's tableaux came to occupy an equally, if not more, eccentric position in the panorama of American sculpture.[4]

His aesthetic is maximalist, as it were. His "rooms" or "scenes" are often filled with the clutter of life: letters, photographs, knick-knacks, and every other sort of item that connotes a place that possesses a history or patina of use. He employs these things much like the novelist of Realist temperament would: to place characters (in his case, the figure or figures within the constructed environment or implied by it) within a quite specific social milieu. However, the figures in these tableaux are decidedly not the stuff of Realism. They function as generic types rather than as fully realized individuals, providing nightmarish, quasi-surrealist correlatives for the anguish, loneliness, and cruelty of those who live and suffer in such places. In this respect, their oeuvre reveals its debt to the *objets trouvés* and tableaux of the Surrealists dating from the 1930s and 1940s.

However, Kienholz's works—particularly his assemblages of the late 1950s and the tableaux of the 1960s—find their most precise contemporaneous parallels in literary rather than plastic works: William

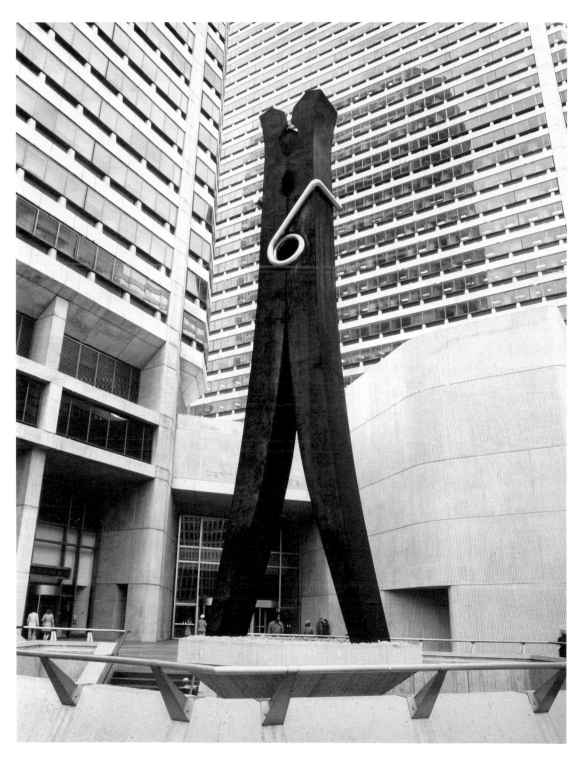

3. Claes Oldenburg's monumental scale sculpture of a clothespin, installed in downtown Philadelphia. © Claes Oldenburg/VAGA New York 1990. Photograph courtesy of The Leo Castelli Gallery.

Burroughs's fiction and Allen Ginsberg's angry early poems such as "Howl" and "America." More generally, they are related to two traditions in the history of the arts in America. One is to be found in genre painting of democratic subjects by William Sidney Mount and George Caleb Bingham during the mid-nineteenth century that is revitalized and updated in the art of John Sloan and Edward Hopper. The second is the current of American cultural criticism that stretches back to the late eighteenth- and early nineteenth-century poetry of Joel Barlow, gathers strength in Walt Whitman's prose pieces such as *Democratic Vista* (1871), and perseveres in the writings of Ginsberg, Burroughs, Mailer, and others.

What Kienholz did share with Minimalists such as Carl Andre and Donald Judd was a concern with the interrelationship between sculptural form and architectural space. These Minimalists, however, were chiefly preoccupied with the ways common objects or fabricated ones could create new relationships between the object and the gallery, between their sculpture and that of their modernist predecessors. By 1966, Andre was stacking bricks in a straight row on the floor, declaring, "All I'm doing is putting Brancusi's *Endless Column* on the floor instead of in the sky. Most sculpture is priapic with the male organ in the air. In my work, Priapus is down on the ground" (Battcock, *Minimal Art,* 104). In other words, there is an implicit

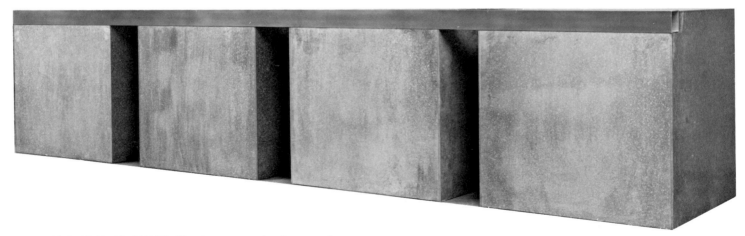

4. Donald Judd, Untitled (1966). Blue lacquer on aluminum and galvanized iron. Collection of the Norton Simon Museum of Art, Pasadena; partial purchase and partial gift of the artist.

attack on the monumentalism of sculpture, whether modernist or earlier. Even when the forms are large like Kienholz's, as with Donald Judd's galvanized steel floor- or wall-mounted boxes (fig. 4), they are repeated forms. Their seriality emphasizes their existence as no more or less than they appear to be, forms with the smallest possible degree of metaphysical or humanist resonances hovering about them; forms arranged according to the artist's system of composition. The Minimalists' ambition was, in a sense, to create forms with as few suggestions of metaphor or symbol as was possible. Their criteria were predominantly optical, formal, and spatial and only implicitly social. In what has become an emblematic statement of the Minimalist sensibility, Frank Stella tersely asserted, "What you see is what you see" (Rose, *Readings,* 173).

For Kienholz, however, optics, form, and space were—and have remained—secondary. Each of these criteria are subordinated to a work's theme, which invariably focuses on a large cultural problem and offers a critical reading of it. Although this approach relegated him to the category of "eccentrics" in the 1960s, he was nevertheless recognized as a major eccentric. But only in Europe, where he and Reddin Kienholz have lived and worked half the year since 1973 (in Berlin), has their oeuvre long been recognized as a uncontestably important one of the post-1945 era; in the United States, where they have assumed the posture of outsiders—living in rural Hope, Idaho and rarely mounting solo shows in New York—critical acceptance lags behind.[5]

In the late 1970s and the 1980s, however, Kienholz's work as well as the later tableaux executed with

Reddin Kienholz had looked increasingly less idiosyncratic, as the dominance of optical and formal criteria had given way to a whole host of strategies for introducing social realities and ideas as well as figurative imagery into the plastic arts. In an era when optical and formal criteria for art no longer dominate, the literary orientation of the Kienholzes' art no longer seems eccentric or idiosyncratic. Indeed, their work seems to have anticipated other significant art; and its influence is widespread. A host of artists, from those devoted to socially critical picturemaking, such as Leon Golub and Sue Coe, to later tableaux artists, like Michael McMillen and Roland Reiss, are indebted to Kienholz's pioneering work of the 1960s.

My essay traces the development of Kienholz's and the Kienholzes' oeuvre, which in following its own trajectory, has assumed an increasingly more prominent position in recent and contemporary American art. It also attempts to place this body of work within the context of post-1945 American art and the tradition of American cultural criticism in literature, as I have outlined them above. These assemblages and tableaux insist on this kind of interdisciplinary reading, because the Kienholzes integrate a wide array of effects—literary, theatrical, visual, and plastic—into their art as they attempt to address various aspects of life in both the United States and Europe. Working on a scale that competes with that of our prosaic environment, they recreate it in ways that make it seem utterly familiar but also extraordinarily strange and richly interpreted.

INTERCHAPTER ONE

Drift and Consolidation: Becoming An Artist

In 1952 or 1953, Edward Kienholz drove into Los Angeles in a 1932 Buick that had been modified into a pickup truck. He was accompanied by a Great Dane and had little more than that to his name. He had passed through Los Angeles before—in 1947, during some restless years following his graduation from high school in Fairfield, Washington, which took him to Montana, Portland, Oakland, Minneapolis, and back to Spokane. But this time he was to stay for two decades.

Born in 1927 to Lawrence and Ella Eaton Kienholz, descendants of Swiss immigrants who came to the United States shortly after the Civil War, he grew up in the small northeast-Washington farming community of Fairfield. His first exposure to great art came in 1951, when he viewed a Rembrandt exhibition at the Walker Art Center in Minneapolis. Twenty-six years later, he recalled his state of mind while standing in front of those paintings: "You know, I thought, 'Geez, if that's a Rembrandt, and he's such a hot shot, you know, there might be a chance for me.' . . . I had the intention of becoming an artist, and an artist makes art. And that was good enough for me" (Weschler, 74).

In a documentary made by David Wolper in 1961, Story of An Artist, Kienholz was to claim that he was inspired to become an artist when he saw a movie in which a painter attracted the most glamorous women; by the time he found out this was a glorified image of the artist, he had already become so obsessed with the process of creating art that it made no difference. The reality of being an artist had proved even more appealing than the fantasy of becoming one.

From both of these stories about becoming an artist we can draw the same conclusion: that with little knowledge of what had come before him, Kienholz had become firmly committed to the notion that art was his avocation. Yet it was a decidedly unlikely choice for someone who had grown up in rural Washington. Fairfield is one among a group of several towns set amidst rolling hills southeast of Spokane; it is a quintessential American small town, with a tidy little main street and nearby granaries that service the local wheat farms. "The cultural aspects of life were listening to 'King of the North' and Bob Hope and Jack Benny on radio," Kienholz recalls (Weschler, 32). He showed a few signs of interest in the plastic arts. In high school, he often designed sets for school plays and sometimes built them too. Kienholz also entertained the notion of becoming an architect, but soon dropped that idea because he felt he was not good enough in mathematics. Ultimately, though, he exhibited no driving ambition to become an artist during his teens.

At some point during his decade of wandering, however, Kienholz defined himself as an artist. By 1954, he had obtained a little studio on Ventura Boulevard in the San Fernando Valley. A year later, he had moved to a place (in essence, a storage room in back of a car design shop) on Santa Monica Boulevard, in the Hollywood area; the rent was $10 a month. Kienholz did construction work and was at times forced

to collect deposits on bottles to get enough money to eat.

For the first time—in 1954—he saw the inside of a serious space for modern art, the Felix Landau Gallery. "Everything was white and clean and pretty," he recalled. "I thought [whistles] that's the way it should be" (Weschler, 87). At that time, Kienholz was making paintings on plywood, adding more wood chunks and scraps to create a relief surface (fig. 5). He often laid on the paint with a broom, to make the expressionist effects deliberately crude—"anti-gestures," as he once termed them (Kienholz, Kienholz, n. p.). Felix Landau, who exhibited early twentieth-century modernists and painters of the New York School, had no interest in showing Kienholz's paintings, nor did the other two serious dealers of contemporary art then operating in Los Angeles: Paul Kantor and Esther Robles. Thus he decided to establish his own white gallery walls, by transforming the lobbies of two movie theatres on La Cienega Boulevard, the Turnabout and the Coronet, into galleries. In these spaces, he exhibited the work of other artists.

In 1954, a few miles away on Gorham Boulevard in Brentwood, a junior majoring in art history at the University of California at Los Angeles (UCLA), Walter Hopps, poet/mathematician Ben Bartosh, his wife Betty, and artist/mathematician Michael Scoles opened a gallery, the Syndell Studio, devoted to Abstract Expressionist work emerging in Los Angeles and the Bay Area. Two years later, while working on an All-City

5. Edward Kienholz, Untitled (1955). Painted wood construction. Collection of the Museum of Contemporary Art, San Diego; gift of Mr. and Mrs. M. Gribin.

Art Festival at Barnsdall Park, Kienholz and Hopps met. They took a quick liking to each other and wrote an informal one-line contract on a hot dog wrapper while having lunch at a stand on La Cienega Boulevard: "We will be partners in art for five years" (Turnbull, n. p.). They closed the transaction with a handshake and by 1956, they were mounting cooperative shows, in which Syndell Studio artists such as Craig Kauffman, Fred Wellington, Paul Sarkisian, Bartosh, and Scoles exhibited at Kienholz's Now Gallery and Kienholz showed his work at Syndell. Some of those shows widened the geographical scope further to include artists from the Bay Area whose work was loaned by the East and West Gallery and Gallery Six. (The last of these two spaces was the site of Allen Ginsberg's historic first reading of "Howl," recounted in Jack Kerouac's roman à clef, The Dharma Bums.)[1]

In April 1957, Hopps and Kienholz opened a gallery together and it is one that has since acquired legendary status in West Coast art history. Hopps named it the Ferus Gallery, in memory of a young artist he knew at Eagle Rock High School, James Ferus, who died at fourteen or fifteen. Its name held a second allusion too, as Hopps recalled; it referred to the anthropological term Ferus hominus, which designated

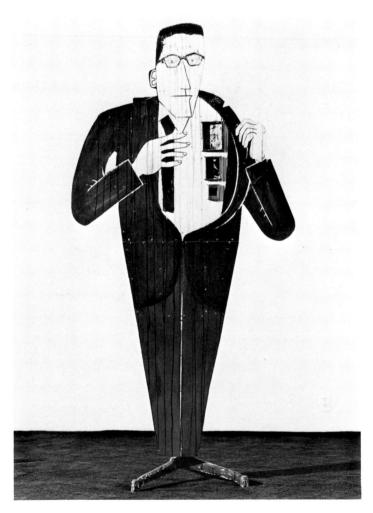

6. Edward Kienholz's homage to his partner at the Ferus Gallery from 1957 to 1958 and his early champion, *Walter Hopps Hopps Hopps* (1960). Mixed media assemblage. Collection of the Lannan Foundation, Los Angeles.

the very primitive people of the Australian aborigines or a prototype people described in, as I remember, Probers' Anthropology textbook as having a certain contained violence, irascibility, and tremendous physical prowess for survival— definitely subhuman pre-Homo Sapiens. So it was from Ferus hominus that this seemed to describe, somewhat ironically, the kind of people

we were and the kind of people we were dealing with. (Turnbull, n. p.).

Hopps provided a sound knowledge of modernist art history and contemporary art. In addition to his academic training, he had sought out the Los Angeles-based Walter Arensberg, whose collection allowed Hopps, then still in his teens, to view works by Marcel Duchamp, the Surrealists, and other prominent figures. Kienholz provided the physical labor and the bargaining skills he had developed during his transient years. The gallery was to introduce a number of artists who became synonymous with Los Angeles art during the 1960s: the late John Altoon, Billy Al Bengston, Wallace Berman, Robert Irwin, Craig Kauffman, John Mason, Ed Moses, and Ken Price. Hopps, who was also a partner in the Dilexi Gallery in San Francisco, continued to showcase Bay Area painters at the Ferus; he and Kienholz exhibited artists of importance to that region: Jay DeFeo, Sonia Gechtoff, Frank Lobdell, and Hassel Smith, among others (fig. 6).

The co-owners of the gallery and the Ferus stable did indeed need a prowess for survival, since collectors were scarce and the public small for art such as theirs. Humor and irascibility, as Hopps's words suggest, was one way of dealing with this situation.

Kienholz was to stay on as a gallery artist until 1961, but he remained Hopps's partner only until late 1958, staffing the desk in exchange for a studio space in the back of the gallery. In the fall of that year, he sold his share of the Ferus to Hopps, who then formed a partnership with Saydie Moss and Irving Blum. The end of Kienholz's involvement marked the end of his days as a gallery person—at least until 1977, when he and Reddin Kienholz opened the Faith and Charity in Hope Gallery on their property in Hope, Idaho.

In retrospect, Kienholz's timing seems uncanny, because by 1959 his art had reached a critical juncture. Perhaps he sensed as much, since during 1957 and 1958, his compositions were becoming more elaborate, protruding out from the wall further until he built one that stood on the floor. The second of the freestanding constructions, John Doe *(1959) (plate 3), proved to be a pivotal work, for it combined social commentary with a figurative approach to assemblage. Clearly, Kienholz had some notion or intuition he had uncovered a worthwhile direction, for he constructed two more freestanding assemblages as companion pieces to* John Doe *within the next two years:* Jane Doe *(1960) and* Boy, Son of John Doe *(1961).*

John Doe *was the centerpiece of his exhibition at the Ferus Gallery in March and April of 1959. That year also marked the beginning of a new era for Kienholz. "I was around on La Cienega Boulevard for a short period of time in my life," he explains, "and then I was up on the hill" (Weschler, 460). In late 1958, he bought a house in Laurel Canyon (on Nash Drive) and built a studio there. His works of the 1960s were to bear out the wisdom of that decision.*

ONE

The Horrific Object: Sculpture as Social Criticism

[T]he American imagination, like the Puritan mind itself, seems less interested in redemption than in the melodrama of the eternal struggle between good and evil, less interested in incarnation and reconciliation than in alienation and disorder.

—Richard Chase, *The Democratic Vista: A Dialogue on Life and Letters in Contemporary America* (1958)

It is art made for no one's living room, and hurrah for that. It is an art which it would be quite pointless to understand in terms of the standard categories of art history. It comes out of the compulsive cataloguing of the details of our days and ways that begins innocently enough with Whitman, and within a century, spirals insanely to the relentless lists of horrors compiled by the Beat poets and the obsessive, obscene humor of Lenny Bruce.

—Philip Lieder, from a review of a Kienholz exhibition published in *Frontier* in 1964

When asked by a journalist to characterize the aesthetic virtues of *The Beanery* (1965), his most ambitious environment of the 1960s, Edward Kienholz replied, "I don't know if it's art, but I don't give a damn" (Martin, 103). The statement is a telling one, because the chief ambition in Kienholz's assemblages and tableaux of the 1960s and beyond isn't formal or stylistic. In the creation of his first significant sculptures, Kienholz's animating impulse was, quiet simply and straight-forwardly, anger—an impulse borne of his perception of estrangement and disgust with his own culture. As the artist himself would later state, reflecting on his output during those years: "Adrenalin-producing anger carried me through that work—though that hard-cutting anger is now gone."[1]

Kienholz was to find the plastic form to contain and express such fury in *John Doe*. It is a kind of visual invective, a savage attack on the archetypal American male. Kienholz portrays his everyman as infantile: the head and torso of a mannequin rests in a baby stroller. He is religious but not passionately so: in place of a heart he possesses a cross in his chest. And he wears the traces of violence: red paint drips down his face and body like blood.

The explicitly social focus of *John Doe*—more particularly its heavily satirical tone—is anomalous in significant American art of the late 1950s, even if its format is not all that unusual. By 1960, when the art historian and critic William C. Seitz curated *The Art of Assemblage* exhibition for the Museum of Modern Art, assemblage had clearly come to be recognized as a

major genre of twentieth-century American and European art. This important survey spanned the history of assemblage, from Picasso's *Bottle of Suze* (1913) to contemporary examples that included Kienholz's *John Doe* and *Jane Doe.* Yet one will find no other artist, among the 139 represented in that survey, whose work is as overtly socially critical as Kienholz's.

Though in technique and format his work was clearly of the assemblage variety, the contemporaneous parallels for Kienholz's enterprise primarily lie outside this genre. In fact, Seitz himself suggests that we might do well to look for analogs other than in visual art for the work of particular assemblagists. He writes in his essay for the *The Art of Assemblage* catalog:

> As element is set beside element, the many qualities and auras of isolated fragments are compounded, fused or contradicted so that—by their own confronted volitions, as it were— physical matter becomes poetry. Directed, intentionally or unconsciously, by an artist's intellectual position, emotional predisposition, or any other conditioning attitude or coloration, a vast repertoire of expression—exultant, bitter, ironic, erotic, or lyrical—can be achieved by means different in kind from that of painting and sculpture, but akin to those of literature. (86)

Seitz's analysis is highly suggestive for an understanding of both the sensibility and purposes of Kienholz's art. The strongest contemporaneous parallels, for Kienholz's Doe trilogy and the seminal tableaux such as *Roxy's* and *The Illegal Operation* (1962), are to be found in texts that articulate, or are allied with, the Beat sensibility of the late fifties and early sixties. Nor is it coincidental that such texts— Allen Ginsberg's *Howl and Other Poems* (1956), William Burroughs's *Naked Lunch* (1959) and his closely related novels, *The Soft Machine* (1961) and *The Wild Boys* (1969), as well as Norman Mailer's essay, "The White Negro: Superficial Reflections on the Hipster" (1957)—take a passionately critical stance toward American society too.[2] With these writers, Kienholz shared a penchant for horrific images—those pictures of American society, visual or verbal, which could reveal the sordid aspects of American society. Indeed, the grotesque *John Doe* is the plastic realization of the archetypal citizen of Ginsberg's hellish metropolis of "Howl"—a visual equivalent of the characters in Burroughs's novels who seem to be in love with violence itself. The overarching theme in all of these works is strikingly similiar; confronting American society in the late 1950s, each artist sought to expose the forms of oppression and violence, psychological and physical, of a society that looked calm and complacent on the surface. None of these writers, nor Kienholz, were to offer a programmatic approach to America's social ills. Rather, each sought to dramatize the drift of American culture toward what he perceived to be an antidemocratic and militarized state.

Ginsberg's encapsulates the underlying despair of much of this criticism when he declares, at the outset

of his short poem, "America" (1956): "America I've given you all and now I'm nothing." He continues: "America two dollars and twentyseven cents January 17, 1956 / I can't stand my own mind. / America when will we end the human war? / Go fuck yourself with your atom bomb" (*Howl*, 31). It is the same tone of immense, almost unbearable, disillusionment, coupled with an undercurrent of sardonic self-mockery, which one also finds in Burroughs's fiction, Mailer's essay, or Kienholz's *John Doe* and the two works that followed in quick and sequential fashion, *Jane Doe* and *Boy, Son of John Doe.* The world within Burroughs's novels is a brutal place where violence, incarceration, cruel sex, and consumption of drugs predominate. Power is only maintained through methods that promote fear— "the CONTROL GAME," as it is called in *The Wild Boys.* And in the world within this novel, it is Americans who are best at this game, as a drunken sergeant claims. "When you want the job done come to the UNITED STATES OF AMERICA. AND WE CAN TURN IT ON ANY DIRECTION," he exlaims (35).

Mailer takes an equally bleak view of postwar American society in "The White Negro," when he declares:

> No wonder then that these have been the years of conformity and depression. A stench of fear has come out of every pore of American life, and we suffer from a collective failure of nerve. The only courage, with rare exceptions, that we have been witness to, has been the isolated courage of isolated people. (Mailer, 312)

Instead of producing a new race of men and woman,

as St. Jean de Crevecoeur and many others had prophesized in the late eighteenth century, America had given rise to a cowardly and complacent one; in the 1950s it had produced "the smothering orthodoxy and conformism of the Eisenhower age" as critic Richard Chase phrased it in *The Democratic Vista* (159).

With the Beats, Kienholz shared a strong distaste for the state of postwar American society. Much like Burroughs, Ginsberg, and Mailer, he expressed the desire for social change, the ambition to discover a fissure in a social order each perceived to be oppressively stabile. Kienholz found the example of the Beats to be inspirational in this regard. "Back at the time of Kerouac, there was a change in the air; you could feel a change coming," he was later to recall (Weschler, 126).

Yet his affinity with the Beat sensibility, in its West Coast manifestations, was tenuous. As the co-owner of The Ferus Gallery in Los Angeles—from 1957 to 1958— Kienholz did provide Wallace Berman, one of the few significant visual artists among the Beats, with a place to show his work. The gallery also hosted readings for a number of poets, including Michael McClure and Robert Duncan; both of these figures were intimates of Berman and both numbered among the writers who published works in the artist's sporadically published little magazine, *Semina*.[3] In addition, Berman provided a valuable precedent for Kienholz, if only by example; he was the first of the West Coast assemblagists. As early as 1949, he assembled one construction, *Homage to Hesse* (1949), and had begun work on another, *Veritas Panel* (1949–1957). Then, in 1957, he had a solo exhibition of such work at the Ferus Gallery.

Yet Berman was an artist with a strikingly different sensibility from Kienholz's. Until his death in 1976, Berman assumed the posture one most often associates with the Beats: that of the artist as visionary or mystic. *Temple* (1956; now destroyed) (figs. 7 and 8), his most ambitious work in that 1957 exhibition, illustrates the cryptic, almost hermetic form his spiritual aesthetic assumed. It consisted of a roughly hewn structure that looked much like an old voter's booth. Inside, with back to the viewer, was a hooded figure with a key on a chain around its neck portion. Posted on the walls and strewn on the floor were the loose pages of the first issue of *Semina.* The figure within the booth was clearly metaphorical—a representation of the artist as spiritual figure, at work in his shrine reading and interpreting his "sacred texts." For Berman, spirituality was inseparable from art—and inextricably intertwined with powerful emotion. "Art is

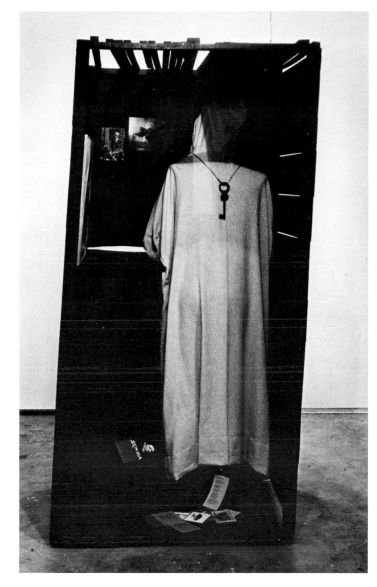

7. Wallace Berman, *Temple* (1956; destroyed). Mixed media assemblage. Photograph: Charles Brittin.
8. Wallace Berman, Detail of *Temple,* showing pages of *Semina.* Photograph: Charles Brittin.

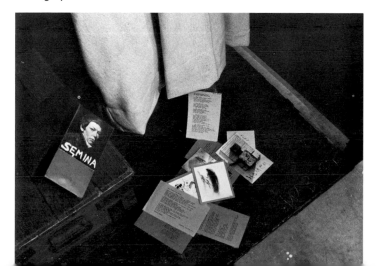

Love is God" is the aphorism he used to articulate his aesthetic. He wrote it in the second issue of *Semina,* published shortly after his Ferus gallery exhibition, and again in two subsequent issues of the magazine.

Where Kienholz parted ways with the Beats was in his rejection of the role of the artist as spiritual visionary. Ginsberg, for all of his socially motivated anger, was also, of course, an ardent proponent of a visionary tradition he located in the poetry of the Bible, William Blake, Walt Whitman, and Eastern mystics. Mailer, too, offered a highly mystical reading of social phenomenon. In an interview conducted a year after the publication of "The White Negro," he offered an amplification of his views of what Hip represented. Mailer defined it as a willingness to "get involved with more expression"; and to do so, he intuited, was to be more fully engaged in God's work. As Mailer asserted, "Perhaps He is trying to impose upon the universe His conception of being against other conceptions of being very much opposed to His. Maybe we are in a sense the seed, the seed-carriers, the voyagers, the explorers, the embodiment of that embattled vision" (Mailer, 351).

Kienholz, on the other hand, was—and is— thoroughly and unequivocably atheist. "I can't believe there's a heaven," he once said, "I think the whole idea of continuance after death is an understandable projection of man's ego" (Weschler, 342–343). Thus while Berman forged assemblages embodying mystical concerns, Kienholz was creating a decisively secular-minded mode of constructed art. Poet David Meltzer, friend of both artists during the 1950s, was to recall, Berman's art provided Kienholz with "permission" to do something other than paint little figurative pictures or create abstract constructions.[4] Kienholz recalls that this was simply not the case; his evolution was entirely separate from Berman's (Personal interview, 1982).

Until 1959, Kienholz had conceived of himself as a painter. He made use of the clumsiest of brushes—the broom—and he used it to cover plywood surfaces, both flat and relief. The instrument was appropriate to his intent too: "to make these pieces 'as ugly as possible.'" In addition, these works led into his freestanding works. "As time went on," Kienholz recounted in a 1974 catalog, "the relief structures got more and more intricate and protruded further and further into the room until they finally demanded floor space" (Kienholz, *Kienholz,* n. p.).

Kienholz's creation of the Doe trilogy was the pivotal event in the adaptation of assemblage to his own secular-minded sensibility. These works are psychologically charged as well as sociological portraits—images of victims and victimizers. *John Doe,* with his aura of religiosity and violence, is Kienholz's archetypal aggressor figure, while *Jane Doe* (fig. 9) is the first of many such victim figures in his work. To create her, he employs objects that assert that the female, from the vantage point of her male counterpart, is little more than an object herself.

On one level, Kienholz communicates this idea quite straight-forwardly, by attaching a female doll's head to a cabinet with drawers and covering this sculpture up to her neck with an ornate bridal gown. But Kienholz also accents this aspect of the work, since she is the passive recipient of whatever attention the viewer might choose to lavish upon her. If one lifts the covering, one discovers drawers that can then be

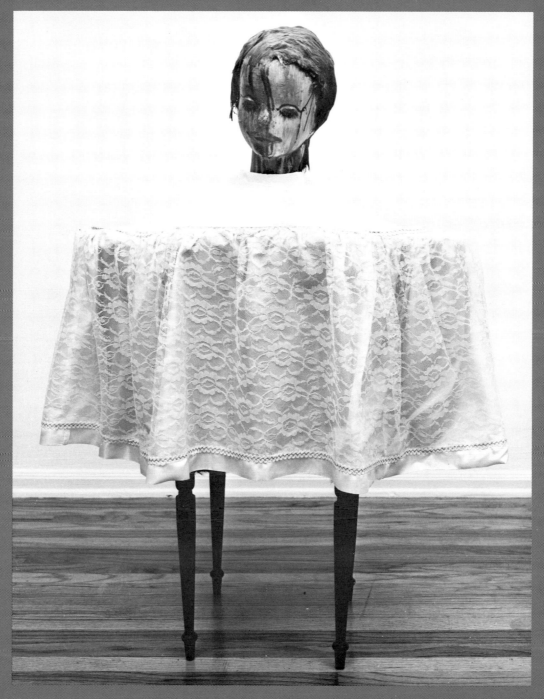

9. Edward Kienholz, *Jane Doe* (1960). Mixed media assemblage. Collection of Laura Lee Stearns, Los Angeles. Photograph: Frank J. Thomas.

opened. And if one opens these drawers, one discovers them to be filled with little trinkets that are metaphors for Jane Doe's emotional and sexual secrets. It is, then, each viewer who must decide whether to lift her skirt and open her drawers to uncover her most intimate memories and feelings.

In a culture full of John Does, this work strongly implies, the concealment of one's feelings is a necessary act and this theme is dramatized by the viewer who must act to reveal this aspect of the work's meaning. He or she is forced to assume the role of the aggressor, when faced with Jane Doe's passivity. Thus the sculpture as object becomes a surrogate for the woman as object and Kienholz has made his *Jane Doe* look appropriately lifeless.

Boy, Son of Jane Doe is the logically grotesque outgrowth of his "parents," both in terms of the issues he evokes as well as his formal composition. His father's stroller is replaced by a toy car, attached at waist level to the tall mannequin that serves as the figure of *Boy, Son of John Doe*; and he wears it in the manner of some immense and curious belt. Much like the stroller, the child's car is another reference to arrested development. In the trunk, one finds the artifacts of his and—as we are surely to assume—the typical American adolescent: playing cards, a Coors beer can, a condom, a pack of cigarettes (Pall Malls), and some assorted litter. The most telling item of baggage, however, is a cheap paperback book whose title, *The Impotent Fear Through the Erogenous Zones*, reaffims the central theme of the Doe trilogy: the true cost, for the culture, of male domination and female victimization. All are rendered impotent in the process of maintaining this cultural dynamic. *John Doe* possesses a phallus, but it is hidden in a compartment at the bottom rear side of the torso. *Jane Doe,* in turn, is a lifeless looking effigy of a woman. Implicitly at least, these works manifest an identification with, and defense of, the victim—as *Jane Doe* demonstrates quite vividly. Kienholz was to make this empathy with society's victims a major theme of his oeuvre, focusing on powerless figures such as criminals, prostitutes, and unwed mothers as an implicit expression of his own marginality.

This perception of marginality is a central theme, too, in the work of all three of the writers to which I have been comparing Kienholz's art. In "Howl," it is the search for mystical visions which sets "the best minds" apart from others, but not without risk since some go mad in the process. For Ginsberg, it is only personal vision, the ability to see the holiness in everything and anything as he declares in his "Footnote" to this long poem, that saves him from the kind of madness which has beset Carl Solomon in Part III of "Howl." In "The White Negro," Mailer envisions the survivor in this "bleak scene" of post-World War Two America to be that of the hipster, whose strategy is "to divorce oneself from society, to exist without roots, to set out on that uncharted journey into the rebellious imperatives of the self" (313). The journey is one that would carry the hipster to the extreme periphery of American society, where the junkies of Burroughs's *Naked Lunch* would be waiting to greet him as it were.

Each of these artists speaks of a betrayal, of some promise on which America has reneged. Whether this betrayal is real or imagined is irrelevant; the

perception that a breach of trust between the artist and his culture has occurred is sufficient. Ginsberg, for instance, dreams of a "lost America of love" as he imagines himself strolling with Whitman in "A Supermarket in California" (*Howl*, 24). Kienholz's *John Doe* is a horrific antithesis of Walt Whitman's vision of the fulfilled self in a democratic culture, as the great poet so passionately envisioned this American in his various editions of *Leaves of Grass* (beginning in 1855) and in *Democratic Vistas* (1871). To Kienholz, as much as Burroughs, sarcasm and invective seemed appropriate to an American society of the 1950s and 1960s, whose actualities paled miserably beside older aspirations for and visions of a democratic culture. In *Naked Lunch*, the "high-tech" society called Freeland "is clean and dull my God." Doctor Benway is the dominant force there, a man who runs the Reconditioning Center and possesses a total contempt for the individual. Of one group of potential subjects, he quips, "Who cares what they think? Same nonsense everybody thinks, I daresay" (28–34).

It is against the backdrop of the grand idealism of American visionaries such as David Humphries, Joel Barlow, and Walt Whitman that we should consider Kienholz's socially critical works. For these sculptures create a kind of bleak antithesis to the hope that America was still the locus of the new man; that the glorious "democratic vistas" that the poets had, in varied ways, imagined would become social realities. It was Crevecoeur, of course, who had set the tone most explicitly for the subsequent dialogue concerning the American in *Letters from an American Farmer* (1782) when he asked his central and enduring question, "What then is the American, this new man?" His own answer: "He is an American, who, leaving behind him all his ancient prejudices and manners, receives new ones from the new mode of life he has embraced, the new government he obeys, and the new rank he holds" (39). Barlow, a younger contemporary of Crevecoeur, was equally enraptured with the idea of the future, as it would unfold in the New World. In *The Columbiad* (1807), he offered a vision strikingly similar to Crevecoeur's when he declared, "Here social man a second birth shall find, / And a new range of reason lift his mind" (Pearce, *Continuity*, 65). In Barlow's quasi-epic poem, America and the rest of the Western hemisphere would be watched over by the benevolent goddess, Hesper, as Western civilization is reborn in a grander state. A half century later, Whitman was to articulate one of the most famous visions of a greater America, both present and future. He declared in his 1855 preface to *Leaves of Grass*, "Here at last is something in the doings of man that corresponds with the broadcast doings of day and night. . . . Here is the hospitality which forever indicates heroes" (411).

Yet Whitman's utopian yearnings could suddenly give way to a great despondency, as he demonstrated in his lengthiest essay on the state of American culture, *Democratic Vistas* (1871). Reflecting on the state of things in Brooklyn during the late 1860s, Whitman wrote: "Confess that to severe eyes, using the moral microscope on humanity, a sort of dry and flat Sahara appears, these cities, crowded with petty grotesques, malformations, phantoms, playing meaningless antics" (462). It is this darker picture of America which reappears, in newer guises, in Ginsberg's poetry,

Burroughs's fiction, Mailer's nonfiction, and Kienholz's art. For these figures, however, this picture is the dominant one, not a momentary lapse in the drive toward fulfillment of a grander American culture. With Whitman's dreams of a heroic America seemingly dissolved, hopes of utopia turned to visions of dystopia. Barlow's goddess of America had turned into Ginsberg's "sphinx of cement and aluminum," as it were, a deity who presides over destruction rather than birth. She is a goddess of, in Ginsberg's terms, "Moloch! Solitude! Filth! Ugliness!" (9). According to Burroughs's prophesy as well, the future for the United States, in fact all of the Western world, was very dark indeed:

> The uneasy spring of 1988. Under the pretext of drug control suppressive police states that have been set up throughout the Western world. The precise programming of thought feeling and apparent sensory impressions by the technology outlines in bulletin 2332 enables the police states to maintain a democratic facade from behind which they loudly denounce as criminals, perverts and drug addicts and anyone who opposes the control machine. (*The Wild Boys*, 138)

If the Doe trilogy dramatizes a similarly dark vision of the state of American society, it also adumbrates the shape that Kienholz's own vision of socially critical art would take, beginning with *Roxy's*. The viewer wasn't allowed simply to remain a wholly innocent bystander to the event or issue dramatized but was to become a voyeur and often a kind of participant in the depicted social drama. His idea of how to make objects

articulate his ideas, in this trio of sculptures, announces the method that would become fundamental to the work that followed. Kienholz focused on the covert meaning of objects, making an entire work as well as its individual components function metaphorically. Moreover, it is the viewer who has to decide whether to activate that covert meaning. One must crouch down behind *John Doe* to discover that he is a hollow man, as it were, with a pipe leading from his back to the cross positioned where his heart should be (fig. 10); one has to look long and carefully to see what all the items are in the trunk of *Boy, Son of John Doe*. In Kienholz's art, then, looking is almost always a highly loaded sort of activity, where the uncovering of meaning is also dramatized as a transgression of the subject's privacy.

10. (Opposite) Edward Kienholz, A view of the back of *John Doe*. Photograph: Susan Einstein.

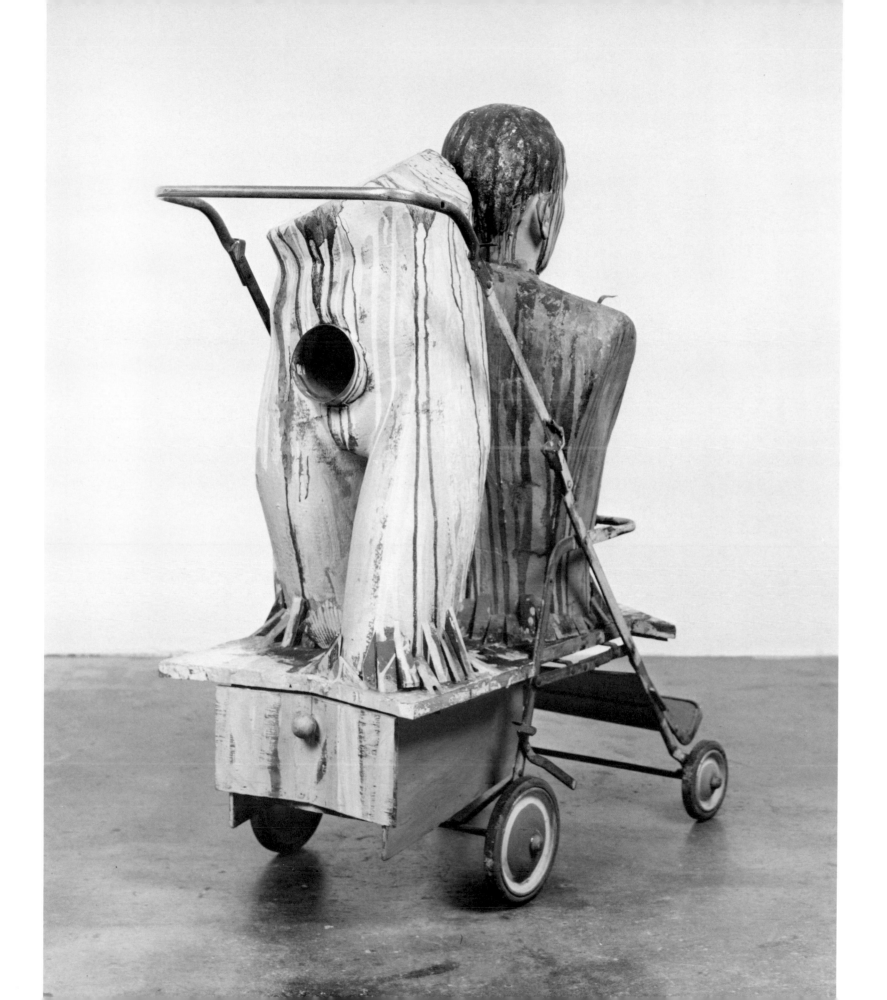

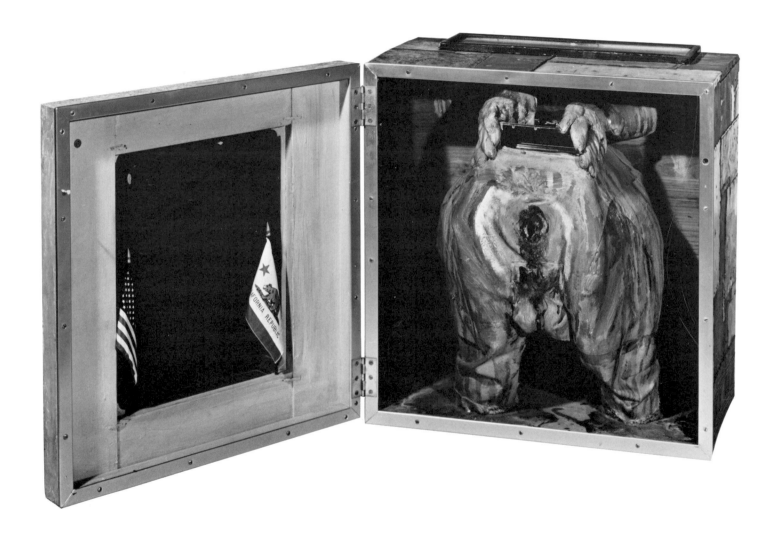

11. Edward Kienholz, *The Psycho-Vendetta Case* (1960). Mixed media assemblage. Collection of the Museum Moderner Kunst, Vienna.

12. (Opposite) Ben Shahn, *The Passion of Sacco and Vanzetti* (1931–1932). Oil on canvas. Collection of the Whitney Museum of American Art, New York; gift of Edith and Milton Lowenthal in memory of Juliana Force. © The Estate of Ben Shahn/VAGA New York 1990.

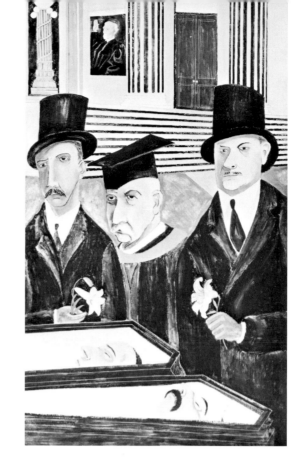

In *The Psycho-Vendetta Case* (1960) (fig. 11), a wall-mounted assemblage created during the same year as both *Jane Doe* and *Son of John Doe,* Kienholz reveals just how pointed his use of this strategy could be. The acerbic title is, quite obviously, a pun that alludes to the infamous Sacco-Vanzetti case of 1921. During that trial, two Italian immigrants, Nicola Sacco and Bartolomeo Vanzetti, were tried and convicted— ostensibly for murder, but in actuality for their anarchistic politics. They were subsequently executed in 1927, despite a large public outcry.

Kienholz's titular pun means to draw a parallel between that case and the one that is the explicit subject of this assemblage: the 1956 conviction of Caryl Chessman, who was sentenced to death in California on a charge of sexual molestation. That earlier execution was also the subject of a well-known American picture, Ben Shahn's painting, *The Passion of Sacco and Vanzetti* (1931–1932) (fig. 12). Kienholz was completely unaware that such a painting existed when he created *The Psycho-Vendetta Case;* yet comparing Shahn's treatment of Sacco's and Venzetti's demise to Kienholz's work on Chessman's execution yields intriguing results. For one can readily see just how much his methods differ from Shahn's more conventional approach to social satire.

The Passion of Sacco and Vanzetti is rendered in the style of slighly flattened and linear realism that generally characterizes Shahn's paintings. It shows the two immigrants—already executed, reclining in their coffins—presided over by rather pompous-looking judges holding flowers. Clearly (and most ironically) the men in robes are supposed to be paying respects to the dead whom they themselves have killed. What makes Shahn's picture more conventionally satirical than Kienholz's *The Psycho-Vendetta Case,* however, is its presentation. The viewer is a spectator, wholly outside the action of the depicted scene. Not so in *The Psycho-Vendetta Case;* we spy on and participate in Chessman's execution, so to speak. Kienholz vividly describes the means by which he believes this work transforms a viewer into both voyeur and participant:

> It's just a box that swings open, made out of tin cans (it's covered with tin cans). Its got the great seal of approval of California on the surface of it, and when you open it up, it's Chessman shackled with just his ass exposed. The hands are holding a tank periscope. And when you look in that, you read down there, and it says "If you believe in an eye for an eye and a tooth for a tooth, stick your tongue out. Limit three times." And you realize while you're reading that you're lined up exactly with his ass. (Weschler, 223–224)

As Kienholz implies, there is a continuum of viewer-voyeur-participant that supplies the foundation for the assemblage's physical and thematic structure. The work first confronts the viewer with only the "California seal of approval"—a parody of the California state seal, stridently linking governmental policy with capital punishment. Yet if the viewer opens the box, thereby seeing just what it is the state approves of, he is instantly transformed into a voyeur; he is looking at the suffering of the "exposed" Chessman. Having come that far, the voyeur must make another decision: whether or not to look down the "periscope" to which Chessman's hands point.

At this juncture, Kienholz relies, of course, on simple human curiousity to lure each of us to look down that opening. And having done so, each voyeur must then decide whether or not to perform the childish act of extending the tongue and thereby become a participant in the biblically rooted revenge of capital punishment.

Clearly, the thrust of *The Psycho-Vendetta Case* is sarcastic; it makes the viewer into the object of a practical joke, which is meant to dramatize the foolishness of capital punishment. As a member of a society which allows such acts of retribution to take place, this work implicitly asserts, each and every viewer is justifiably deemed a fool or an ass. Thus, the aesthetic logic of this work is obviously satirical. It calls us names—a variety of satire which, as Northrop Frye rightfully asserts, is an extreme manifestation of the genre.[5]

Generally, Kienholz was not to point his criticism so directly at the viewer. Instead, as he began to focus his attention on the tableau format, social tensions and injustices were projected into the realized scene. His art became less that of statement or invective than a series of situations. From the time of *Roxy's,* those situations were clearly charged with a message, but one had to experience that message as both voyeur and participant in spaces that parallel those of our own world. Within those spaces are representations of society's victims; a viewer is implicitly directed to imagine him- or herself as one of those victims or as one of society's victimizers.

For *Roxy's,* Kienholz created a series of figurative assemblages, each of which had a sort of generic name: *Ben Brown; Miss Cherry Delight; Five Dollar Billy; Dianna Poole, Miss Universal Joint; Cockeyed Jenny; Fifi, A Lost Angel; A Lady Named Zoe;* and *The Madame* (fig. 13; also see plates 1 or 2). They are not fully realized characters so much as differing visual metaphors for the same social reality: the dreary existence of the prostitute. In 1977, thinking back on this tableaux, Kienholz was to recall:

> I went back in memory to going to Kellogg, Idaho, to a whorehouse when I was a kid, and just being appalled by the whole situation—not being able to perform because it was just a really crummy bad experience, a bunch of old women with sagging breasts that were supposed to turn you on, and like I say, it just didn't work. (Weschler, 89–90)

But if these recollections inform the tableau and perhaps inspired it, *Roxy's* offers not so much plastic autobiography as a way of making personal experience into the stuff of an archetypal experience. To his

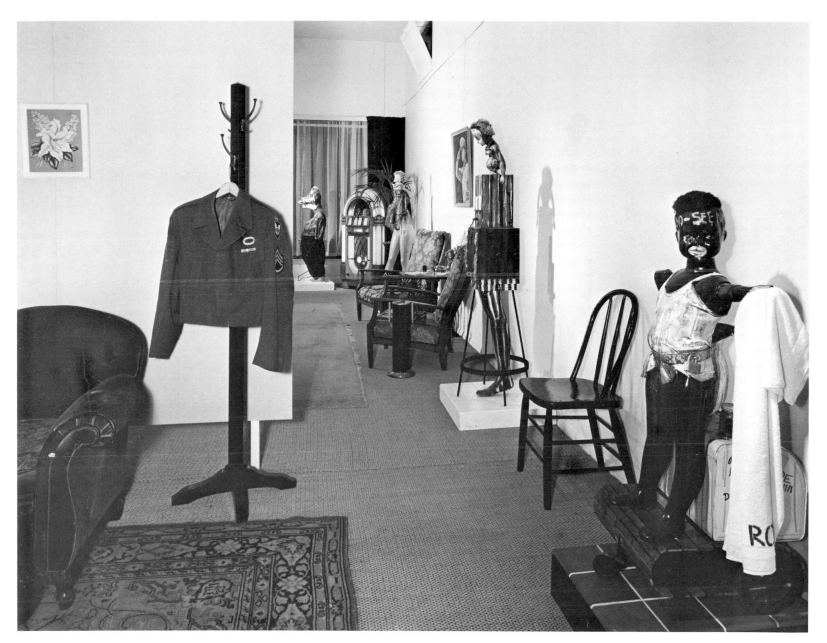

13. Edward Kienholz, *Roxy's* (partial view), in its original installation at the Ferus Gallery in 1962. *Ben Brown* is in the immediate foreground (at right); adjacent to the same wall, the figurative assemblages, from closest to furthest, are: *A Lady Named Zoa, Fifi, A Lost Angel,* and *The Madame.* Photograph: Seymour Rosen.

recollection of a youthful experience in a brothel, we must add Kienholz's comment that "My *Roxy's* is a combination of eighteen-year-old rememberings, blue movies and imagination" (Weschler, 89). Indeed, his imaginings give the broadly cultural experience of a whorehouse a material form—not a form that recreates this environment in a meticulously realistic fashion, however, but a work that unmasks its psychological, physical, and social cruelties.

Kienholz's brothel is horrific rather than erotic. Upon entering *Roxy's,* the viewer is greeted by a madame who establishes the oppressive and morbid ambience of the tableau. She is simply a wigged boar's skull, attached to a propped up dress-form and placed on a pedestal. As the aged prostitute, she confronts us as a graphic juxtaposition of the dead dressed up in the clothes of the living; she is an assembled metaphor for death in life. This theme is then amplified, as one proceeds from figure to figure and finds each in a state of physical decay and grotesqueness. *Five Dollar Billy's* decrepitude, for instance, serves to remind us of the consequences of her labors. She is horizontally positioned atop a crude sewing machine with a foot pedal. A rose is attached to her neck, a squirrel is creeping out of her breast, and her legs are shriveled. By pushing on her pedal, the viewer becomes the customer since he can make her undulate at will.

Jenny, Dianna Poole, and *Miss Delight* all represent emotional cruelties that serve as corollaries to Billy's physical condition. Jenny's torso consists of a garbage pail with a bra, her head, of a wig-covered lid. Here again, Kienholz preys on the viewer's curiousity—in this case, to open the lid and reveal one

word that poignantly mocks her existence: LOVE. And if Jenny's appearance lucidly communicates the notion of wasted love, Poole and her children provide a different kind of visual manifestation of the same problem. Male and female marionettes hang from her leg; whereas, she is a seated figure who first confronts us as a burlap potato sack attached to a pair of attractive mannequin legs. As children, of course, the marionettes seem horribly blank and lifeless; Poole's removed sack reveals a correspondingly grotesque hollow head with a blank jack-o'-lantern face and deformed body.

Creating *Roxy's,* Kienholz gave clearer shape to his mode of response to cultural and social issues. With the Doe trilogy, where no setting was provided to unite all three, the imaginary backdrop was America in its entirety. Beginning with *Roxy's,* however, the figures were placed within a locale, however generic it might be. *Roxy's* is about every and any brothel. Subsequent tableaux were to be equally generic, provoking the viewer to create a large range of associations in each case.

In *Roxy's,* Kienholz also arrived at the formal strategy that would work so well: within a seemingly ordinary and recognizable setting he placed quite horrible sights. All of the "women" in this brothel are curious figures as well as repulsive ones. Yet we find them located within a quite ordinary and meticulously recreated setting. A June 1943 calendar is posted in the waiting room, and all of the furniture, clothes, titles on the jukebox, and the portrait of General MacArthur are carefully chosen to correspond with the time period established on that calendar. It is as if Kienholz wanted

to fuse the immediacy and actuality of a documentary photograph with the moral urgency of an allegory. There is an air of familiarity to this place called *Roxy's,* yet everything is distorted to the degree where reality is mirrored in a shocking form.

It is this fusion of the prosaic and the horrible which makes Kienholz's socially critical tableaux so effective. These rooms and scenes are not predominantly didactic or satirical so much as visually and plastically repulsive. Even more intensely than in *Roxy's,* he was to illustrate this quality in his work in *The Illegal Operation* (plate 4). The scene is the operation room for a backstreet abortion—sparely recreated in this case—and the aura that permeates this presentation is that of death. A lamp with a single naked bulb shines down on a shopping cart altered to look like a surgical bed. Surrounding this "bed" is a stool, a pan with a few medical implements, and a pail filled with rather soiled looking items; and resting on this bed is a concrete slab, spilling out of a military-style sack, which vaguely resembles the midsection of the female body. Although the concrete form is only loosely figurative, its effect is akin to that of seeing a corpse. Its grey hue and shape evoke a dismembered section of a body, abandoned and utterly lifeless.

Kienholz was to say of this tableau that it "has the most art in it, it contains the most anguish and anger" (Personal interview, 1982). In other words, what he was striving for in these earliest tableaux, it seems, was a palpable immediacy, visual and physical effects that are wholly accessible and vivid at once.

That desire for accessibility is clearly rooted in his desire to convey a message in the most graphic form he could imagine and his fulfillment of that ambition is unequivocal here. Though the form on the "table" of the tableau is abstract, it vividly approximates the experience of looking at a corpse. Indeed, because this concrete shape is only vaguely figurative, it seems more grotesque than any literal rendering of the human figure would in this context.

Created at a time when abortions were illegal in California (and much of the United States for that matter), *The Illegal Operation* lucidly speaks to us of the brutal realities of the surreptitious abortion, of the risk to women's lives this situation presented. Yet it doesn't preach to us about this problem so much as horrify us with its specific social consequences. It confronts us with that situation in the form of a three dimensional image, a theatrical construction that is both a drama and a setting simultaneously—a scene designed to convey the artist's anguish in the form of something palpably horrible. What is more, *The Illegal Operation* functions as a kind of mirror of our attitude concerning a woman's right to an abortion. A decade ago, for instance, it seemed a commentary on a bygone era, on a time before the Supreme Court had effectively legalized abortion across the United States with the *Roe v. Wade* decision. Yet in the 1980s and now the 1990s, when anti-abortionists have conducted a militant crusade to strip this right from American women, Kienholz's tableau is as relevant as it was in the early 1960s, when abortion was illegal in many states. In the context of our own moment, it is a sculptural metaphor for the backstreet abortion that would become a reality once again if the crusaders against abortion were to have their way.

Ultimately, Kienholz's major works of the 1960s, such as *The Illegal Operation,* find their most precise analogs in the fiction of William Burroughs. During this decade he relied, like Burroughs, on the grotesque or horrific image as a way of sensitizing the audience to cruelties camouflaged by mass media and statistics. It is no coincidence that both also attempted—and still do—to subvert the "official face" of mass media. In Keinholz's *The Eleventh Hour Final* (1968)—one of many of his and Reddin Kienholz's works that take television as their subject—he recreated an entire living room equipped with a television console.[6] Engraved on its screen is the daily body count that became such a familiar fact during the Vietnam War. But looking within the screen, the viewer sees a doll's head, floating, looking startlingly morbid in this context—akin to a severed head in an aquarium. In this way, the numbers are made individual. For this is an image of death.

In Kienholz's creation of art to express this passionate disillusionment with American society in the late 1950s and 1960s, he became an indirect descendant of Whitman. By exhorting his audience to see the shortcomings of the culture, he also implicitly hoped to transform it. In other words, Kienholz believed that art and criticism should still address itself to a vast array of people, that each person could serve as a catalyst for social change and art could play a role in this process. Indeed, he made that hope evident in a work proposed for a site in Hope, Idaho. *The World* (1964), as it is entitled, is one of a series to which Kienholz gave the name *Concept Tableaux* (1963–1967), since he offered them for sale in the form of written descriptions.[7] This particular work, as proposed in writing, was to be placed on a plot of ground above the town cemetery and was perhaps his most literally participatory concept for a tableau. Although he would begin making *The World,* by design others would have to finish it. He offered this description of the still unrealized project:

> This tableau will be a simple rectangle of concrete, about five feet thick, fifteen feet wide and forty feet long. On the Southwest corner I plan to inscribe "THE WORLD . . . Kienholz 1964 ()." However, I would never attempt such an act for myself alone. I only want to be the first of many persons who might care to come to Hope to sign this peaceful corner of the world as a symbolic gesture of true acceptance and reaffirmation of it. No one will have the right to judge what anyone else may choose to write. If, for instance, someone wants to use his space (on the world) to write something stupid or obscene, that is his decision or problem only. (The Fuck You's will have to stand with the Jesus Saves' [sic].)
> When the surface is finally covered with names and inscriptions (chisels and hammers will be stored there), more concrete slabs will be added. (*11 + 11 Tableaux,* n.p.)

In these paragraphs, Kienholz bluntly and wryly points to the sentiments that underlie his usually shocking scenes and rooms. There is something rather sentimental about this *Concept Tableau*—a gesture of peace in a small corner of the world called Hope. (Kienholz is, of course, encouraging us to think about the puns attached to both the title of the piece and the name of the town.) *The World* is also a very democratic

gesture, as his description makes clear. The stones would be placed there to create a memorial in which all would have their say, whether the message is eloquent or obscene, well-intentioned or malevolent.

Kienholz's stridently critical works arise from the same democratic sensibility as *The World.* Shocking sights and grotesque figures are placed within settings that recreate our world, places that are immediately and easily recognizable such as the brothel setting of *Roxy's* or the living room of *The Eleventh Hour Final.* Employing this air of familiarity, he entices us to enter these environments and thereby see ourselves as accomplices in the creation and perpetuation of everyday social cruelties. We are all indicted here, just as we are all encouraged to identify with the victims of depicted cruelties. We are asked to step outside of ourselves and see things through the eyes of the criminal, in *The Psycho-Vendetta Case,* or the prostitute, in *Roxy's.* Like Whitman in "Song of Myself," we are ultimately asked to make a leap of empathy and declare, "I was the man, I suffer'd, I was there" (51). It is this humanistic principle that provides the foundation of all of Kienholz's angry attacks on the given social order in the 1960s and would continue to do so in the ensuing decades, whether the particular work was his alone or the product of his collaboration with Reddin Kienholz.

INTERCHAPTER TWO

Two Rites of Passage

"Edward Kienholz Presents a Tableau at the Ferus Gallery" read the card announcing the first showing of Roxy's. In retrospect, we can mark this as a landmark event in Los Angeles art history of the 1960s, for the tableau established Kienholz as one of the three major assemblagists of the postwar period. (The other two being Rauschenberg and Joseph Cornell.) The opening for Roxy's on March 6, 1962 was accompanied by more than the usual Ferus Gallery hijinks. To show respect for "the girls" of Kienholz's brothel, everyone was required to wear formal attire and Kienholz hired a Brink's guard who stood at the entrance to the gallery to insure enforcement of the dress code. Kenneth Price arrived by limousine "dressed like a Texan with a white coat and tails," Kienholz recalls; Robert Irwin, too, appeared attired in white coat and hat. There were telegrams as well from patrons and friends Monty and Betty Factor, Michael and Dorothy Blankfort, actor Dennis Hopper and his wife Brooke, and Hopps. "Hope That Visitors To House Will Show Half The Life But Twice the Rapture Of The Inmates Keep The Ladies Sober Love Mike and Dossy" read the message from the Blankforts; "May The Ladies Have Luck Tonight" read another.

This exhibition was also his last at the Ferus Gallery. In 1962, collector Virginia Dwan, inspired by Hopps's example, opened her own gallery in the Westwood section of Los Angeles and Kienholz joined her stable.

The change in galleries signaled an expansion of Kienholz's circle of artists, for the Dwan stable emphasized recognized French rather than West Coast artists; in addition to Kienholz, Arman, Jean Tinguely, Martial Rayesse, Niki de Saint Phalle, and Yves Klein were the prominent figures. Tinguely's American reputation, in particular, preceded him, for he had become both acclaimed and notorious in the United States for his self-destructing kinetic sculpture, Homage to New York (1960) (fig. 14), which caught fire in the sculpture garden of the Museum of Modern Art when it was activated. He and Kienholz became fast friends. They shared an interest in society's castoffs and together sifted through thrift shops and salvage yards in Los Angeles and Pasadena during 1962 and 1963, when Tinguely lived in Malibu. "He was like a kid with scap metal and junk," Kienholz would recall. "He was just arranging stuff and then looking at it and then stepping back and studying it . . . in a sort of classical dance" (Weschler, 272).

Tinguely's art was no more classical than Kienholz's. His nonutilitarian, delightfully nonsensical machines extended the lesson of Duchamp's motorized devices such as Rotary Glass Plates (Precision Optics) (1920) and Rotary Demisphere (Precision Optics) (1925). Both Tinguely and Kienholz were part of a stable that emphasized artists of the Neo-Dada and Pop persuasions; exhibitions included work by New Yorkers such as Oldenburg and Rauschenberg as well as the European contingency. But as some commentators aptly observed, Kienholz's art displayed its own distinctive links with rural American know-how and pragmatism as much as the modernist tradition of

assemblage. *In 1961, Gerald Nordland, then art critic of the* Los Angeles Mirror, *called him "an esthetic Huck Finn" (Section D, 7). Reviewing an exhibition of gallery artists held at the Dwan in June 1964 for* Artforum, *art historian and influential critic Philip Lieder wryly commented: "Old hog-pen builder Edward Kienholz who first cleared the heavy timber for assemblage-making in the Far West some years back, has maintained the most consistently abrasive and irascible imagery of any of his peers" (25). Even Kienholz's physical appearance—expansive, burly, and bearded—fit the image his art projected.*

With one exception, all of the tableaux (through 1966) which followed Roxy's—The Illegal Operation, National Banjo on the Knee Week *(1963),* The Birthday, While Visions of Sugarplums Danced in Their Heads *(1964),* The Wait (1964–1965), The Back Seat Dodge '38 (1964)—*were first shown at the Dwan Gallery in Los Angeles. (The exception was* The Beanery, *which was first exhibited in the parking lot of Barney's Beanery itself from October 23–25, 1965 and then shown at the Dwan Gallery in New York before returning to Los Angeles for its inclusion in Kienholz's survey at the Los Angeles County Museum of Art.) It was an amazingly prolific period for Kienholz; in retrospect, the production of so many important, large-scale works within this five-year period is extraordinary. However, contemporanous critical reception was mixed. The late Henry Seldis, then art critic of the* Los Angeles Times, *offered strident objections to Kienholz's work on the occasion of* Three Tableaux, *an exhibition that ran*

14. Jean Tinguely with his *Homage to New York* (1960; destroyed). Metal assemblage with mechanical parts. Remnants are in the collection of the Museum of Modern Art, New York. Photograph: David S. Gahr.

from September 29 to October 24, 1964.[1] These works, he declared in the opening paragraph of his review of October 2, "can arouse little but disgust." Continuing his attack in the second paragraph, Seldis wrote, "Out of a psychotic anger this artist has created images that reflect the hate and horror he finds in fundamental areas of life in our time and place" (View section, 5).

However, like Hopps, Maurice Tuchman, the curator of modern art at the Los Angeles County Museum of Art, was a great believer in Kienholz's

"It's awful! . . . Close the door!!"

15. Paul Conrad's political cartoon, "It's awful! . . . Close the door!!," was published in the *Los Angeles Times* on March 30, 1966, at the height of the controversy surrounding Kienholz's exhibition at the Los Angeles County Museum of Art. Copyright, 1966. *Los Angeles Times.* Reprinted with permission.

work.[2] Tuchman decided that his assemblages and tableaux of both the 1950s and 1960s would be the subject of the first retrospective for a local artist at the museum's new quarters on Wilshire Boulevard, which had opened in 1965. The exhibition was scheduled for March 30 through May 15 of 1966.

If Roxy's had been one rite of passage for Kienholz in the 1960s, this one proved to be another. "It made me grow up," Kienholz was to recall of that exhibition (Weschler, 378). If his first tableau had provided an aesthetic breakthrough, this exhibition proved to be a different sort of milestone. For the first time in his life, Kienholz was a genuinely public figure. He conducted a tour of his show for a throng of television, radio, and print journalists, and he held a lengthy press conference before yet another large gathering of broadcasters and writers. Articles appeared almost daily in the newspapers during the six-week run of the show. Political cartoons concerning the exhibition appeared in both the Los Angeles Times *and the* Los Angeles Herald Examiner *(fig. 15).* And all because the Los Angeles County Board of Supervisors had tried to pressure the museum into stopping the show when they deemed Kienholz's work to be something less than art.

A few days before the exhibition was set to open, two of these supervisors, Kenneth Hahn and Warren Dorn, had paid a visit to the museum. Immediately afterward, they held a press conference at which Warren Dorn made a remark that was quoted again and again in the popular press during the coming weeks: "My wife knows art; I know pornography." Supervisor Dorn tried to pressure the museum into

closing the exhibition by appealing to Edward W. Carter, the president of the Board of Trustees in a letter of March 17. He stated: "While certain of the objects or creations are quite meaningless, others are most revolting and, I feel, pornographic in nature. In particular, I find the scene in the automobile [The Back Seat Dodge '38] and House of Prostitution [Roxy's] most repugnant." The acting director of the museum, Kenneth Donahue, sent a terse reply on March 28: "The Kienholz exhibition will open as scheduled, Wednesday, March 30, 1966." Hahn did not stop there, however; he threatened to stop county pay subsidies for museum personnel, though it was ultimately never done. Members of the Los Angeles City Council attempted to pass a resolution condemning the show, but it failed by a 7–7 vote. The only compromise on the museum's part concerned The Back Seat Dodge '38. Rather than have the interior scene of the Dodge always visible, as it had been in the Dwan Gallery showing of the tableau, the door of the automobile was to be opened every fifteen minutes by a guard.

The supervisors' attempt to suppress the exhibition only succeeded in fueling public interest in Kienholz's art. This was poetic justice, since it has been one of his consistent, underlying ambitions to reach a wide audience. Now, for nearly two months, he had one and the supervisors had played the largest role of all in attracting the audience that Kienholz desired.[3] Furthermore, the artist had one more form of revenge on the supervisors. Without anyone's knowledge, including Tuchman's, Kienholz had bugged the exhibition. Though he later destroyed the tape, it left a distinct impression on him:

They [the Supervisors] came into hearing range of the microphone and then go out—but they'd say things like "Gee, Kenny [Hahn] look at this. I haven't been in a place like this in twenty years. Look at that over there." It was like old home week. They're in there, just having a ball. And the next thing you hear them come out of Roxy's and they're saying, "Why it's a moral outrage. Can you imagine women and children seeing that? I can't believe it." (Weschler, 387–388)

The event, as Kienholz recounts it, reads like a neat parable of dual morality. It brings to mind the famous episode in the Adventure of Huckleberry Finn (1884) where Huck observes the men in two Missouri families, the Grangerfords and Shepherdsons, listening to the sermon in church on Sunday with their guns between their legs or up against the wall. Later that day, of course, they conveniently forget the words from the pulpit and resume their longstanding feud. The Grangerfords and Shepherdsons possess no awareness of their hypocritic ways; nor, it seems, did the Los Angeles County supervisors.

Yet Nordland's comparison of Huck Finn and Kienholz is not the right one, for the artist was not some kind of naive social observer; he was a knowing one. The better analog is to Huck's creator. Like Samuel Clemens, Kienholz cast a shrewd and probing eye on the foibles of American culture in the assemblages and tableaux he created in the late 1950s and the first half of the 1960s. The controversy his art sparked at the Los Angeles County Museum of Art only proved that Kienholz had discovered a powerful way to present the covert and unsettling aspects of contemporary culture.

33

TWO

Generic Tragedies: The Creation of a Narrative Sculptural Art

Kienholz's essential vision of sculpture crystalized, as I have argued, with the completion of *Roxy's*. And having found the appropriate vehicle for his socially critical sensibility, he explored its possibilities in a dizzyingly rapid fashion, creating many strong works in a remarkably short period of time. This phase of his development reached a climax with the completion of *The Beanery* (1965); for after finishing this environmental tableau, Kienholz no longer felt compelled to build every tableau he imagined, concentrating for the next two years on what he termed *Concept Tableaux.*

Roxy's opened at the Ferus Gallery during a one-week period in which Rauschenberg and Jean Tinguely had shows that opened at the Dwan and Everett Ellin Galleries respectively. Critic and curator Gerald Nordland, writing in the May/June 1962 issue of *Arts,* categorized it all as a "concentration on 'neo-Dada' activity which could not be ignored." However, in retrospect, neo-Dada is a problematic label for a wide range of work that used found objects—from the kinetic machines sculptures of Tinguely to the "combines" of Rauschenberg, from the target, map, and number paintings of Jasper Johns to the table utensil and plate constructions of Arman. As Nordland saw it—and he was not alone in this judgment—Kienholz's art was yet another manifestation of neo-Dada. Kienholz certainly appreciated Tinguely's art of motion and chance. During the week before Tinguely's show opened, he, Tinguely, and another French artist, Niki de Saint Phalle, collaborated on an elaborate construction of boards, mannequins, bottles, cans, and bras, all painted white. And in the fashion of earlier Tinguely "events," the artist had someone activate his contraption at a set time. Saint Phalle appeared at 4:30 P.M., shortly before the opening, to fire a gun at the cans and bottles—filled with paint—to complete the piece.[1] By late 1962, Kienholz, Tinguely, and Saint Phalle would all be showing at the Dwan Gallery, and, as Kienholz would appreciatively recall of that time, "Virginia Dwan was responsible for the whole influence of Europeans on the West Coast. I mean, she brought a whole cultural dimension to Los Angeles that no one else did" (Weschler, 277).

Yet if he praised her contribution to the Los Angeles art milieu of the 1960s, his direction with tableaux was already too strong to be influenced greatly by the influx of assemblages by Tinguely, Rauschenberg, and others. We get one good indication of Kienholz's aesthetic in his misreading of Andy Warhol's *Campbell's Soup Can* paintings, during their first public showing at the Ferus Gallery in 1962 (fig. 16):

Everybody lumps us together and says "Oh well, it's just a rebirth of Dada"—which is not true. The need is different. There's no Dada need, it's just a thing of this time. The thing now is social protest. The show down at the Ferus Gallery right now, the Andy Warhol show—the Campbell's Soup show—is social protest. (Secunda, 31–32)

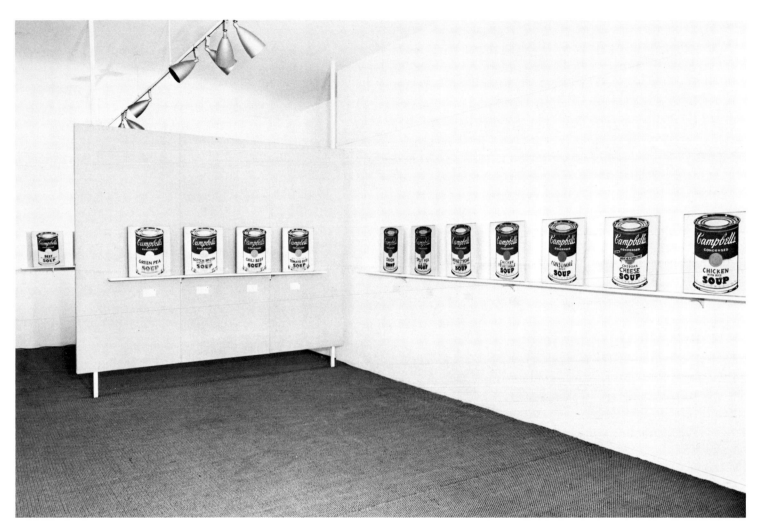

16. An installation view of Andy Warhol's first exhibition of the *Campbell's Soup Can* paintings in 1962 at the Ferus Gallery in Los Angeles. Photograph: Seymour Rosen.

Warhol's pop sensibility, with its passive acceptance of the visual possibilities of the American urban environment, was not truly a form of visual social protest, even if his work of the 1960s offers an implicitly tragic vision of contemporary culture. To paraphrase Susan Sontag, Warhol sized up the open fields of American experience with a shrug.[2] Or, as Warhol himself put it, "I feel that whatever I do and do machine-like is what I want to do" (Carey, n. p.). This was indeed an application of the Duchampian pose and anti-aesthetic to American culture of the 1960s; and Warhol was to make large use of the Dadists—in particular, Marcel Duchamp's—subversion of the art object: he proceeded to mass produce his own serial versions of mass media imagery and packaging designs, blurring the dividing line significantly between product and art object.

The ambitions of the key New York-based assemblagists and environmental sculptors, Rauschenberg, Claes Oldenburg, and Allan Kaprow, more closely paralleled Kienholz's own ambitions than did Warhol's. As the germinative figure in the rise of American assemblage in the late 1950s, Rauschenberg put forth the intriguing ambition for an art that existed in some tension with life and art. "Painting relates to both art and life," he asserted in one of his most often quoted statements. "Neither can be made. (I try to act in the gap between the two.)" Or, as he said on another occasion, "A pair of socks is no less suitable to make a painting than wood, nails, turpentine, oil and fabric" (Carey, n. p.). Oldenburg also argued for the extension of the role of painter, and did so in terms of a theatrical conception:

Stage = place where I paint.
It should have been made clear that Happenings came
about when painters and sculptors crossed into Theatre
taking with them their way of looking and doing things.[3]

Like Kienholz's tableaux, Happenings evolved from the sensibility that gave rise to assemblages. And like Oldenburg, Kienholz compared his human scale constructions to paintings:

I still today [1977] think of myself as a painter. I don't think of myself as a sculptor. I know that I'm a sculptor; I mean, I understand the contradiction. But when I'm fiberglassing a piece, I go to the trouble of building the piece. And when I get it built, then I paint it. And that's essentially—the painting gesture is the fiberglass. (Weschler, 227–228)

Happenings, a non-narrative form of theatre that employed a prepared script that also allowed for much spontaneous action, evolved as a major New York *modus operandi* for use of the assembled environment. Assemblage, environment, and happening were all intimately related during this period, as a passage from Kaprow's book reveals:

Assemblages may be handled or walked around, while Environments must be walked into. Though scale obviously makes all the experiential difference in the world, a similar form principle controls each of these approaches, and some artists work in both with ease. (159)

Later in the same essay, comparing environments to happenings, he would add, "They are passive and active sides of the same coin" (184).

In 1959, Kaprow presented the first happening, *18 Happenings in Six Parts,* at the Reuben Gallery in New York. Within the year, Oldenburg also presented happenings at the studio on East Second Street which he called "The Store"; here, he also sold loosely painted, roughly surfaced plaster sculptures of hamburgers, pie slices, ice cream sodas, hats, shirts, and all sorts of other items—as if this were a cross between a clothing store, a coffee shop, and a theatre.

This blurring of the boundaries between the arenas of art and life, what William Seitz termed *extreme actualism,* is a characteristic that Oldenburg's "store" shared with Kienholz's tableaux. Yet there are more differences than similarities between their work. The actualism of Oldenburg as well as that of Kaprow and Rauschenberg carried on a dialogue with previous art even more than the surrounding culture. Their notion of extending the space of art was an expansion of the concept of Action Painting, articulated first and most eloquently by Harold Rosenberg. "At a certain moment," he declared in his essay "The American Action Painters," "the canvas began to appear as an arena in which to act—rather than a space in which to reproduce, re-design, analyze or 'express' an object, actual or imagined" (*Tradition,* 25). Jackson Pollock represented one of Rosenberg's prime examples of this practice and, in turn, Kaprow drew upon the example of Pollock, too, when he characterized the impulse to create assemblages, environments, and happenings in this fashion:

Some interesting alternative emerged, leading in different directions, but all of them involved relinquishing the goal of picture making entirely by accepting the possibilities that lay in a broken surface and a non-geometric field. (159)

For these New York assemblagists and environmental sculptors, the attempt, it would seem, was to aestheticize a greater number of activities and spaces untouched by art.

Kienholz's assemblages and tableaux pointed up a different direction for what we can call actualist art. As much as each tableau absorbed quotidian activities within an aesthetic setting, it insistently pointed us back toward those activities as filtered through Kienholz's perspective. As early as 1960, he drew a distinction between Rauschenberg's work and his own by parodying that artist's important "combine," *Monogram* (1957) (fig. 17). Kienholz's use of a deer

17. Robert Rauschenberg, *Monogram* (1957). Mixed media assemblage. Collection of the Moderna Museet, Stockholm. © Robert Rauschenberg/VAGA New York 1990. Photograph courtesy of The Leo Castelli Gallery.

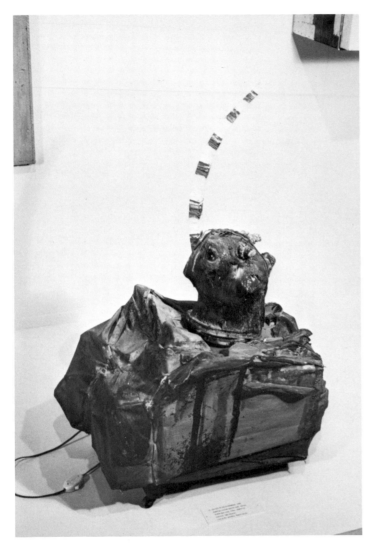

18. Edward Kienholz, *Odious to Rauschenberg* (1960). Mixed media assemblage. Private collection, Los Angeles.

head was, quite obviously, an allusion to Rauschenberg's use of a goat head. But it was an antagonistic, as well as an amusing, allusion; in the cutaway portion of the deer head, Kienholz placed a long, curved strip of wood which, in his words, was "a big kind of tongue that sticks out." To further the comical nature of the work, he motorized it so it would turn round and round when its cord was plugged in.

However, the rotating head was also a ploy that was intended to activate the major prank of the sculpture. Kienholz planned to send this assemblage to Rauschenberg as an anonymous gift; and he offered this explanation of how it was supposed to function:

> [B]uilt into that machine was a diathermy apparatus. A diathermy is an early medical radio-radar kind of thing. And when you plug in a diathermy machine, it just completely fucks up the television reception in that area. So I figured that the movement of the head was enough to keep it plugged in, and people would say, "Oh, that's funny." And they would leave it on. And then there would be complaints going into the police station or the television station, and they'd send out trucks to discover what the trouble is in the community when you get a bad reception like that. Those trucks go around with little antennas; and they finally figure it out, and [whistle] they zero in on it. They'd bust in on it and they'd say, "Okay," and everybody gets a big fine and goes off to jail. I just thought it would be a really funny kind of thing. (Weschler, 173)

Odious to Rauschenberg (fig. 18) and the scenario that inspired its creation provided an elaborate and

amusingly malicious play upon Rauschenberg's notion of an assemblage as filling the gap between art and life. Kienholz had concocted an assemblage that could have had real consequences for Rauschenberg's life, though in the end he never forwarded it to him. As a work of art, however, it had already accomplished its purpose. It provided a sly tribute to Rauschenberg and the other New York assemblagists, even as it revealed the distance between his and their vision of the function of art.

It was between 1961 and 1965, then, that Kienholz defined and presented a good number of the themes and formal strategies that would also later resurface in other guises. Moreover, it was during these years that he forged the narrative mode of presentation which distinguishes his tableaux. Highly related symbolic figures surface in the same archetypal scene or subsequent ones. Each tableau presents a different episode in his stop-action drama of American culture—a collective dramatization of tragic predicaments of the powerless, the marginal, and the victimized.

No scenario this grand or self-consciously ambitious had occurred to Kienholz when he created *Roxy's*. In fact, this first tableau developed incrementally. Working much as he had when he created the Doe figures, Kienholz made the figure of *A Lady Named Zoe* (fig. 19), a tall vertical assemblage consisting chiefly of a doll's head and torso with a coin dispensing machine as an abdomen and one leg of a mannequin for her lower half. He conceived of her as a figure of a prostitute, but had no notion of making accompanying figures. One by one, though, the other figures came into being and acquired identities related

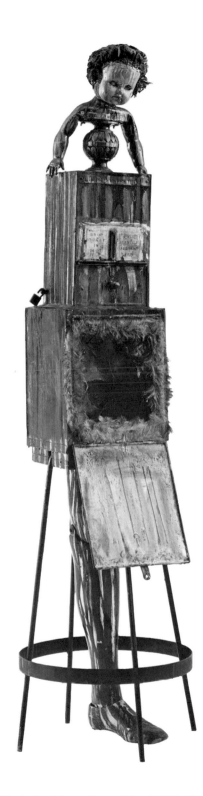

19. Edward Kienholz, *A Lady Named Zoe* (1961). Mixed media assemblage. Collection of the Los Angeles County Museum of Art; gift of Mrs. Lillian Alpers.

to Zoe's. In Kienholz's imagination, they became the personae of a whorehouse, all triggered by his own memories of the Idaho brothel he visited during his adolescence.

It was during the composing process of *Roxy's* that they began to acquire narrative lives of their own. For instance, it was for practical reasons that Kienholz made a figure identical to *A Lady Named Zoe,* but he in turn imagined a tale that included both. *A Lady Named Zoe* had already been sold to dealer and collector, Virginia Dwan, by the time he conceived of *Roxy's.* But when she refused to contribute it to the cast of characters for the tableau, Kienholz built her an almost identical sculpture, entitled *A Lady Named Zoa.* "In my fantasy that I produced this tableau out of," Kienholz was to recall, "Zoe worked in a house of prostitution, and Zoa, her twin sister, is off someplace else" (Weschler, 228–231).

This fantasy points to one narrative aspect of the artist's imagination; Kienholz's figures sometimes suggest stories, which hover around the work itself, existing solely as the artist's fantasies. More important to the viewer is the fact that, in *Roxy's,* as in other tableaux, evidence of his interest in story surfaces within the sculptural scene too.

Inside the half-open bottom dresser of *Miss Cherry Delight,* (see plate 2) there is a letter that tells us how she has concealed her true means of employment from her family:

Dear Sis,
How are you? We are fine except Momma has her dizzy spells yet. Poppa got the crops in but he says it doesn't look too good this year what with the dry spell and all. By the way Poppa said to thank you for the $20.00 as it came in real handy. Poppa says you must have a real good job to be able to spare that kind of money. I have to go back to school this fall. I'll be a senior this year and then maybe I can come to the city and get a good job too, huh? Things are about the same in this place. Fultons barn blew down and last week the Guthmillers cow had twin calfs. Its all so dry and dull here. If only I could be there with you and see all there are to see. Carl Rathburn asked after you again and wanted to know when you were coming home so I told him, huh that'ed be a pretty day!! I got to quit now and help momma with the chores.

Love till I see you,
Sis

P.S. Write soon as we haven't heard from you in quite a spell.
(Hulten, *Tableaux,* n. p.)

This letter is indeed integral to the "sculpture." There is no enacted story, of course, but the viewer is confronted with a scene that asks him to piece together a tale from the given clues—verbal and visual.

The letter to *Miss Cherry Delight* is an example of how Kienholz's clues can be both direct and rich with implications at once, allowing us to construct a revealing biographical sketch of her life. She feels compelled to let her family believe that she has found a respectable job. And because she has deceived her family, Sis's utterly sincere letter becomes unwittingly ironic in lines such as "Poppa says you must have a real good job to be able to spare that kind of money"

and "I'll be a senior this year and then maybe I can come to the city and get a good job." Miss Delight has stopped communicating with her sister and others in her hometown, it seems, because of a sense of shame concerning her profession. Yet she continues to express her attachment to family by forwarding some of her earnings to her father. In essence, then, hers is an archetypal tale of the country girl seemingly forced into prostitution by financial need and a lack of skills for making a living in any other way. Her tale is also emblematic of those represented by the other figures within *Roxy's*. Though the story itself isn't startling or unexpected, its context gives it poignancy. The letter sits in her dressing table drawer, amidst the resin-encrusted bric-a-brac and her disembodied head, which is suspended in the space where a mirror should be. Her tale is also emblematic of those represented by the grotesque figures that surround her.

In general, though, Kienholz does not provide a great deal of biographical information about his figures. The objects themselves reveal, as he once said, "all the little tragedies . . . evident, and all the things that have happened to people" (Silk, 113). "I feel a story in picture terms," he remarked more recently (Personal interview, 1982). Imagining these tableaux to be three-dimensional paintings, he covered (and he and Reddin Kienholz still cover) their surfaces with dripping resin, much as if he were adding a final expressionist patina to a canvas. In his art, objects function as a sort of pictorial vocabulary; objects and occasional literary props evoke the kind of tragedy or social critique which they emblematize—an approach that still holds in his and Reddin Kienholz's work.

There is compelling evidence that, with *The Birthday* (plate 5), Kienholz came to realize just how precisely he could evoke these "tragedies" within the tableau format. Whereas in previous human-scale constructed scenes, such as *Roxy's* and *The Illegal Operation,* he had worked from a random inventory of found objects, for this one he selected items according to a preconceived idea. Nor was he committed to employing found objects exclusively; Kienholz used a plaster casting of a torso for the first time here. Such changes in method allowed him to stage his ideas more exactingly than before, extending the range of his vision even as he maintained its essence.[4]

The Birthday vividly exemplifies both the shift in presentation and the continuity of this vision, for it revives the *John Doe–Jane Doe* dynamic and recasts it in a different light. Instead of companion pieces, we view only a female one—reclining on a delivery table and seemingly in the throes of labor. But we are undoubtedly supposed to reflect upon the father who is absent from this hospital room scene, since a letter, its text sardonic, sits in a suitcase beside the delivery table. It reads:

Dear Jane,

I couldn't come down now because Harry needs me here. Ma says she might make it later. Keep a stiff upper lip Kid.

(ha-ha)
Dick
(Hulten, *Tableaux,* n. p.)

Once again, Kienholz uses names that insist on a reading of the figure and the letter writer as archetypes. Like *Jane Doe* or the women in *Roxy's,* this Jane is also a victim of circumstances—her state of isolation at this crucial moment accented by the insensitivity of Dick's note. This same note also reveals that Dick, like *John Doe,* is emotionally impotent, fleeing when confronted with the birth of his own child. If the earlier figure is a sculptural metaphor for a heartless male, the letter in *The Birthday* firmly places Dick in the same category.

The consequence of his impotence is her terrible isolation—the overarching subject of this tableau. Yellow and red arrows extend from her abdomen as emblems of pain, while the plastic bubble covering her mouth, part of which is painted blood red, functions like a silent scream. Many of Jane's accoutrements—the operating table, her suitcase, her shoes, her purse, and other items of the scene—are painted silver-grey and flocked, their stark and icy look providing a striking and fully realized visual corollary to Dick's letter. It is this clinical style of presentation which prevents the tableau from becoming maudlin or overly sentimental.

With the creation of *The Birthday,* the fundamental characteristics of Kienholz's tableaux had been firmly established: the symbolically charged use of found objects; the scene that is ordinary and familiar yet simultaneously archetypal; the figures, props, and constructed environment implying characters and story; and the inclusion of the viewer as both voyeur and participant. In *The Birthday,* we are voyeurs not only when we read the note from Dick, but when we look between the figure's legs to view the birth suggested by both the constructed scene and its title: there, we find a mirror. Clearly, then, we are to see this as a "drama" in which we are to see ourselves, metaphorically, as both parents and offspring.

Having established these aspects of his aesthetic for the tableaux, Kienholz then proceeded to subsume others aspects of experience into this arena on an epic scale. To dramatize adolescent sex and the adult world's disapproval of it, he evoked the most typical locale, the automobile, in the most specific and concrete terms, by including an actual 1938 Dodge in his tableau. As Gerald D. Silk observed in his article, "Kienholz's 'Back Seat Dodge '38,'" not since Salvador Dali created his *Rainy Day Taxi* for the International Surrealist Exposition of 1938 had anyone used an automobile with interior figures, as he did in *The Back Seat Dodge '38* (1964) (plate 6).[5] However Kienholz, unaware of Dali's formal precedent, had been inspired by a different source: his father's 1938 Dodge, which had been the scene of his own early sexual experience in 1944.

As with previous tableaux, he emphasized the typicality of this scene over and above its auto-biographical associations, although he was determined to find either a 1936, 1937, or 1938 Dodge. Only those three model years matched the car of his memories, "because in '39 they had changed the style" (Weschler, 251). The props of the tableau, too, are true to the era of the 1938 Dodge: a racoon's tail hanging from its antenna; an Olympia beer bottle of the time, resting on a little patch of astroturf. The figures themselves, however, are highly generic: the body of the male consists of shaped chicken wire; the female's, of cast

body parts partially attired. They share one faceless head too, since, according to the artist's view, "they both have the same thing in their mind" (fig. 20) (Silk, 112).

Here are Kienholz's Everyman and Everywoman at the same stage in life as *Son of John Doe,* passionately embracing in the cab of a Dodge. As with the Doe trilogy and earlier tableaux, Kienholz gave names to the couple in *The Back Seat Dodge '38*. He called them Harold and Mildred, based on props he discovered in a thrift shop. As Kienholz recalled:

> So this guy goes through his box of rejects and watches the customers never come in for, there was an Ingersoll . . . It was a three-dollar watch when it was brand new, and engraved on the back of it was, "To our son Harold." And anybody that would engrave a cheap watch with that kind of sentiment—the engraving costs three times what the watch costs new—I couldn't believe it. And in the same tray was a little pin that said "Mildred." So that named the figures immediately. (Weschler, 257)

He placed the watch on Harold's wrist and the pin on Mildred's dress, imagining identities for each that obviously resonated with poignancy for him. In turn, they had all but turned into actual people within his imagination, whose privacy was transgressed by the viewer:

> I really felt almost like crying because Harold and Mildred became real in the process of making them—real enough that I felt like I betrayed them by making them subject to the will of anybody that wanted to take the handle and open the door. (Weschler, 257–258)

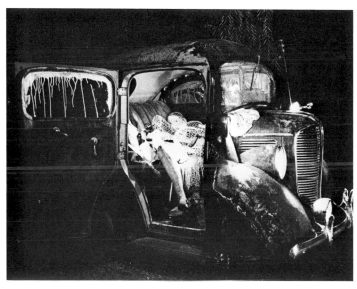

20. Edward Kienholz, Interior of *The Back Seat Dodge '38*.

The open door was, of course, a central aspect of *The Back Seat Dodge '38,* because it revealed to the viewer the major theme of the tableau. Indeed, it has always been exhibited with the door ajar, except at the Los Angeles County Museum of Art in 1966.

Kienholz's "betrayal" of Harold and Mildred is, in actuality, the animating dramatic feature of the work, since it provides the moment when the viewer is transformed into a voyeur. Looking into the cab of the 1938 Dodge, a viewer is spying on a couple in the throes of sexual passion as well as looking, perhaps, into his or her own past. This scene has another vital narrative component as well, in that the present always exists as an overlay on the actual time period evoked by the sculpture itself. Though the setting of the tableau is the late 1930s or early 1940s, the car radio is always playing a contemporary station during its exhibition. The message of this ploy is clear. We are not to see *The Back Seat Dodge '38* as an exercise in nostalgia, but a tableau whose theme is continuously renewable. It may not have the power to shock viewers, as it demonstrably did in the mid-1960s, but the relevance of its theme persists. This tableau addresses itself, as the license plate of the Dodge declares, to "Everywhere, U.S.A."

The layering of time, as exemplified in *The Back Seat Dodge '38,* was fast becoming a central characteristic of Kienholz's tableaux of the mid-1960s. In *The Wait* (plate 7), the central figure is an old woman, seated in a rocking chair and seemingly waiting for death. Yet the series of photographs on a living room end table evoke her entire adult life. Although Kienholz collected these snapshots in thrift shops, we imagine them as her own visual mementos. We see a young man's portrait sitting on a table and imagine it to be her husband in uniform, or perhaps a son, at some indefinite moment in her past. On the wall in back of her is a large oval portrait of a handsome, moustached man—either husband, father, or descendant. On the front of the jar which serves as her head, there is a picture of an attractive and youthful face which we take to be hers.

This picture of the subject in her youth is wholly at odds with the rest of the figure, however, which evokes age and physical decay. If one looks at the subject in profile, he or she discovers a deer's skull inside the jar. Her limbs, too, consist of bones hinged together, emerging out of a dress—as if she is simply an attired skeleton. And in jars arranged around her neck in the manner of a necklace are all sorts of bric-a-brac, her keepsakes and mementos of a life stored in them.

In this pivotal period in Kienholz's career, each tableau seemed to expand the thematic perspective of the last, reviving a theme of the earlier works and simultaneously taking it in a different and fruitful direction. Like the madame in *Roxy's* (see fig. 13), this figure in *The Wait* is a poignant image of living death. Kienholz gives us a symbolic portrait of a woman in decay, her physical deterioration made all the more poignant by visual reminders of this same woman in her prime. In her last years, as depicted within this tableau, she clings to life much as she clings to the stuffed cat in her lap; but the bones that protrude from her dress create the most vivid kind of *memento mori* image. The palpable sense of impending death which she projects is only heightened by the live canary in a

cage which is another component of this scene.

In an important sense, *The Wait* is a companion work to *The Birthday*. Both tableaux expanded the narrative possibilities of the tableau form, by demonstrating how much drama could be created with a single figure. Each presents us with women who are utterly and uncompromisingly alone. In each case, too, the isolation of the figure is so explicit that it is excruciatingly intense. And taken together, they connote the entire sweep of life, of course, since these tableaux take us from birth to death. *The Wait* also anticipated a characteristic of the tableaux of the 1980s: the use of photographs, as faces for figures. Both here and in later works, this was to be a way of suggesting, quite firmly, that the scene before us is a portrait. It might be three dimensional, on a human scale, and even environmental, but it was as carefully composed as any studio photograph or painting.

The Beanery (plate 8; fig. 21), Kienholz's most technically ambitious environmental tableau of the 1960s, marked a return to the multiple figure format of *Roxy's*, but used the cast figure approach of *The Birthday*. The completed work demonstrated how the tableau format, in Kienholz's hands, was suited to expansive as well as intimate drama. He filled his recreation of this Los Angeles bar with seventeen figures. While in the earlier tableaux Kienholz had fruitfully exploited the notion of the frozen moment in an ongoing story, here it took on added resonance. Entering the bar, one is literally surrounded by figures; there is no possibility of separating one's self from its ambience, of functioning as a removed spectator. The viewer becomes one with the crowd. Yet the presence

of a soundtrack—recreating the sound of people chatting, laughing, clinking glasses, and so forth—sets up a strange discontinuity with the still figures standing, perched on barstools and seated at a little table off to the side of the counter.

Unlike Kienholz's other tableau of the 1960s, *The Beanery* offers a setting that is actual as much as archetypal. Although he was to take poetic liberties with its details, his version of the bar in Barney's Beanery, an eating establishment in West Hollywood, recreates the original to a remarkable degree. However, the accuracy of the setting only illuminates Kienholz's symbolic vision more acutely. With the exception of the figure of Barney, all of them are decidedly generic. Furthermore, they resemble each other in one decisive way: they all possess clocks for heads, with the face of the clock replacing the human face. And emphasizing the notion of the frozen moment, each clock is fixed at the same moment in time: 10:10.

For Kienholz, time is suspended here to heighten our awareness of its passing. As he once remarked, in a discussion of *The Beanery*, "A bar is a sad place, a place full of strangers who are killing time, postponing the idea that they're going to die" (Calas and Calas, 46). The figures that populate *The Beanery* are indeed vivid emblems of life postponed, of the unreality of time measured in rounds of drinks. T. S. Eliot's famous line from "The Love Song of J. Alfred Prufrock," "I have measured out my life with coffee spoons," finds a sculptural equivalent in this tableau (*Collected Poems*, 4). Moreover, with the increasing passage of time between the year in which this tableau was created and the present, this environment offers

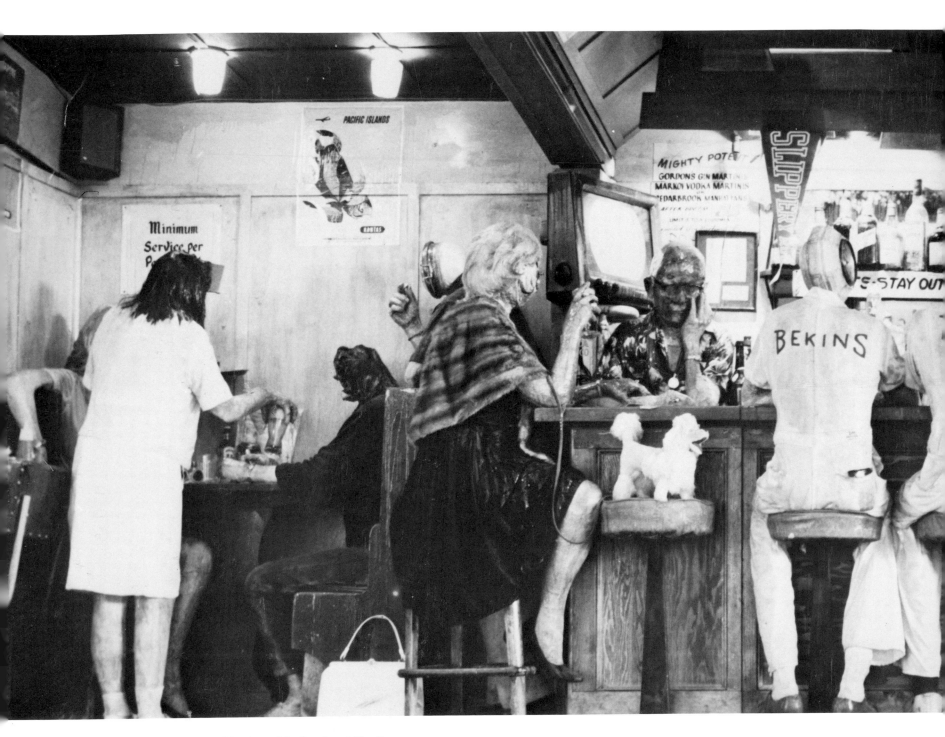

21. Edward Kienholz, Wide view of the interior of *The Beanery.*

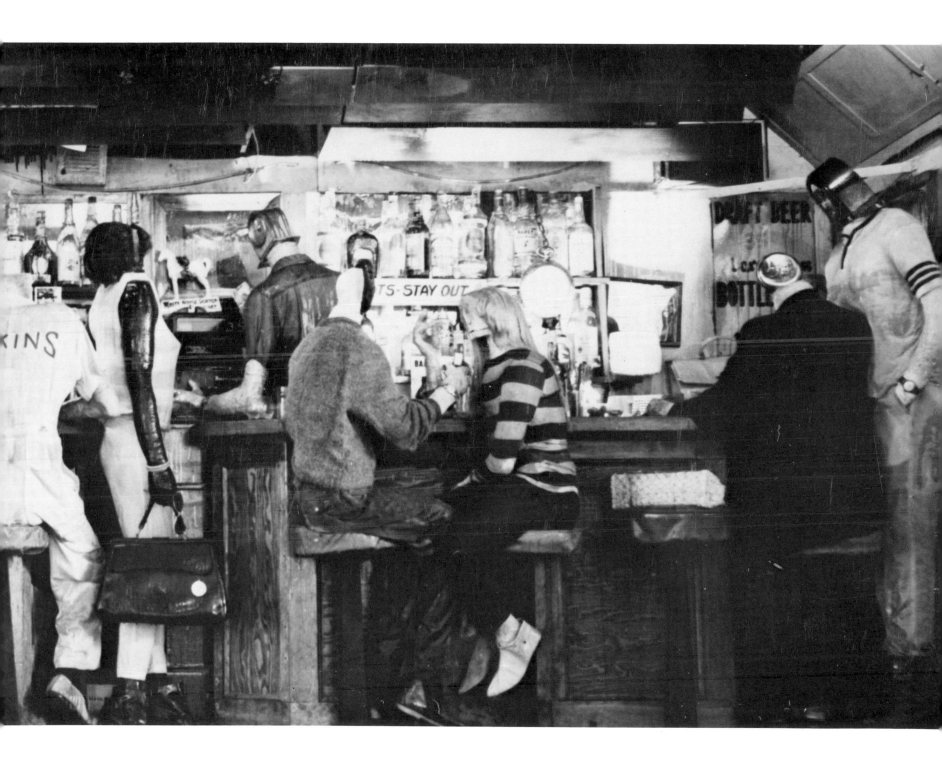

another dimension to this aspect of its meaning. We can imagine people much like the figures within Kienholz's tableau, returning day after day to the same bar by habit alone and finding that, seemingly all of a sudden, decades have gone by.[6]

As the one figure whose face corresponds to an actual subject, the casting of Barney functions as an emblem of mortality here. Since the work was constructed, he has died; time isn't fixed on his face, as it were. Moreover, just outside the door of *The Beanery* sits another icon of real time, reminding us again of how many years have passed since the creation of this tableau: a 1965 newspaper sitting in a dispensing stand, proclaiming and resurrecting a real event: "Children Kill Children in Vietnam Riots."

As Kienholz himself surmised, *The Beanery* was the supreme demonstration of his craftsmanship at that moment in his career. He believed it proved his ability to realize any tableau, no matter how ambitious in scale or concept. Not coincidentally, it was at this point in his career, too, that Kienholz committed himself to creating *Concept Tableaux*: a project he had begun two years earlier. Reconstructing the motivation behind this shift in direction, Kienholz remarked, "Once *The Beanery* exists as an example of my 'craft' (quote-unquote), then I should be able to trade in just the ideas rather than in the physical presence" (Weschler, 420). Indeed, these conceptual works were not dependent upon realization; rather, they were presented as ideas in a written, framed description. The interested buyer would purchase this description and a bronze title plaque for a fee as substantial as anything one might pay for a completed tableau. For an additional fee, Kienholz would create a drawing; for a third amount, covering labor and materials, he would construct the actual tableau (Hulten, *Tableaux,* n. p.).

This commitment to a conceptual version of the tableau, as we shall see, was Kienholz's declaration of confidence in the aesthetic he had forged between 1961 and 1965. He had realized a concept of the stop-action tableau which elevated it to the level of art, even as he remained committed to a notion of accessibility rooted in its vernacular forms as he had experienced them as a child. Reflecting on *The Beanery*, Kienholz once asserted:

> I always thought that art should be an easier experience than what it is. Like I can't imagine going into The Louvre and standing in front of a painting and having a vicarious experience with this painting or that artist. It's too pristine; it's too properly hung; it's too perfect; . . . it isn't as easy as walking into *The Beanery*. (Weschler, 361–362)

It is to this democratic notion of art which Kienholz had devoted himself with the creation of his sculptural tableaux. It was his hope that these works would be accessible to the most general sort of audience. If socially critical ideas were the catalyst for these environmental sculptures, he in turn strived to convey these ideas as forthrightly and viscerally as possible. As we have seen, however shocking or confrontational the works could be, their settings were rooted in everyday experience and quite recognizable settings. Furthermore, the implied narratives that Kienholz

created served to dramatize his ideas. If the stop-action tableaux of his childhood could convey comprehensible meaning in a posed scene, then it only seemed logical to Kienholz's that his tableaux should do so as well.

The strongest validation of his aesthetic came within months of the completion of *The Beanery,* for the reaction to his 1966 retrospective at the Los Angeles County Museum of Art proved just how comprehensible—and also, as we have seen, how controversial—his art could be. If *The Beanery* was, for Kienholz, the work that ultimately demonstrated the worth of his craft, his retrospective was the event that demonstrated the power of his socially critical art to communicate its concerns to a wide audience. Perhaps it seems paradoxical that he would have been motivated to make less rather than more tableaux following its close, since the exhibition had brought him such widespread recognition. But in another way, we can understand why events provoked him to commit himself to the *Concept Tableaux* for the next two years. The success of this retrospective provided persuasive evidence that the written ideas for tableaux were intrinsically interesting enough to stand as works of art. If Kienholz didn't provide the setting, figures, and their narrative context, the viewer would simply have to imagine the fully realized tableaux, much as one would when reading a play rather than viewing a production of it.

This conceptualist phase of Kienholz's career, as we shall see, proved to be a short, if important, episode; like plays, the tableaux ultimately cry out for realization to convey their full impact. But this self-conceived sabbatical from the physical realization of tableaux permitted him to continue refining and expanding the possibilities of the genre. Neither extensive funds nor appropriate materials or spaces were needed to propose ideas for elaborate and immense works. Having already given the tableau such vital form in the five short years that preceded his controversial exhibition, he now proceeded to articulate plans for still more projects that would rival these important works and perhaps surpass them in ambition and impact.

INTERCHAPTER THREE

The Grand Tour
of the Tableaux

When Kienholz built Roxy's, he believed he was creating an uncollectible work of art.[1] But in 1965 collector Burt Kleiner bought the equally "uncollectible" The Beanery for $12,500. It was an incredibly modest sum by contemporary standards, for Kienholz or any other major artist, but a substantial purchase at that stage in the artist's career. With the money from the sale of The Beanery, Kienholz was prompted to move to a new home in Laurel Canyon; it was located on Magnolia Drive and was built, he was told, for a notorious gambler who had acquired an all too common nickname—Nick the Greek.

Kienholz's last great labor in his previous home on Nash Drive was, of course, The Beanery. He spent Saturdays and Sundays, often accompanied by Tuchman, journeying to swap meets in search of beer signs, cigarette lighters, and everything else he would need to furnish his bar.[2] Kienholz built the entire tableaux in six months beginning in the spring of 1965—"working like a madman on it," he would recall (Weschler, 364).

Constructing The Beanery had proved exhausting. Transporting it down the seventy stairs from his house to the street proved almost impossible. By this time, too, the problem of storing immense works loomed large for Kienholz. "It was just as easy to exhibit them (future tableaux) as wall plaques. When realized, there would be a place for them to go; I wouldn't have to worry about storing them or shlepping them" (Personal interview, 1987). He had begun creating

works that consisted of a framed description and a bronze title plaque as early as 1963; but it was after the completion of The Beanery that he devoted all of his energies to them in 1966 and 1967. His tableaux had indeed proved collectible: Monty and Betty Factor had acquired The Illegal Operation; Howard and Jean Lipman had purchased The Wait for the Whitney Museum of American Art, where Mr. Lipman served as an influential member of the Board of Trustees. Perhaps, Kienholz deduced, the tableaux would also be collectible as concepts, which in turn would be built if the purchaser wanted to pay for the artist's materials and wages. If not, a tableau could simply exist as text; its image could simply exist in the mind of the beholder.

This was an untried experiment, to be sure. Kienholz was asserting an unprecedented degree of control over the patron. His Concept Tableaux, in the spirit of Italian critic Benedetto Croce's philosophical essay, Aesthetic (1902), separated the "impression" from its "expression," its articulation in language from its plastic realization.[3] Thus Kienholz's Concept Tableaux begged the question whether collectors, individual or institutional, would accept a sculptor who operated in this fashion. Ultimately not, it seems, at least in those years just before Conceptual Art, with its emphasis on language, came to the fore. For only two of Kienholz's own conceptual works (The Office Building and The Commercial No. 2) were purchased and only one (The Commercial No. 2) was realized

according to the procedures Kienholz had established. He ended production of these written works in 1967, took them off the market and began constructing tableaux again, as he had done in the first half of the decade. Kienholz created The Eleventh Hour Final, his version of a typical American living room with a horrific version of a television containing a doll's head and war casualties etched on the screen; and he exhibited it at the Eugenia Butler Gallery in Los Angeles from April 23 to May 18, 1968. He then constructed his more expansive and thematically resonant antiwar tableau, The Portable War Memorial, which had its first showing in Untitled 1968, an exhibition held at the San Francisco Museum of Modern Art and the San Francisco Art Institute. The following year, his "memorial" journeyed to London for inclusion in the much seen and discussed Pop Art Redefined at the Hayward Gallery in London. Neither of these tableaux had been conceived in written form first. The State Hospital, constructed in 1966, had been a concept tableau first and was later purchased by the Moderna Museet in Stockholm on the initiative of the museum's director, Pontus Hulten; however, Kienholz had constructed it before it was acquired.

The Moderna Museet's acquisition was only a small part of Hulten's contribution to the artist's career, for he initiated the exhibition, 11 + 11 Tableaux, which established Kienholz as one of the major American artists in Europe. As the title of the show implies, Hulten's idea was to bring together both the tableaux of objects and the tableaux of words—eleven of each.

He had met Kienholz in New York, he recalls— probably in 1968.⁴ Five years earlier, he had seen Roxy's at the Alexander Iolas Gallery in Manhattan. Hulten also included one of Kienholz's works, The Friendly Grey Computer, in an ambitious and wide ranging theme exhibition, The Machine as Seen at the End of the Mechanical Age, which he had curated for The Museum of Modern Art in 1968. "Very few people knew of him," Hulten recalls, commenting on the European audience; but Hulten was convinced that an exhibition of Kienholz's tableaux would be received as a significant survey. When the show opened in early 1970, his intuition was confirmed (Personal interview, 1983).

To prepare for the exhibition, Hulten came to Los Angeles in 1969 to visit Kienholz. Hulten conducted a series of interviews which both he and the artist transformed into a series of texts on the individual works for the catalog. It was not an easy task, Hulten claimed: "You had to drag the information out of him; at that point, he was very inarticulate. It was really another Ed compared to how he was later" (Personal interview, 1983). Hulten was also surprised at the dearth of photographic documentation Kienholz had on his oeuvre. They had to advertise in the local press to find people who had taken pictures of particular works.

Kienholz's exhibition at the Los Angeles County Museum of Art had firmly established his reputation on the West Coast. The last years of the 1960s foreshadowed the full flowering of his European reputation in the first years of the subsequent decade. Roxy's was included in the prestigious international survey of art, Documenta IV, held in Kassel, West Germany in 1968; the next year this tableau was shown in Finland, as part of the Ars 69 Helsinki Exhibit. The same year that

Roxy's *was in Finland,* The Portable War Memorial *was exhibited at the Hayward Gallery in London. All of this activity reached a climax with* 11 + 11 Tableaux *and it marked the beginning of the end of his West Coast years.*

He and his former wife, Lyn, arrived in Stockholm sometime between Christmas and New Year's Day 1969 to begin preparing for the exhibition. To show the works at the Moderna Museet and other European locales would require the rewiring of The Beanery *as well as the installation of all eleven environmental-scale works. But Kienholz confronted these tasks with good humor. He relished this, his first trip abroad. In Hulten's estimation, "He radiated a warmth, a curiosity, an openness, a willingness to communicate—maybe more than either earlier or later" (Personal interview, 1983). Hulten hired an unemployed Swiss worker to assist Kienholz and he and the artist developed an instant rapport.*

The exhibition toured to six cities: Stockholm, Amsterdam, Dusseldorf, Paris, Zurich, and London. By the time it reached Paris in 1971, Hulten recalls, the crowds were immense. This level of success was duplicated in Zurich and London. The show was not a success de scandale, *like the Los Angeles County Museum of Art exhibition, so much as a confirmation of Kienholz's ability to communicate with a wide public. Moreover, like so many other American artists who came of age in the 1960s, Kienholz found greater and readier acceptance abroad.*

The enthusiastic reception of 11 + 11 Tableaux *did not motivate him to abandon Los Angeles immediately. But a fellowship awarded Kienholz in 1973 by the*

German government's sponsored exchange program for artists, Deutscher Academikischer Austauschdienst (DAAD), providing him with a studio and a stipend for the year, showed him just how hospitable Germany could be as a place to work and live. He also noticed that each year the smog was inching its way closer to his hillside home in Laurel Canyon.

Everything pointed to one conclusion: it was the end of his Los Angeles era. In 1974, he sold his house and he and Reddin Kienholz, then married for two years, established a way of living they maintain until this day: part of the year is spent in the metropolis of Berlin; the other portion along the shores of Lake Pend Oreille.

THREE

Words, Numbers, and Rooms: Concept Tableaux, Watercolors, and Occasional Tableaux

1 Kienholz's stated rationale for the *Concept Tableaux* was largely pragmatic, based as it was on evidence of his craftsmanship and the sheer cumbersomeness of his human-scale tableaux. Indeed, he had been—and remained—consistently antitheoretical about his art, even antagonistic to the notion of articulating his aesthetic.[1] Recalling his dialogue with artists in Los Angeles during the 1960s, Kienholz explained, "We didn't talk the art out. I, first of all, would never feel qualified to speak to someone about art" (Weschler, 208). Yet he was willing to admit that the *Concept Tableaux* originated with the notion that "I should be able to trade in just the ideas rather than in the physical presence" (Weschler, 420).

With the introduction of this strategy for the tableaux, Kienholz was clearly rethinking his approach to the production of his art and the shift was implied in the language of the contract each buyer of a Concept Tableau was required to sign. The work existed, at its point of introduction into the public arena, simply as a metal plaque inscribed with the title accompanied by a framed written description. In other words, the initial composing process of the artist ended with the completion of the tableau as writing. Its subsequent stages of creation depended not on the artist but the collector, since the person who chose to purchase the Concept Tableau obtained only the plaque and the written description. One had the option of commissioning "a working drawing" for an agreed upon sum; subsequently, he could also purchase "a finished Tableau." But in essence, the patron who bought the plaque and description obtained only *the idea* for a Kienholz tableau; he or she purchased only words.

All of this was spelled out in greater detail in a two-page contract, first published in the catalog for *Works from the 1960's by Edward Kienholz,* an exhibition that opened at the Washington Gallery of Modern Art (the predecessor to the Joseph Hirshhorn Museum and Sculpture Garden) in late November 1967.[2] The "right, privilege and option to purchase of and from Artist" either the drawing or the drawing and tableau could be exercised "at any time during the productive lifetime of Artist." For the completion of the tableau, all expenses had to be covered: "materials, outside labor, permits, out-of-pocket costs, rental or storage of materials, reasonable living expenses and transportation of Artist during all periods of time that he is engaged in the accumulation of materials or actual construction."

If the shift from object to idea signaled a change in Kienholz's thinking during the second half of the 1960s, the overarching concept of the *Concept Tableaux* pointed to another new ambition. To the focus on idea over and above execution he added the desire to control his means of production. In other words, the *Concept Tableaux* were an experiment concerning the degree of control he could exercise over the private or

22. Edward Kienholz, An example of the *Watercolors* (1969), first sold
for the amount stenciled on the surface of each picture. Watercolor
and pencil on paper; courtesy of the artists.

institutional collector. Moreover, this experiment carried over to Kienholz's *Watercolors* (1969) (fig. 22), though by then he was parodying his own desire to manipulate the marketplace for his art. If with the *Concept Tableaux* he set up a three-stage process for the production and merchandising of his sculpture, with the *Watercolors* Kienholz contrived a system of currency, as he termed it, whereby the work was sold for the amount handpainted on the framed sheet of paper (which encompassed $1 to $1000 in systematic increments) or bartered for the items small and large stenciled on the sheet (*For Nine Screwdrivers* was among the smallest trades, *For a 4-Wheel Drive Datsun Jeep* perhaps the largest).[3] The *Concept Tableaux* was clearly the more ambitious undertaking of the two, because it provided a working inventory of ideas for prospective sculptures. The *Watercolors* were, in essence, a grand spoof on the value of the artist's name in the marketplace; all the buyer actually received was a sheet of paper good for the amount or item Kienholz painted on it, simply because he and the artist agreed it should be so.

Both of these series introduced another item to Kienholz's agenda for social criticism and satire of course: the art world itself. Indeed, one of two *Concept Tableaux* Kienholz undertook on his own financial initiative was *The Art Show* (fig. 23)—introduced as an idea in 1963 and finally completed in 1977—which parodied both the art opening and art criticism. The museum or gallery room which houses the tableau becomes part of the piece too, for Kienholz's figures (nineteen in all, as well as a dog) look as if they are milling about in cocktail attire. Their mouths consist of automobile air-conditioning vents, which can issue forth critical "hot air" at the push of a button that activates a tape recorder.

This is one of his most narrowly effective tableaux, for it possesses little of the pathos we find in his tableaux of 1961 to 1965. Yet it illustrates the suspect status that art theory and criticism have consistently held for Kienholz. Even at the time he was devoted to the tableaux in the form of concepts, he still maintained a general distrust of theory; *The Art Show* is the expression of a pragmatist.

The erudite Harold Rosenberg was to find the *Concept Tableaux* quite intriguing on a theoretical level, however; for him, each of these works suggested that the idea for a tableau, in and of itself, could stand as a self-sufficient work of art. Writing in the *De-Definition of Art* (1969), Rosenberg argued:

> Art communicated through documents is a development to the extreme of the Action Painting idea that a painting ought to be considered as a record of the artist's creative processes rather than as a physical object. It is the event of the doing, not the thing done, that is the work. Logically, the work may therefore be invisible—told about but not seen. The sculpture Oldenburg made to be buried underground has become an influential work through hearsay. . . . One step further and the work of art need not even be made; the creative act can consist of a proposal for a work. Not long ago, Kienholz exhibited a score of framed sheets describing projects he was prepared to execute. Thus, intellectually, a more rarefied gesture than sending diagrams to a factory and delivering finished products to an art gallery. (59)

23. Edward Kienholz, *The Art Show* (1963–1977). Mixed media tableau. Collection of Klaus and Gisele Groenke, Berlin and Hope, Idaho.

Commenting on the *Concept Tableaux,* Kienholz framed the issue in his pragmatic fashion, remarking, "[P]robably artists should be able to do just that. . . . And people should subsidize that activity" (Weschler, 423).

Yet in its emphasis on the idea, this series would seem to anticipate some of the significant, highly theoretical work that would come to be categorized as Conceptual Art. Sol LeWitt, who has fashioned one of the most influential oeuvres emphasizing idea over object, brought the term into wide critical usage with his "Paragraphs on Conceptual Art" (1967). "The idea is the machine that makes the object," LeWitt asserted in one of those "paragraphs" (Miller-Keller and Ravenal, n.p.); and he fulfilled this assertion in his own work. LeWitt's written propositions, which sound like hypotheses for geometric postulates, determined the structure of his floor-mounted structures of open and closed white cubes; wall drawings of colorful geometric shapes; and sequences of grid-oriented drawings in book form. Other people fabricated—and still fabricate—his grid structures and executed his wall drawings according to a written description. Thus LeWitt's working methods affirmed his notion that the object need not be completed by the artist once its idea had been formulated.

When he published his paragraphs in *Artforum,* Conceptual or Idea Art was only beginning its rise to prominence as a movement and Kienholz's production of *Concept Tableaux* was ending. Thus, even though a good deal of Conceptual Art was to use words in addition to or instead of images or objects, it would be a mistake to see Kienholz as an early participant in this aesthetic arena. He was, in actuality, an inadvertent and unwitting precursor.

Characterizing Conceptual Art, critic Donald Kuspit once remarked that it has "the look of thought" (Miller and Ravenal, n. p.). This phrase can be applied just as well to the *Concept Tableaux* and the *Watercolors;* yet the nature of Kienholz's thought in these works separates them decisively from Conceptual Art. They are projects that are not actually as rarified as they might initially appear to be, for implicit to each of them is the notion that a completed sculpture would be the desired result.

Contrastingly, much Conceptual Art attempted to confront the limitations of the art object; as a genre of art, its focus was ontological. As one of the seminal Conceptualists, Joseph Kosuth, wrote in "Art After Philosophy, I and II" (1969), "The 'purest' definition of Conceptual Art would be that it is an inquiry into the foundations of the concept, 'art,' as it has come to mean." Painting and sculpture, no matter how experimental in appearance, were suspect, for they were the historically established genres of Western art. Kosuth articulates this bias forthrightly when, at another point in his essay, he declares, "It is easy to realize that art's viability is not connected to the presentation of visual (or other) kinds of experience. That that may have been one of art's extraneous functions in the preceeding centuries is not unlikely" (Battcock, *Idea Art,* 88). Indeed, Conceptual Art in general set itself in opposition to optical art, because its practitioners collectively asserted that advances in art were more intimately connected to new ideas than new visual presentations at this juncture in the history

of art. For instance, John Baldessari's canvas, *Terms Most Useful In Describing Creative Works of Art* (1966–1968) (fig. 24), contains only a handpainted list of fashionable critical terms, rendered not by him but by a sign painter he paid to execute it. In one of Kosuth's important works, *One and three chairs* (1965) (fig. 25), he aligned a enlarged photograph of a dictionary definition of a wooden folding chair, an actual folding chair, and a photograph of that chair. This technique of juxtaposition diminished the importance of each

portion of the work as a purveyor of *the* essential information about a chair: whether physical object, verbal description, or photographic transcription.[4] Though Kosuth's piece is heavy-handed and rather ponderous in its approach, it is representative of the emphasis on inquiry over and above objectmaking which characterizes much Conceptual Art. Like the *Concept Tableaux,* Conceptual Art exhibited a penchant for language; but it strove to strip art of its need to be painting or sculpture.

TERMS MOST USEFUL IN DESCRIBING CREATIVE WORKS OF ART:

GIVE VISION	ENJOY	DISCIPLINE
DIRECTION	CHARM	DELICATE
FLAVOR	INFLUENCE	COMMAND ATTENTION
A NEW SLANT	INTEREST	EXALT
FORCE	DELIGHT	DEVELOP
UNIQUENESS	AROUSE	SATISFY
PERMANENCE	COMMUNICATE	BEAUTIFY
INSPIRATION	CULTIVATE	IDENTIFY
A GLOW	NURTURE	INSPIRE
MOTIVATION	PLAN INTELLIGENTLY	ORIGINATE
ENCHANTMENT	DETACH	CREATE
BLEND	TRANSFER	ASSOCIATE
ENLIGHTEN	CHALLENGE	CHERISH
INVIGORATE	ELEVATE	ALTER
ENTHRALL	SATIATE	REVISE
TAKE SERIOUSLY	IMPROVE	CRITICIZE
PRECISE CARE	VALUE	IMPRESS
OUT OF THE ORDINARY	FLAGRANCE	IMPART

24. John Baldessari, *Terms Most Useful In Describing Creative Works of Art* (1966–1968). Acrylic on canvas. Collection of the Museum of Contemporary Art, San Diego; gift of John Oldenkamp.

25. Joseph Kosuth: *One and three chairs* (1965). Wooden folding chair, photographic copy of chair, and photographic enlargement of a dictionary definition of a chair. Collection of the Museum of Modern Art, New York; Larry Aldrich Foundation Fund. Joseph Kosuth/VAGA New York 1990.

The *Concept Tableaux,* for all of their rarified trappings, didn't truly participate in this inquiry, for they revealed Kienholz's continuing commitment to the completed tableau. He wasn't questioning the validity of his sculptural activity—rather, the process by which it got made. Although each Concept Tableau originated as an idea, the finished environment was an ultimate aim. The central arena of his artistic activity remained plastic. The apparatus governing purchase and production of a Concept Tableau, though it is of note, remains of secondary importance. These *Concept Tableaux* aspire to a condition of completion, for Kienholz's sculptural scenes and rooms require the viewer's immersion in them to activate the socially resonant drama each establishes. Ultimately, we might even see the aim of the *Concept Tableaux* to be a rather traditional one: Kienholz simply wanted to secure patronage for large works rather than submit himself to the whims of the art marketplace.

Nonetheless, by using words rather than building sculpture one by one, Kienholz did indeed provide himself with a venue for developing ideas for the tableaux at a more rapid pace. Pontus Hulten asserted that "Kienholz has systemized his subjects in his series of 'concept tableaux' in a truly wonderful and totally original way" (Hulten, *Tribute to Sollie 17,* n. p.). Systemize isn't quite the right term, I would argue, for the approach in these tableaux isn't governed by a progression or plan of any kind. Yet the shift from constructed to written form clearly did, as Hulten implies, provide Kienholz with the means of en-visioning new possibilities of scale, setting, form, and theme.

If the completed tableaux of 1961–1965 had incorporated large chunks of the American cultural milieu into his art—from the actual, if altered, automobile in *The Back Seat Dodge '38* to the replicated bar in *The Beanery*—an early Concept Tableau, *After the Ball Is Over #1* (1964) (fig. 26), reveals that Kienholz was thinking concurrently about subsuming even larger aspects of the social landscape into his art. Its text reads:

This tableau is to be built in the town of Fairfield, Washington. It will be an existing two or three bedroom frame house with living room, kitchen, back porch, etc. It will have to have a driveway, walks, etc. And the yard will need perpetual care. All the windows are to be painted black or mirrored so the interior of the house is dark. The house will be furnished in 40's or 50's contemporary Sears and Roebuck farmer style. It will be complete and obviously functioning, with four people in the inhabiting family. They have a dog and four-door sedan which is parked in the driveway. To withstand the weather, it will probably be a shell of just the metal parts, mounted on pipe standards or painted black or mirrored, etc.

In the driveway is a second car which has pulled up behind the family sedan. The driver's side door is open and a dome light is on: It had obviously just arrived. (Again, concrete seats, tires, etc.)

Just inside the front door is a young man and his date (the girl from the family). They are standing close together, shyly intimate, but not actually touching or embracing. She is in a prom gown (corsage). He is in a suit.

In one bedroom is the younger brother, sleeping soundly. In another bedroom is the

AFTER THE BALL IS OVER #1 1964

This tableau is to be built in the town of Fairfield, Washington. It will be an existing two or three bedroom frame house with living room, kitchen, back porch, etc. It will have to have a driveway, walks, etc., and the yard will need perpetual care. All the windows are to be painted black or mirrored so the interior of the house is dark. The house will be furnished in 40's or 50's contemporary Sears and Roebuck farmer style. It will be complete and obviously functioning, with four people in the inhabiting family. They have a dog and a four-door sedan which is parked in the driveway. To withstand the weather, it will probably be a shell of just the metal parts, mounted on pipe standards or pylons, with concrete tires, concrete seats, all the windows painted black or mirrored, etc.

In the driveway is a second car which has pulled up behind the family sedan. The driver's side door is open and a dome light is on: it has obviously just arrived. (Again, concrete seats, tires, etc.)

Just inside the front door is a young man and his date (the girl from the family). They are standing close together, shyly intimate, but not actually touching or embracing. She is in a formal prom gown (corsage). He in a suit.

In one bedroom is the younger brother, sleeping soundly. In another bedroom is the mother, lying in bed stiff, listening. (Soft light illuminates the piece.)

In the kitchen, sitting at a table, under an unshaded light bulb is the father, tired, rigid, menacing. He has been teased into letting his daughter go to the dance (this is her first real date). He doesn't know why, but right now he hates the young man.

PRICE: Part One $ 15,000.00

 Part Two $ 1,000.00

 Part Three Land, materials and artist's wages

26. Edward Kienholz, Framed text of the Concept Tableau, *After the Ball Is Over #1* (1964). Collection of the artists.

mother, lying in bed stiff, listening. (Soft light illuminates the piece.)

In the kitchen, sitting at a table, under an unshaded light bulb is the father, tired, rigid, menacing. He has been teased into letting his daughter go to the dance (this is her first real date). He doesn't know why, but right now he hates the young man.

Price: Part One $15,000.00
 Part Two $1,000.00
 Part Three Land, materials and artist's
 wages

(*11 + 11 Tableaux,* n. p.)

On one level, this proposed tableau simply expanded Kienholz's established notion of the tableau. Instead of creating the interior of a building, as in *Roxy's,* or an exterior scene, as in *The Back Seat Dodge '38, After the Ball is Over #1* gives us both. But it is different in a more striking way from his realized tableau, because the museum is not the intended locale of the work; this tableau, if realized, was to exist within the social landscape. Free to imagine what shape a tableau should assume and unconcerned about its immediate execution, Kienholz decided that a domestic drama should be set in a house on an actual small town street in his own hometown. His version of the given social world was to exist amidst that world.

This proposed tableau might seem to be the stuff of very conventional and sentimental domestic drama, but the description of *After the Ball Is Over #1* also suggests otherwise. For even as he envisioned transplanting his tableaux from the museum into the landscape, the description of *After the Ball Is Over #1*

reveals that Kienholz held fast to his aesthetic of intensifying our experience of the prosaic social environment. The blackened and reflective windows of the house mirror the father's hatred of his daughter's suitor. So, too, does his position in the kitchen under an "unshaded light bulb." Other phrases suggest that the work would have the subtly eerie quality of an entombed site: the automobiles were to have black, mirrored windows as well as concrete tires and seats; the whole piece was to be illuminated by soft light, presumably at night. And though Kienholz omitted an important element of the tableau from his written version—the appearance of the figures themselves— we can surely conclude, based on his realized tableaux, that the mood of each "character" would find its physical correlative in one of the sculptural figures.

Kienholz's notion of employing an entire existing structure and then entombing it, an integral element of *After the Ball is Over #1,* was to have assumed a more literal form in two of his other *Concept Tableaux: The Cement Store #1* (1967) and *The Cement Store #2* (1967). For the first of these works, he needed to find a building "made of cinder blocks, cement blocks, adobe bricks or form poured concrete" in a town of less than 5,000 population; for the second, a structure of the same materials in a town of over 50,000 citizens. In both cases, he proposed the same use of the store:

> The buildings, businesses and inventory must be purchased and left intact. The windows will be replaced by clear plexiglass or bullet proof glass to withstand internal pressures or malicious breaking. The doorways will be board formed in such a way to allow the door to swing both

ways. A section of roof will be removed and the interior of the store will be filled with concrete completely covering all merchandise, cash register, records, etc. The roof section will be replaced and repaired. The board forms at doorway will be removed, the hardened concrete now making it impossible to enter the building. (*11 + 11 Tableaux,* n. p.)

These two proposed works, coupled with *After the Ball Is Over #1,* clearly illustrate that Kienholz wanted to make tableaux that merged with the manmade world, works that extended the tableau aesthetic into the arena of outdoor monuments, but were to function less like monuments than simply extraordinary aspects of the ordinary environment. We can see that he had fulfilled this ambition, to a degree, with *The Back Seat Dodge '38,* begun the same year as Kienholz conceived of *After the Ball Is Over #1*; it created the illusion of an outdoor scene to be placed within a museum or gallery. Yet his cement stores and his "Sears and Roebuck farmer style" house as frozen theatre were homages to prosaic American commercial and private life, which were to exist within the landscape.

This was a logical extension of his aesthetic—and it affirms that the *Concept Tableaux* provided a venue for introducing ideas sooner than Kienholz could expect to execute them. Perhaps this was also a venue for ideas that he might never expect to execute. In Weschler's introduction to his lengthy interview with Kienholz, he too suggests as much with his own description of a Concept Tableau: "contractual title to a proposed but not necessarily realized or even realizable idea-tableau is awarded in exchange for a

fairly large sum of money" (xviii). After all, would anyone or any institution offer the funds for the purchase, alterations, and maintenance of a house in Kienholz's hometown of Fairfield, Washington? or the purchase of stores to be encased in cement? Even Kienholz seemed amused by some of his proposals. There is a wisecracking tone to the concluding sentence in *The Cement Store,* in which he comments on the cryptic place his "monument" would have in the American landscape: "The store will be left with little or no explanation, other than it is now some sort of art object and no longer subject to improved property taxes." Kienholz would seem to have conceived of these related works as mysterious presences in the American landscape: grand-scale variations on the theme of Marcel Duchamp's readymades. Each "store" was to be a found (and rather wry) monument, its aesthetic status signified only by the overlaid skin of cement.

Yet by 1969, we might recall, Kienholz's former dealer, Virginia Dwan, had commissioned Michael Heizer to create one of the first Earthworks in the Nevada Desert; entitled *Double Negative* (1969–1970), it consists of two giant ravines created in the barren landscape.[5] She had also purchased the plaque and title panel for a seemingly outlandish Concept Tableau, *The Office Building* (1964)—one that Kienholz described as "a unique marriage of art and business." It was to be a functioning four- or five-story office building, with additional offices and shops containing sculptural versions of business men and women. Perhaps, given the right circumstances, one of these monumental tableaux just might have been realized as well during the time Kienholz made them available to collectors.

2 The only Concept Tableau completed during the 1960s was *The State Hospital* (plate 9), a brutal representation of its stated subject. Actually its completion marked a return to his old method of producing tableaux, since it was constructed on his own initiative and only later purchased by the Moderna Museet in Stockholm. This tableau also revived one of the large themes of the tableau of 1961–1965, the victimization and degradation of society's marginal citizens, even as it manifested a subtle shift in his focus too. For although it presented the suffering of the individual, it also addressed the institutional context of abuse. The two other major works of the period, *The Eleventh Hour Final* and *The Portable War Memorial,* reveal a parallel focus: the former, on television as a desensitizing instrument for communicating the brutalities of war, and the latter, on the unsettling interconnections of a culture's peacetime and warmaking activities. Taken together, these works as we shall see, offer no evidence of a decline in the intensity of Kienholz's vision; they were—and remain—startling in their ability to give his concerns physical form. Like the tableaux of 1961–1965, they become surrogates for the everyday world that appear more vivid, in some manner, than the social realities they replace.

Much like *Roxy's* and *The Back Seat Dodge '38* before it, *The State Hospital* was distilled from vivid personal memories. In 1947, approximately two years after finishing high school in Fairfield, Kienholz worked as an orderly in a state-run mental facility at the nearby Lake Medicine, Washington. He recalls:

[There was] a hell of a lot of prison aspect to it and a lot of brutality, but much, much dirtier than *One Flew [Over the Cuckoo's Nest]*. I mean that would have been a model of a mental hospital compared to where I used to work. (Weschler, 57)

This tableau conveys both the brutality and the prisonhouse atmosphere that remained vivid in his recollections, offering a scene whose repulsiveness is equaled only perhaps by that of *The Illegal Operation.* Indeed, the facade of *The State Hospital* (fig. 27) is carefully designed to look like that of a prison cell as much as a hospital room. The exterior of the work consists of a human-scale stark white box; its front side displays a padlocked door with a tiny window and, in the upper left corner of the wall, is a sign that reads "WARD 19." The interior scene is visible only through the single window, which is covered with bars. Curiosity lures any viewer to the window, of course, but one finds the most grim sort of "peep show" inside, its scene foreshadowed by the nature of the tableau's exterior. Two cast figures recline on a set of bunk beds, one above and one below, each shackled to the bed frame with a leather strap and bracelet. Each also possesses a lucite bubble in place of a face and within each bubble swim two black fish. The bodies of the "patients" are a ghoulish sort of yellow, heavily encrusted with drips and splashes of resin. The mattresses are soiled and tattered; a bedpan rests on the floor.

It is worth noting that Kienholz chose a man who was close to death as the subject for both plaster castings in *The State Hospital.* He had enlisted the

27. Edward Kienholz, Exterior of *The State Hospital*.

cooperation of an acquaintance named Ed Born, who was suffering from cancer. Indeed, the two figures, which face the window, were originally supposed to read from right to left. "That's the way I used to see him [the patient] when I walked into the room at Medical Lake," Kienholz recalled. But because of Born's condition, he was only able to lie on one side and thus the pose of the figures in the work is left to right—determined by his physical condition.[6] More importantly, Born's own condition is emblematic of the effect Kienholz desired to achieve with this tableau: the viewer gazes at men in a state of living death. Confronting imminent death in the form of Born, we can surely deduce that Kienholz hoped his encounter with this subject for his castings would translate into a more authentic representation of the suffering men within the tableau itself.

The physiognomy of the "patients," coupled with their faceless heads, does indeed give them the look of specters more than men. This ghostliness is only heightened by the neon tubing, which casts an eerie penumbra around the figure on the upper bunk; it is shaped like the bubble caption from comic books and strips, as if to suggest that the man on the lower bunk has perhaps only imagined his double on the upper one.

The hollow cavities within their heads become vivid metaphors of wasted minds. The black fish read as metaphors too: of death, simply because of their color; and of confinement, as they swim inside the small bowls within each head. In its entirety, the work functions as a three-dimensional image of tremendous cruelty. For the written version, Kienholz even con-

fronts us with a specific memory of patient abuse. Describing the figure within Ward 19, the artist informs us, "He has been beaten on the stomach with a bar of soap wrapped in a towel (to hide tell-tale bruises)." Bruises are not depicted explicitly, but memories such as this surely inform Kienholz's rendering of each figure, with its sickly hue and pose of utter resignation. Ultimately, this tableau is an image about utter and absolute degradation, mental as well as physical. Writing of the figure on the bottom bunk in the concluding paragraph of the wall plaque, Kienholz explains, "His mind can't think for him past the present moment. He is committed there for the rest of his life" (11 + 11 Tableaux, n. p.). Within the room of The State Hospital, Kienholz created just such a compact hell, where an incarcerated man or men exist in a state of suspended animation, as it were, where each moment is as bleak as the last one.

Neither of the other two major tableaux of this period possess the degree of poignancy Kienholz achieved with The State Hospital. The Eleventh Hour Final is chilling; The Portable War Memorial, wry and sardonic. In conception, both of these works are also more polemical; they offer explicit variations on an antiwar theme. Nor do either of these works have the same link to deeply embedded personal memory that informs Kienholz's most emotionally affecting tableaux. Much like Roxy's and The Back Seat Dodge '38, The State Hospital emerged after it had gestated in his mind for several years. "Something that I'll experience comes back to me in four or five years," he explained, "and then I'll try to sort it out and understand it, and usually I'll build a piece from the

experience. *The State Hospital* was obviously the piece from that time" (Weschler, 59).

That time was a painful episode from the artist's youth, revived and made archetypal in his tableau depicting a ward in a mental institution. By contrast, the mood of both *The Eleventh Hour Final* and *The Portable War Memorial* are more intimately connected to their own historical moment, when the Vietnam War was at its height. Kienholz had first embraced that conflict, as subject, in a small way in *The Beanery.* Though the figures in Kienholz's bar ignore the newsstand and the world right outside its door, the newspaper inside the vending machine is a reminder; "Children Kill Children in Vietnam," the headline of the *Los Angeles Herald Examiner* from 1965 declared. By 1968, with the Vietnam War raging and no end of American involvement in sight, Kienholz made the mass media dissemination of information concerning the war the central theme of *The Eleventh Hour Final.*

This tableau provides a pointed indictment of the communication of carnage in wartime via television. The focal point of the tableau, is, as Kienholz termed it, a "concrete tombstone / tv set." The television console, set in concrete, occupies one wall of a simulated wood panel room. Nondescript furniture of midsixties vintage fills the opposite side of the room: a matching coffee and end table; a synthetic blue velvet sofa; and a cheap-looking painting of a city skyline. But the bland quality of the furnishings is offset by the horrific sight within the television screen, which sits across the room. For floating at the bottom of this chamber is a mannequin's head of a young girl floating sideways, its face pressed against the glass.

Kienholz once termed the television "the voyeur's box"—a phrase that illuminates the central concern of this tableau: the role of television as the medium by which the war reached Americans at home (Silk, 113). Kienholz posed this issue as a question in the *11 + 11 Tableaux* catalog entry for *The Eleventh Hour Final*: "What can one man's death, so remote and far away, mean to most people in the familiar safety of the middle class homes?" he asks. Very little if it is offered in the form of statistics, this tableau suggests. Engraved on the surface of the screen in *The Eleventh Hour Final* are the kind of figures which would appear nightly on the news during the Vietnam War:

This Week's Toll

American Dead	217
American Wounded	563
Enemy Dead	435
Enemy Wounded	1291

(11 + 11 Tableaux, n. p.)

The abstractness of these numbers is contrasted, here, with the vivid image of the floating head, returning our gaze and robbing us of the immunity of the voyeur's role. Its presence particularizes death, forcing our eyes to gaze inside the cavity of this television rather than at the words and numbers emblazoned on its surface. Kienholz's concrete version of a television is transformed into a metaphorical coffin.

Realized within months of *The Eleventh Hour Final, The Portable War Memorial* (plate 10) is a kind of companion piece. While the former critiques the mass

media representation of war, the latter undercuts another variety of iconography historically linked to armed combat: the representations of heroic deeds which commemorate war in public monuments. In the central portion of this tableau, Kienholz explicitly parodies the most familiar public sculpture erected to celebrate victory over Japan in the Second World War: Felix de Weldon's highly conventional realist bronze casting of Marines placing the flag on the island of Iwo Jima, which itself was derived from a picture by then Associated Press photographer Joseph Rosenthal. Kienholz's version transforms the heroic into the ludicrous, since the soldiers—headless in this version and striking the same pose as de Weldon's figures— are about to plant the flag in a patio table on American territory instead of foreign soil.

The parody subverts the purpose of the original kitsch statue and also establishes the broader theme of *The Portable War Memorial;* for the tableau concerns itself with the inseparability of the warmaking and peacetime aspects of American society—or any other society. The image of the soldiers laying claim to a patio table gives us the theme in the form of a metaphor that is both absurd and amusing. Yet the overall tone of this tableau is elegiac rather than parodic, its humorous elements consistently under- mined by other aspects of his "memorial."

Kienholz advises us, in a letter published in *Artforum* in 1969, that the work "reads as a book from left to right."[7] Indeed, the structure of the work confirms his claim because as the viewer's eye and body progress in the prescribed direction, the work suggests a loose narrative about wars past and present

and the potential demise of civilization. It memorializes our culture implicitly and others explicitly, as we progress through a series of panels that give this tableau the look of an immense picture storybook.

The first panel mixes what Kienholz calls "propaganda devices"—of World War One and Two and the decades in between. On the far left is a small figurative sculpture whose body consists of an altered and upside down garbage can, elevated on squat legs and displaying a small head under plastic on top. When "she" is plugged in, a tape plays "God Bless America," because this is a grotesque caricature of Kate Smith. On the wall behind her is the familiar "I Want You" poster; to her right is the grouping of soldiers holding the flag, which carries us forward in time from the World War One era of the Uncle Sam icon (on the poster) to the iconography of World War Two.

These soldiers, then, also carry us, as it were, into the territory of the post-1945 era: the world of leisure and consumption, emblematized by a patio/hot dog stand. This portion of the tableau is a scenario, as Kienholz phrased it, of "business as usual." Below the sign for "Hot Dogs" and "Chili," there is a life-size photographic image of a man and woman sitting at the stand and to the right of this image is a functioning Coca-Cola machine. Patio tables, one sheltered by an umbrella, are situated between us and both the stand and soda machine as we make our approach to the tableau.

This scene depicting peacetime, postwar America is, in turn, sandwiched between two more ominous ones. To the left, as a backdrop to the soldiers gripping

the flag, is what Kienholz terms a "blackboard tombstone"—filled with the names of 475 nations that no longer exist. The implicit point, of course, is that war is the cause of their extinction. Whether this is true in each case or not, Kienholz's blackboard makes its point in a dramatic fashion, for enough of the 475 surely were extinguished by war to assert his theme. To the right of the patio/food stand is another tombstone-shaped stone; and if we follow the logic of reading from left to right, this panel in the storybook represents a prophecy.

The future, at first glance, would look to be a clean slate. The stone appears empty. Yet with closer scrutiny, a tiny figure, only a few inches tall, reveals itself (fig. 28). Fastened to the stone surface at the bottom and assuming the pose of the crucified, its hands have been consumed by fire. Thus this becomes a second tombstone, that of the archetypal victim of wars to come, while the memorial to nations now extinct also possesses a place to mark the end of wars not yet fought. For in the upside down cross fastened at the top of the blackboard, there is an uncompleted text that reads: "A Portable War Memorial/Commemorating V-Day/19——."

Both *The Eleventh Hour Final* and *The Portable War Memorial* depend on a shock of recognition to fulfill their respective thematic purposes: the first, by making the viewer perceive death in terms of one rather than many, the second, by proposing that the demise of American culture can be foreseen in the history of its recent wars. Undoubtedly, the Vietnam War served as the backdrop and catalyst for both of these tableaux. Yet neither tableau makes specific

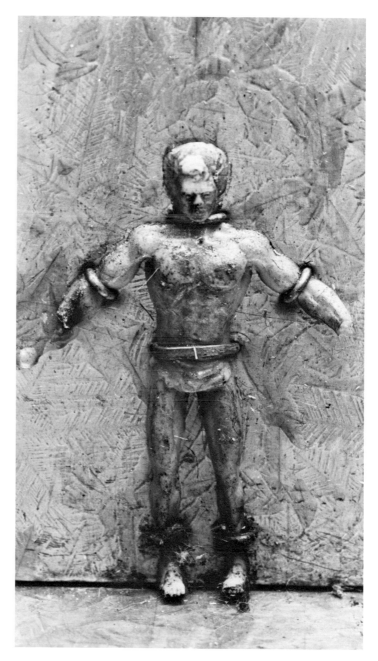

28. Edward Kienholz, Detail of *The Portable War Memorial*.

reference to that particular military struggle; rather, each uses it as a catalyst for a confrontation with and reflection upon the issue of war in general. As Kienholz commented of *The Eleventh Hour Final,* when it was first exhibited, "Nowhere does the tableau say this is Vietnam. . . . It will be apropos 20 years from now" (*Home Furnishings Daily,* n.p.).

Central to Kienholz's aesthetic is the hope that *The Eleventh Hour Final*—or for that matter, *The Portable War Memorial* as well—just might not be as relevant two decades later, if war would be viewed from a different vantage point. Though the setting of these tableaux, much like earlier ones, evokes a specific historical era, the moral theme is generic. Both of them strive to mirror the elemental realities of war— individual death or the demise of an entire society—in a vivid way. If we are repulsed enough by what we see, each work suggests, then perhaps our view of the institution of war could be altered substantially. Kienholz's own comments concerning *The Portable War Memorial* clearly reveal his conviction that it could function as a constructive work of social criticism, that it served to chastise his country out of affectionate concern rather than utter animosity. In his 1969 letter to *Artforum,* written in reply to a letter that questioned the validity of the tableau's point of view, Kienholz wrote: "I would first of all never insult this country (America) as I love it perhaps as well as you. I would, however, in my way presume to change it" (Hulten, *Tableaux,* n.p.).

Implicitly, then, Kienholz returned to the sentiments revealed by the Concept Tableau, *The World.* In that never realized work, he spoke of his hope that it would serve "as a symbolic gesture of true acceptance and reaffirmation of it [the world]" (*Tableaux,* n.p.). In some manner, his two antiwar tableaux were supposed to express something of the same sentiment, even if their collective "gesture" was implicit rather than obvious. Hoping that such tableaux could produce salutary change, he placed faith in the viewer that, to repeat an earlier quoted couplet of Barlow's *The Columbiad,* "Here social man a second birth shall find, / And a new range of reason lift his mind." Perhaps we could transcend the world of cruelty and violence that we had established for ourselves—the world mirrored in such works as *The State Hospital* and *The Eleventh Hour Final.* Perhaps we would never have to fill in the blanks of the inscription on *The Portable War Memorial,* if, as Kienholz also asserted in his letter, we could gain greater knowledge of our motivations as a culture. A point made by Suzi Gablik in her essay on his work, "Crossing the Bar" (1965), is relevant here. "Instructing man that he need not unresistingly accept his unhappy fate," Gablik asserted, "he [Kienholz] proposes that there is, after all, no incurable disgrace" (*Redefining Pop,* 88). A second birth of American culture was possible, but unlikely; the future, as *The Portable War Memorial* envisioned it, was more likely a blank slate than a clean one. Yet these works provide enough evidence for us to believe that Kienholz's view of the fate of humankind, during the waning years of the 1960s, was ultimately not apocalyptic; our past barbarities, as a race, did not guarantee that we would repeat them, even if the historical record argued that we were ever so likely to do so.

3 The sentimental or optimistic undercurrent of Kienholz's tableaux did not go wholly unnoticed in criticism of the mid-to-late 1960s, even if commentary was sparse. Writing in response to the 1967 exhibition, *Works from the 1960's by Edward Kienholz,* at the Washington Gallery of Modern Art, Jo Baer was prompted to title her essay, "Edward Kienholz: A Sentimental Journeyman" (1968). To her mind, his work "reads like a novel"; and its heavily detailed scenes are both "realistic" and "sentimental" at once. Embedded in the gritty detail of his assemblages and tableaux, she found a rich reservoir of what she called "emotionalized principles." If the moral theme animated the work, its form always conveyed a rich array of feelings the artist associated, and wanted us to associate, with the depicted scene. The overarching effect of the work was always greater than its overt message.[8]

Sidney Tillim's short essay on *The Beanery,* written at the time of the work's New York showing at the Dwan Gallery in late 1965, is even more astute than Baer's about the play of sentiment in Kienholz's work. Indeed, it remains one of the best short pieces of criticism on his art, more than two decades after its publication. Tillim begins by addressing the resistance of the New York art world to Kienholz's tableau. "It is safe, I think, to say," he admits, "that local cognoscenti missed its import—as I almost did—out of simple snobbism." His expectation was that it would be "a desperate, latter-day excrescence of Pop art." But his expectation was contradicted; *The Beanery* was something quite different, quite superior to, what he anticipated. Its uses of "banality and kitsch" were vastly different than those of Pop Art, for the tableau didn't assume an ironic posture toward its materials. Tillim then proceeded to make his central point:

> Barney's Beanery [sic] is simply a giant genre sculpture which exhibits the logical distortion of being emotionally rooted in the past while exhibiting the psychological pressures of the present. A bifocal conception, it exhibits affinities with the folk themes of Romantic American genre painters such as [George Caleb] Bingham and [William Sidney] Mount and, especially, the sculptor John Rodgers (1829–1904) whose mass-produced studies of popular literary and Civil War themes and genre scenes of everyday life were huge popular favorites in their day, yet expresses them with an aggressiveness that is all the more contemporary for concealing its deep nostalgia for an existence uncomplicated by anxiety and ambition. (38)

We should recall Kienholz' own claim that he thought of himself as a painter working in three dimensions.[9] The artist had revived, as Tillim implies, the notion of a genre art whose vision was democratic. That vision was no longer predominantly ebullient, as in Bingham's or Mount's paintings; the joyful, innocent mood of pictures such as Bingham's *The Jolly Flatboatmen in Port* (1857) (fig. 29) and Mount's *Dancing on the Barn Floor* (1831) (fig. 30) or *Farmers Nooning* (1836) had been canceled out by more than a century of American history. The reality that lurked outside *The Beanery* was that of the newspaper headline that read "Children Kill Children in Vietnam." The future that loomed just beyond the peacetime

29. George Caleb Bingham, *The Jolly Flatboatmen in Port* (1857). Oil on canvas. Collection of The Saint Louis Art Museum.

30. William Sidney Mount, *Dancing on the Barn Floor* (1831). Oil on canvas. Collection of the Museums at Stony Brook, New York; gift of Mr. and Mrs. Ward Melville, 1955.

world of hot dog stands and patios, in *The Portable War Memorial,* didn't suggest greater things for American society, but potential annihiliation. If Kienholz's work was "deeply nostalgic," as Tillim claimed, it was for a future that had the brightness of that idealized America of its nineteenth-century genre paintings and Whitman's *Leaves of Grass.* Yet the world within these tableaux gives plastic form to Whitman's perception, contained in *Democratic Vista,* that "Genuine belief seems to have left us. The underlying principles of the States are not honestly believed in (for all this hectic glow, and these melo-dramatic screamings), nor is humanity itself believed in" (461). In actuality, the future, as Kienholz's art implied, would look more like Burroughs's Freeland than Whitman's vision of the United States.

Tillim's essay was also the first to compare Kienholz's work with George Segal's in a perceptive fashion. And if the juxtaposition of their tableaux, in criticism, has since become commonplace, Tillim's comments still remain illuminating. In Segal's work, he asserts, "the subject matter has not been permitted an intimacy with style, out of fear of corrupting the latter. Rather than subject matter and style enriching each other, the subject is made to demonstrate the occurrence of Style" (38, 40).

For obvious reasons, the work of Kienholz and Segal has provoked comparison. In formal strategy alone, Segal's use of figures cast in plaster, positioned within reconstructed and found everyday props, loosely mirrors the presentation of Kienholz's tableaux; both employ a heavy emphasis on theatricality in their work. During the first half of the 1960s, Segal, like

Kienholz, was also creating his early sculptural scenes. Indeed, the early course of their respective careers offers intriguing parallels.

In the same year that Kienholz created *Roxy's,* Segal constructed the first of his tableaux, the much more modest *Man Sitting at a Table* (1961) (fig. 31); it features a stiffly posed male figure, seated at an aged table. However, the scale of Segal's works expanded rapidly. A year later, for *The Dinner Table,* Segal created a series of six figures, depicted sitting or standing around a table—one with a coffeepot in her hand. For *Cinema* (1963), he posed a casting of man placing an "R" on a marquis board, lit from within. In *Gas Station* (1963), he incorporated a Coca-Cola machine and a rack of empty bottles; a man seated on one of the crates holds a bottle in his hand. A slight distance away is an oil and tire display behind a window; a figure with oil can in hand stands behind the glass too. *The Diner* (1963–1966) explores similar territory as *The Beanery,* but it contains only a counter and acouterments rather than an entire self-contained room, two figures (a waitress and a seated customer) rather than many. Just as Kienholz had created the essential format for his future work by the mid-1960s, so, too, had Segal.[10]

Yet the sum effect of Segal's work is decidely different from that of Kienholz's tableaux, as Tillim surmised. Segal concentrates much less on *what* is depicted than on *how* it is presented, while Kienholz achieves a greater balance between the two. In other words, Segal emphasizes formal presentation over and above social context: the uniform look of the figures; their poses; and the relationship between figures and

31. George Segal, *Man Sitting at a Table* (1961). Mixed media tableau. Collection of the Städtische Museum Abteiberg, Mönchen Gladbach, Germany; courtesy of the Sidney Janis Gallery, New York. © George Segal/VAGA New York 1990.

props. Those props may reveal the patina of use and age, but Segal's figures seem quite disconnected from the things that surround them; they are phantoms who gently haunt their prosaic surroundings. His work, even when explicitly socially critical as in *The Execution* (1967) (fig. 32), defuses its content with its style. Though the tableau depicts three corpses lying on the floor and one suspended by his feet, it is not grisly so much as a curiously cool depiction of this scene.

Thus Segal's approach contrasts strongly with Kienholz's commitment to an intensified version of the depicted social scene. Segal used (and still employs) the tableau to create a studied sort of realism, while Kienholz created a persuasive—perhaps the most persuasive—socially critical art of the second half of the 1960s. Moreover, in the second half of the decade, Kienholz extended the range of his themes in such a way as to suggest that, for him, the tableau format offered seemingly inexhaustible possibilities.

With the 1960s drawing to a close, Kienholz chose to conclude the decade on a light note: with his series of *Watercolors.* "The basic impulse was frustration," Kienholz wryly commented, in a catalog statement that explained the origins of this work. "Why can't an artist just trade for what he wants without running downtown all the time to get it?" (Kienholz, *Kienholz,* n. p.). The first Watercolor simply read *For Nine Screwdrivers*—and Kienholz did indeed trade it for screwdrivers worth $14.30. This work set in motion a series of individual works traded for the item lettered on the 12 × 16 sheet of rag paper. Each one was similar in format: a series of words placed at the center of the picture's surface with the background rendered

in a delicate wash.

The concept promptly expanded to include the acquiring of money as well as things. "I soon realized that man does not live by barter alone," Kienholz jokingly added, "and some real cash was needed on the old barrelhead" (Kienholz, *Kienholz,* n. p.). He created a few such works, in nonsequential fashion, which led to a more elaborate sequential series that was exhibited at the Eugenia Butler Gallery in Los Angeles in the Fall of 1969. Colors varied according to denomination—black, red, or yellow—with amounts running consecutively from $1 to $1,000 and in thousand-dollar increments from $1,000 to $10,000 (see fig. 22).

This series depended entirely, of course, on the preestablished value of Kienholz's name. If it spoofed the arbitrary nature of that value, it did so without subterfuge; the buyers were Kienholz's willing victims. If this series was theoretical in nature, it was Conceptual Art as conceived by a "horse trader."

These *Watercolors* provided a comic interlude before the return of horror, tragedy, and depicted violence in what is arguably Kienholz's most bitterly socially critical tableau: *Five Car Stud* (1969–1972). Its scale was unprecedented; the tableau contained four automobiles and eight figures arranged to fill a good-sized parking lot. It was foreshadowed by *The Back Seat Dodge '38,* in its use of automobiles, and his unrealized *Concept Tableaux,* in the sheer scale of the piece. *Five Car Stud* was, as it happens, Kienholz's grand finale of his Los Angeles era too.

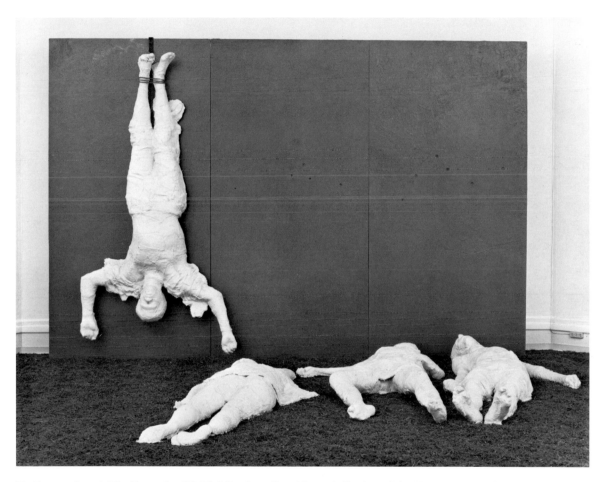

32. George Segal, *The Execution* (1967). Mixed media tableau. Collection of the Vancouver Art Gallery; gift of Mr. and Mrs. Charles Diamond and Mr. and Mrs. Gordon Diamond. Photograph: Jim Gorman. © George Segal/ VAGA New York 1990.

33. Edward Kienholz and Nancy Reddin Kienholz in 1984.

INTERCHAPTER FOUR

An Era of Collaboration

In 1981, on the first page of a catalog that accompanied an exhibition entitled The Kienholz Women, *Kienholz* issued a statement that declared that his wife of nine years, Nancy Reddin Kienholz, was to receive equal credit for all work created since they had been together. "My life and my art have been enriched and incredibly fulfilled by Nancy's presence and I wish to belatedly acknowledge that fact here," he explained in the second of three paragraphs. In the third, Kienholz added, "I further feel I no longer have a man's right to signature only my name to these efforts which have been produced by both of us. Hence, this exhibition is by Edward Kienholz and Nancy Kienholz and is so signed" (The Kienholz Women, n.p.). He acknowledged the belatedness of his gesture by retroactively giving dual credit to all works created together since 1972 (fig. 33).

Kienholz and Reddin met in 1972 at a bon voyage party for the popular writer Irving Stone, who was leaving for Israel. The host and hostess for this gathering were her father and mother, then Los Angeles police chief Tom Reddin and his wife, Betty Parsons Reddin. Kienholz was feeling low that night, he recalls; his marriage with Lyn Kienholz had gone sour.

Nancy introduced herself by asking him, "How does it feel to be infamous?" (Kienholz recalls that he heard her say "famous.") They chatted and the next night he called for a date. She said she was going to play pool and he asked her to have the "best donut in town." They did both. Kienholz, much to her dismay, shot in all the balls before Reddin ever had a chance to use her cue.

They quickly became inseparable and were married in 1972. Reddin had not been involved with art or the art world before meeting Kienholz. Born in 1943, she had attended the University of Southern California for a short time. She worked as a court reporter, medical assistant, and emergency room attendant at various times. But as their relationship unfolded, she quickly became enmeshed with Kienholz's process of creation. In his statement in the catalog for The Kieholz Women, he characterizes her contribution in this fashion: "She has labored beside me these past nine years exchanging ideas, making decisions, painting figures, managing homes, designing catalogs, and all the while maintaining a complete photo chronology" (n. p.).

From the start of their Berlin–Hope era in 1973, she performed these activities. But it was in the mid- to late 1970s, as the Kienholzes created a number of the works that would eventually be shown in the exhibition "The Kienholz Women," that he came to believe that Reddin Kienholz should receive equal credit for the works then being constructed. In the creation of such tableaux as The Queen of the Maybe Day Parade (1978), which dramatizes a wife's suppressed desire's and ambitions, and The Rhinestone Beaver Peep Show Triptych (1980) (fig. 34), which confronts societal preoccupations with the women as object of voyeurism and sexual exploitation, Kienholz became convinced that not

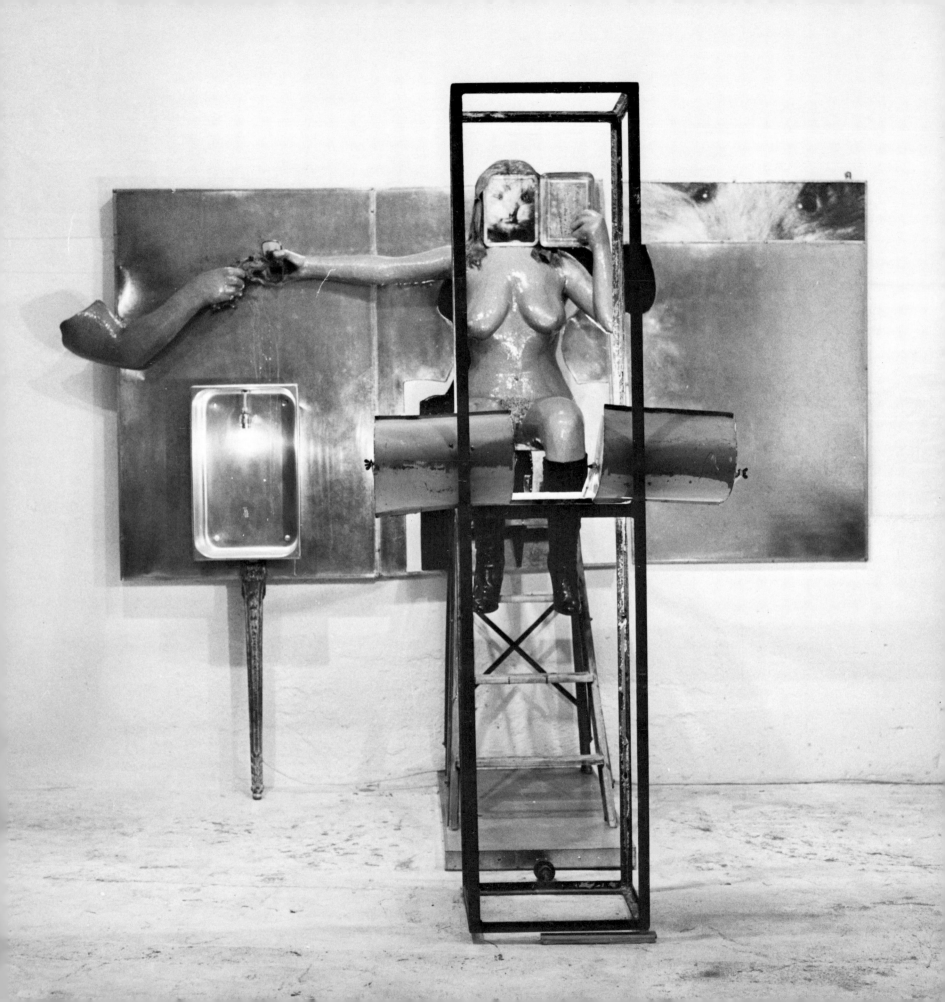

to grant her credit would, in itself, be a form of exploitation.

In Reddin Kienholz's words, his assertion of her equal role in the art is "a gesture to society. To me, that's precisely what this is: it is a gesture, a statement—that he doesn't want to use me."[1] But as the works produced since 1972 reveal, this gesture is not simply a symbolic one. As with many collaborations, it is hard to neatly define their separate contributions. Since Reddin Kienholz has been his collaborator, however, the most marked change has been the frequent use of photographs in the tableaux. The most prominent use of the same is for the face of a figure; the precursor, of course, is the found portrait that is employed as the youthful face of the old woman in The Wait. Thus this strategy has its roots in his earlier work, but beginning with Sollie 17 (1979–1980) (plate 11), they have employed it in many guises and her greater interest in photography has made this possible.[2]

Sollie 17 (1979–1980) became one among a group of works most often referred to as the Spokane cycle (1979–1983), since the materials for it were gathered from soon-to-be destroyed buildings in an aging district of that city. From the time they established a studio in Berlin in 1973 and throughout the 1970s, much of their energy had been devoted to tableaux made in Germany. But with the Spokane series, they both revived and expanded the probing vision of the American social arena which began with Roxy's and had been suspended after Five Car Stud. Collaboration has enriched his art, even as its essential vision has endured. The basic parameters of the assemblages and tableaux which Kienholz established in the 1960s persist, but within those parameters, working together, they have enacted subtle changes. Collectively, their work in the era of collaboration asserts that presentation can be enough; all imagery need not be overtly horrific even though it remains so in some recent works. The tragedy and sadness of the world can be communicated by the powerfully metaphorical three-dimensional scene.

34. (Opposite) Edward Kienholz and Nancy Reddin Kienholz, *The Rhinestone Beaver Peep Show Triptych* (1980). Collection of the artists.

FOUR

Filling the White Easel: Rejections of, Returns to, America

1 In the passage from *Five Car Stud* to the White Easel series (1978–1979) to the Spokane-inspired tableaux, we can trace the contours of a markedly new phase in Kienholz's career in America. *Five Car Stud* marks the culmination of one era and the onset of another for him. It was the last major tableau he constructed in Los Angeles. From the time he departed, in 1973, until he and Reddin Kienholz began constructing scenes from materials gathered in Spokane in 1979, the work turned away from the iconography of American life, past and present, which was such a fundamental feature of his tableaux of the 1960s.

This shift was partly circumstantial. By 1970, he had begun the process of moving his base of operations (home and studio) to Hope, Idaho. And in 1973, with a fellowship from the Deutscher Aca-demikischer Austauschdienst (DAAD), Kienholz and Reddin Kienholz set up a studio in Berlin and began combing its flea markets and streets for materials that were to inspire an ambitious series of works on German culture, *Volksempfangers* (1975–1977); the collective title of these constructions alludes to the extensive use of the radios produced for the populace by the Third Reich. It was entirely consistent with his aesthetic to be engaged with the castoff materials of the locale in which he worked and the *Volksemp-fangers* were the outgrowth of the artists' interaction with Berlin's detritus. In retrospect, the six years

between 1973 and 1978 would seem to have also been a period in which he reevaluated and revised his idea of how to present the discarded materials of American society; and in both this reevaluation and the return to American subject matter, Reddin Kienholz was to play a large role.

In the catalog essay for a 1981 tableaux retro-spective mounted at Trinity College in Dublin, curator David Scott offers one sort of explanation for the abandonment of American scenes. He writes: "The shift from the American context came at a time when Kienholz seemed largely to have exorcised the ghosts of his West Coast past" (15). Scott's statement is only a half-truth, however, for if Kienholz has never returned to subjects that allegorize his own adolescence as persistently as in the 1960s, when he created *Roxy's, The Back Seat Dodge '38,* and *The State Hospital,* the Spokane series, with its recreation of the rooms, hotel front desk, storefront, and apartment hallway of demolished buildings are nonetheless loosely auto-biographical works. They are homages to the "big city" of his youth. By engaging himself with these materials, he found a subject that engaged him as fully as his tableaux of the 1960s. Moreover, *Portrait of a Mother with Past Affixed Also* (1980–1981) marked an evoca-tive return to his past—an interpretation of his own mother's life. It is an archetypal "portrait" but one that also insists on her individuality.

Five Car Stud (fig. 35) was to be the only en-vironmental scale tableau completed in the years

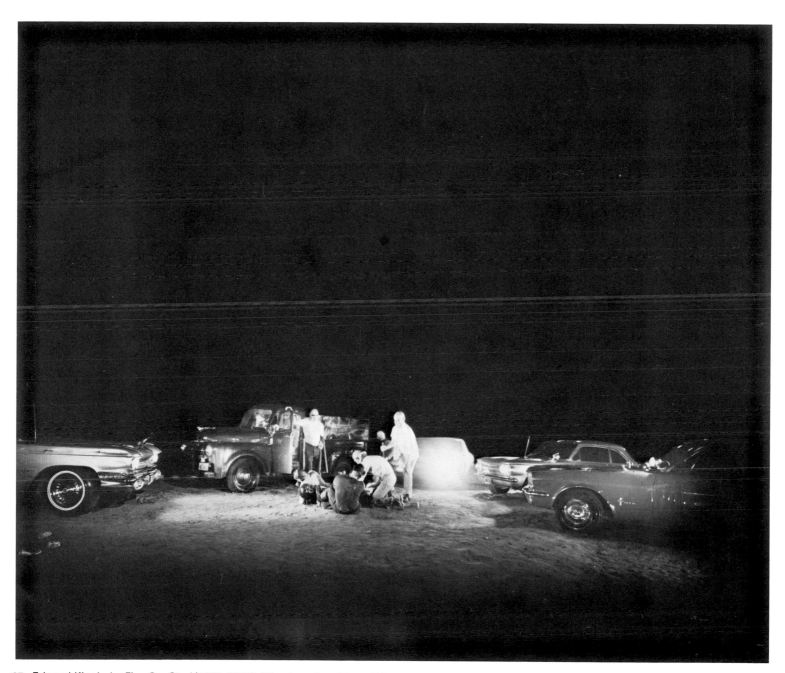

35. Edward Kienholz, *Five Car Stud* (1969–1972). Mixed media tableau. Private collection, Japan.

between his major European exhibition, *11 + 11 Tableaux,* and 1973, when he left Los Angeles. Actually, Kienholz had begun work on it before that survey ever opened—in the Fall of 1969. But it was not until January 1972 that he completed both the tableau and an edition of fifty sculptures based on *Five Car Stud.*[1] Its uncompromisingly cruel scene undoubtedly reflected a disillusionment with the current state of American society at the turn of the decade. The relations between whites and blacks was presented in an utterly stark fashion. "I think of that piece in terms of social castration," Kienholz declared, "like what a tragedy we didn't use the richness of America, which includes the black. . . ." (Weschler, 409).

In the tableau itself, social castration is literalized, as four white figures pin down a black man and are in the process of castrating him. One holds the victim's legs apart with rope; others hold his arms in place. Surrounding them are four parked cars and a pickup truck. Inside the truck is a young white woman, vomiting. From this configuration of cast figures and props, we can clearly piece together the intended narrative of the tableau. A group of men have come upon the black man and the woman in the pickup truck, removed him by force and are enacting their punishment upon him. Kienholz only increases the terrible nature of this scene by giving the faces of his figures grotesque visages. The aggressors' faces were fashioned from rubber masks; thus they resemble a monster from a "B" science fiction film; a ghoulishly pale vampire; an Emmett Kelly style clown; and an idiot. The victim possesses two faces rather than one—a head residing inside a plastic one. The inner

face is composed; the outer one seemingly screaming. The subhuman appearance of the black man's victimizers makes the scene look like a gruesome masquerade, while the props and scale create a simultaneous aura of actuality. The victim's body provides a curious more than a horrible image; it is a cast form that doubles as a container that a submersible (and concealed) pump fills with black water. Plastic letters float within this body that sporadically form the word "nigger."

This placing of grotesque figures in a prosaic setting had, of course, become one of the predominant characteristics of Kienholz's aesthetic. Yet the specificity of the action in this work contrasts with the presentations in previous tableaux. To Kienholz, *Five Car Stud* was "like a stage set for a play" (Personal interview, 1982). Indeed, it was akin to a fully realized scene from one as well. One figure puts his knife into the testicles made from steel as two others pin the victim's arms. A standing figure, with a cross around his neck, trains a gun on the victim, while a fifth blocks the entrance to the truck in which the victim's date resides. The last figure is that of a boy, the son of one of the aggressors, peering timidly out of a Corvair in the tableau. Yet as a dramatic scene, *Five Car Stud* is, like some earlier tableaux, rather gruesome stop-action theatre. Indeed, when it was given its first public showing, in the Documenta 5 exhibition in Kassel, Germany in 1972, the presentation itself was spectacularly theatrical; the entire scene was housed in a large tent, where the lighting could constantly evoke night and the big-top setting perversely connote a carnival.

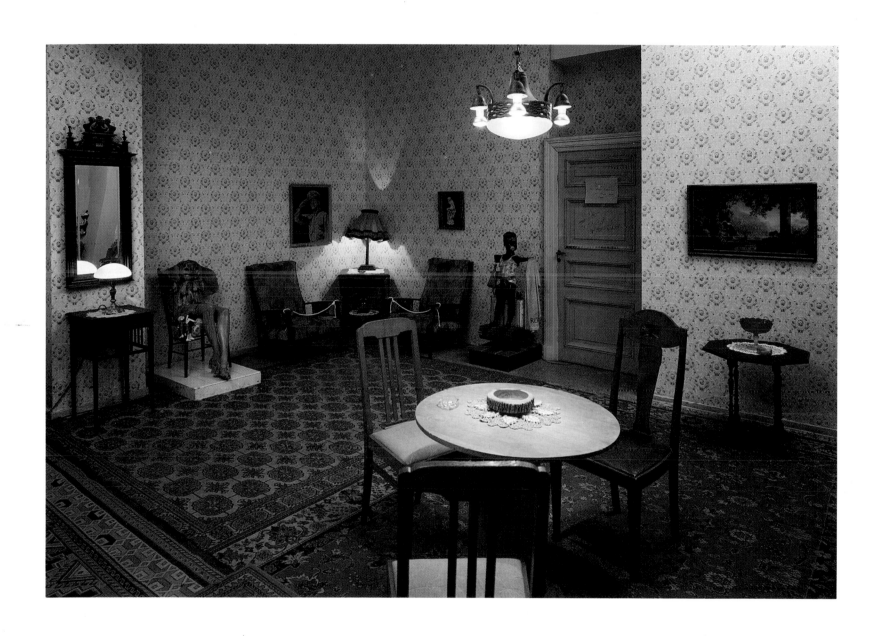

1. Edward Kienholz, Partial view of *Roxy's* (1961), with *Ben Brown* (at left) and *Diana Poole, Miss Universal* (at right). Mixed media environment. Collection of Rinehard Onnasch, Berlin. Photograph: J. Littkemann.

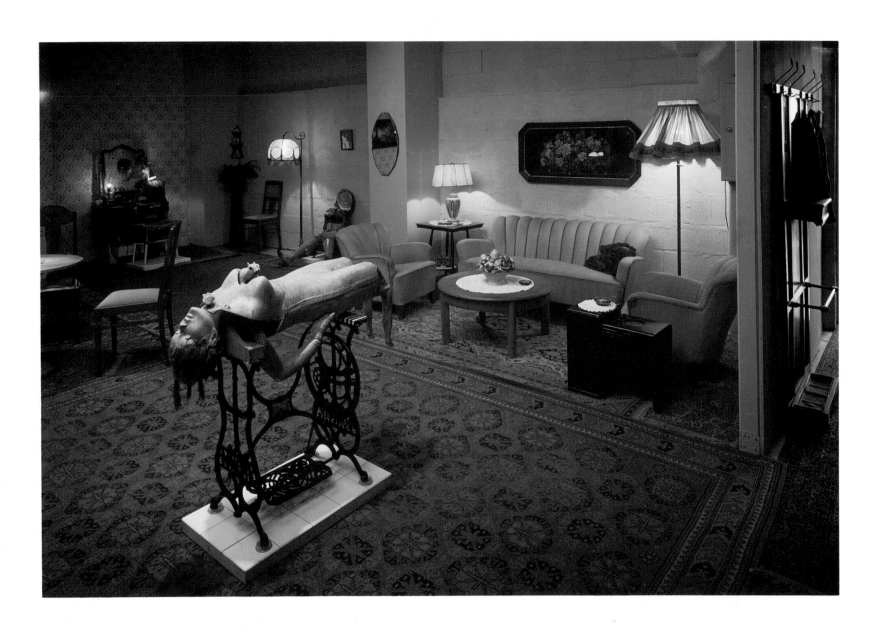

2. Edward Kienholz, Partial view of *Roxy's,* with *Five Dollar Billy* (at center in foreground), *Cockeyed Jenny* (at center in background), and *Miss Cherry Delight* (at left in background).
Photograph: J. Littkemann.

3. (Opposite) Edward Kienholz, *John Doe* (1959). Mixed media assemblage. Courtesy of the The Menil Collection, Houston.
Photograph: Susan Einstein.

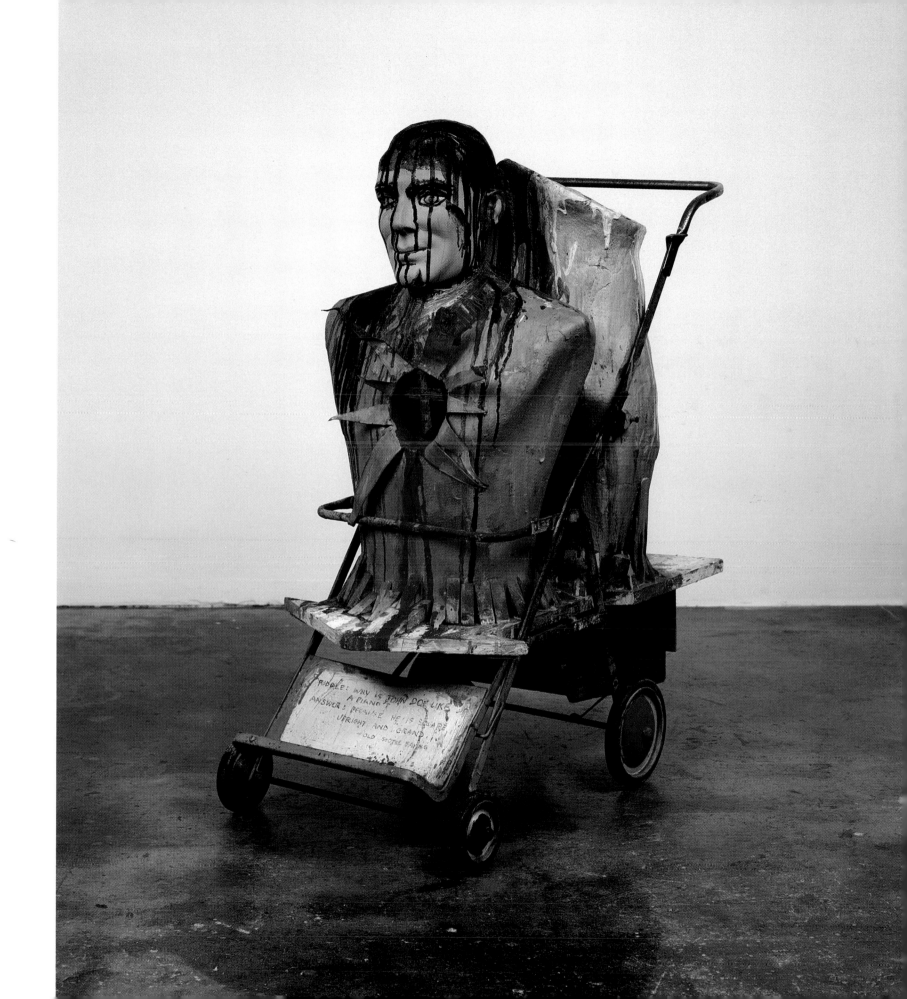

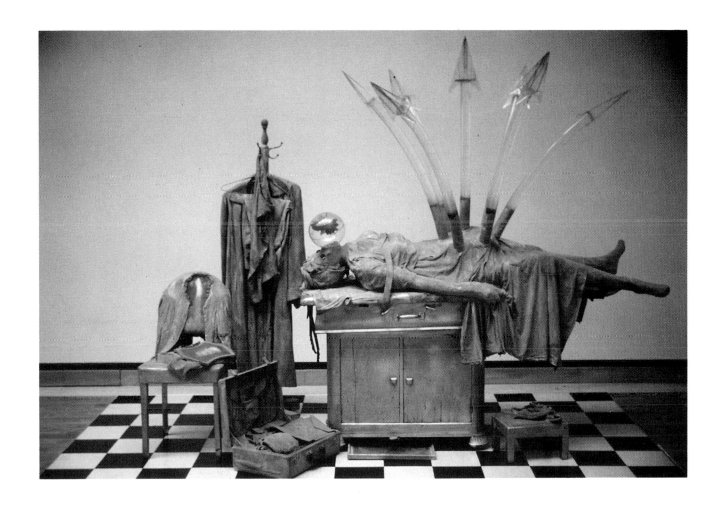

4. (Opposite) Edward Kienholz, *The Illegal Operation* (1962). Mixed media tableau. Collection of Monte and Betty Factor, Santa Monica.

5. Edward Kienholz, *The Birthday* (1964). Mixed media tableau. Collection of the Staatsgalerie Stuttgart.

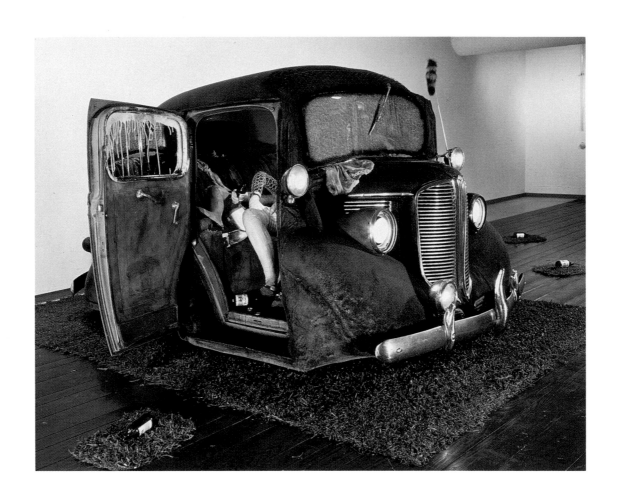

6. Edward Kienholz, *The Back Seat Dodge '38* (1964). Mixed media tableau. Collection of the Los Angeles County Museum of Art; purchased with funds provided by the Art Museum Council.

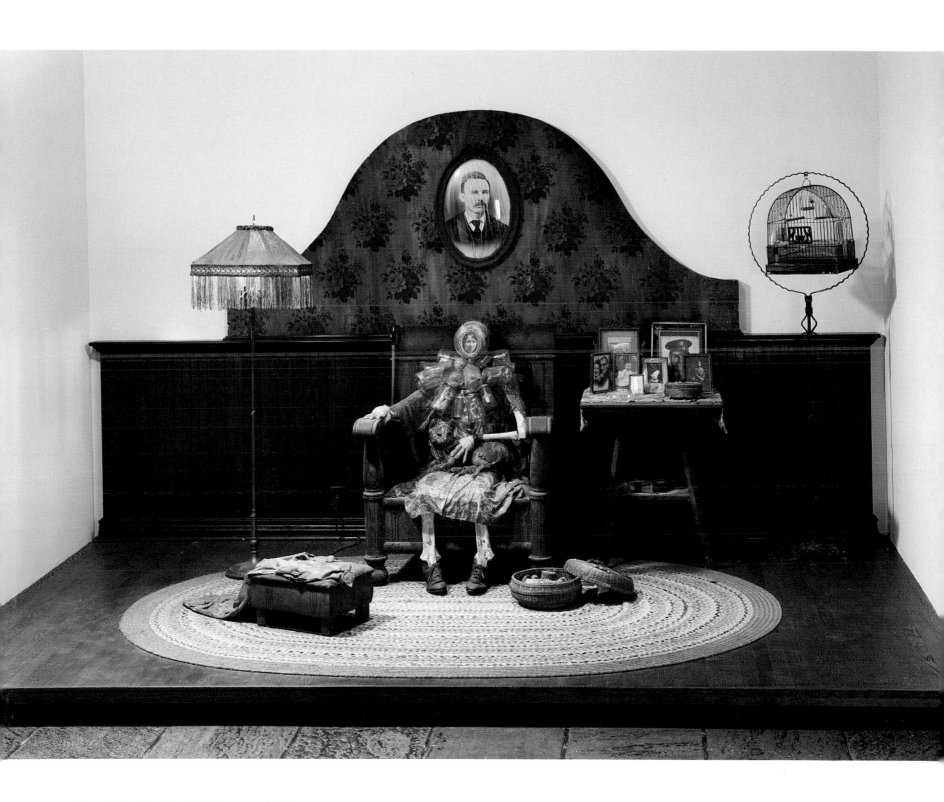

7. Edward Kienholz, *The Wait* (1964–1965). Mixed media tableau.
Collection of the Whitney Museum of American Art, New York; gift
of the Howard and Jean Lipman Foundation, Inc.

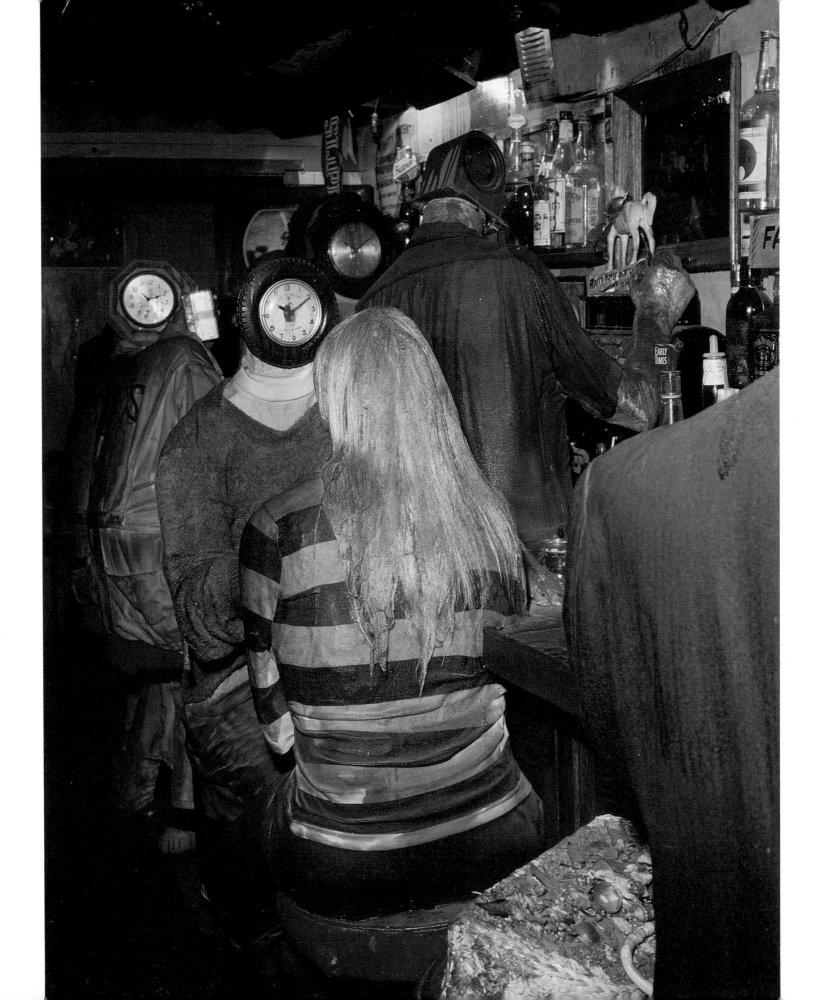

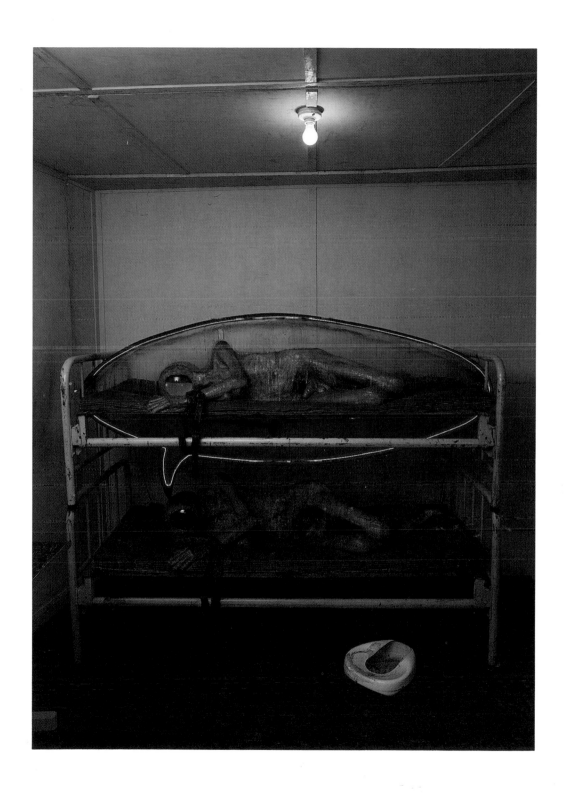

8. (Opposite) Edward Kienholz, Partial view of the interior of *The Beanery* (1965). Mixed media environment. Collection of the Stedelijk Museum, Amsterdam.

9. Edward Kienholz. Interior of *The State Hospital* (1966). Mixed media tableau. Collection of the Moderna Museet (National-museum), Stockholm. Photograph: Statens Konstmuseer.

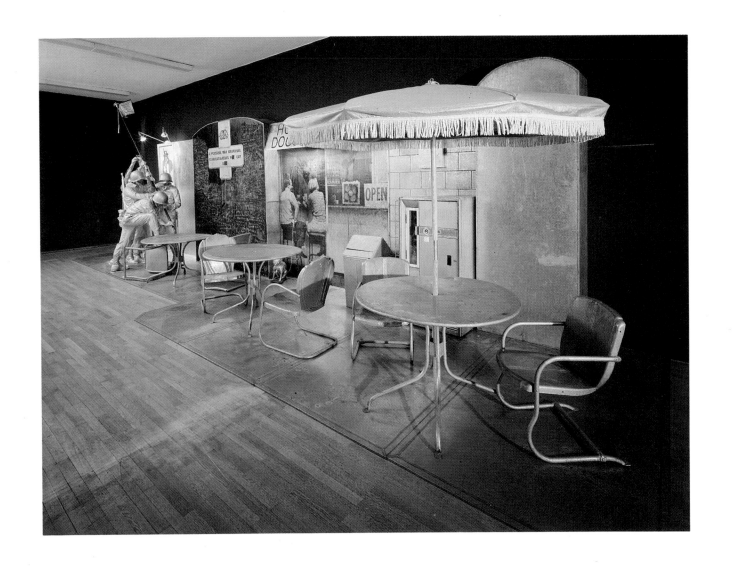

10. Edward Kienholz, *The Portable War Memorial* (1968). Mixed media tableau. Collection of the Museum Ludwig, Museen der Stadt Köln.

11. (Opposite) Edward Kienholz and Nancy Reddin Kienholz, *Sollie 17* (1979–1980). Mixed media tableau. Private collection, Los Angeles.

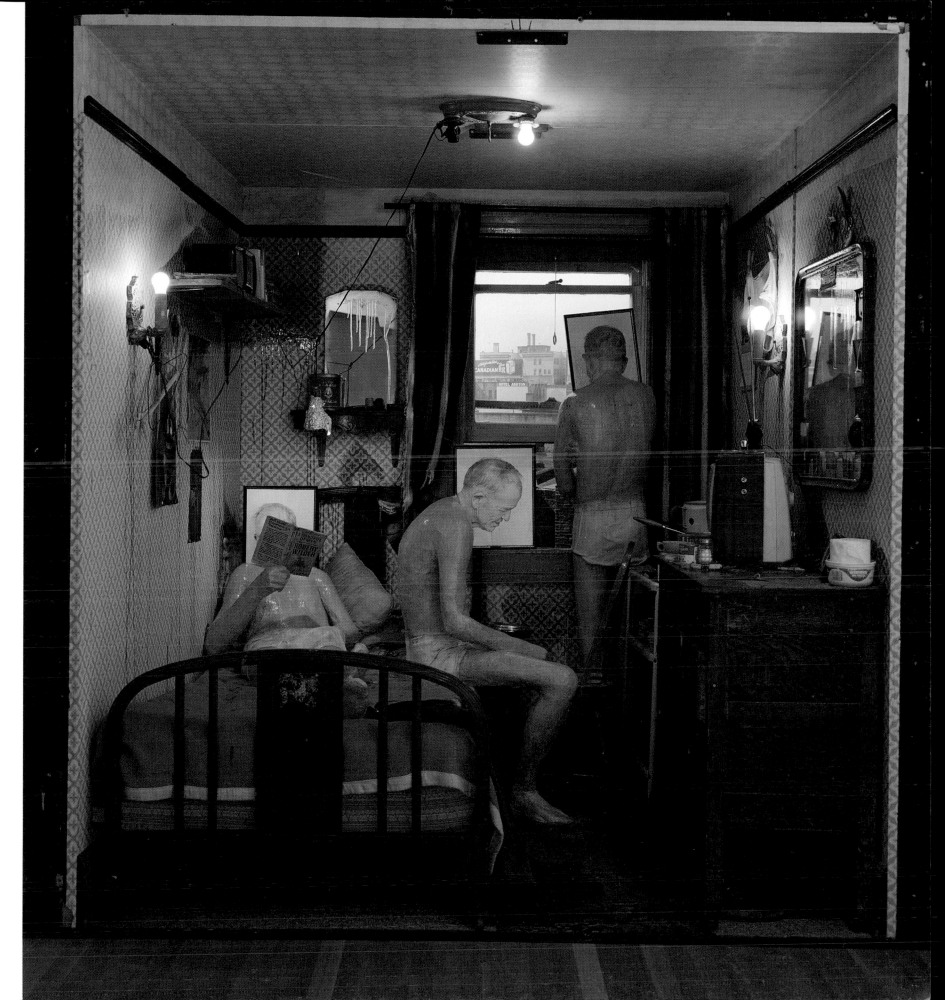

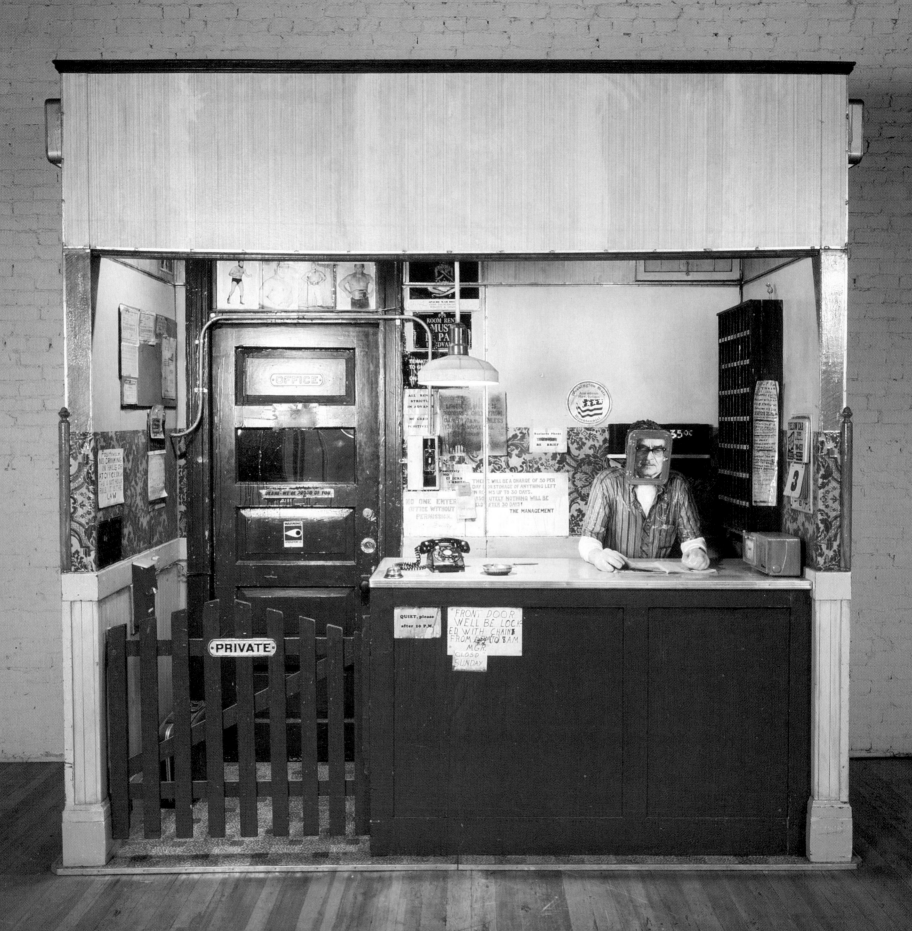

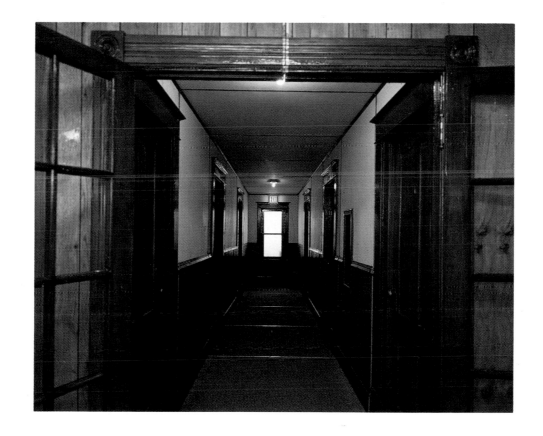

12. (Opposite) Edward Kienholz and Nancy Reddin Kienholz, *The Night Clerk at the Young Hotel* (1982–1983). Mixed media tableau. Collection of the San Francisco Museum of Modern Art; purchased through a gift of Mrs. Henry Potter Russell.

13. Edward Kienholz and Nancy Reddin Kienholz, Interior of *The Pedicord Apts.* (1982–1983). Mixed media environment. Collection of the Frederick R. Weisman Foundation, Los Angeles.

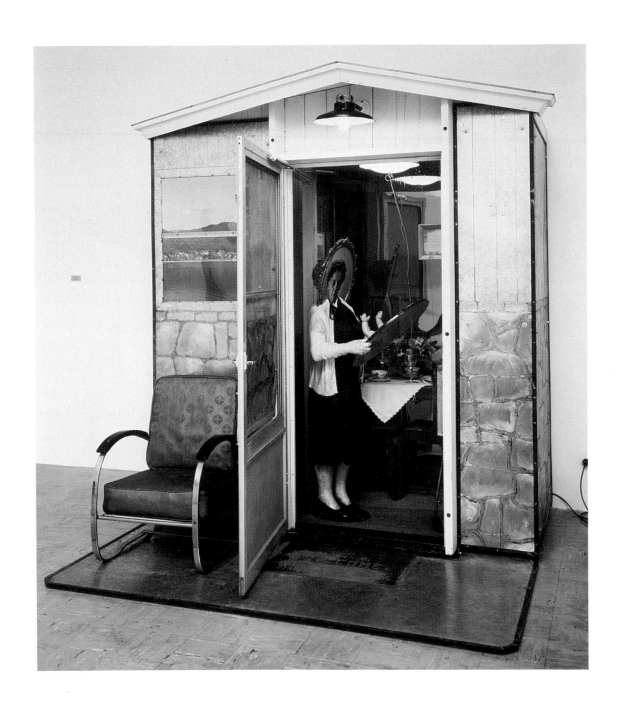

14. Edward Kienholz and Nancy Reddin Kienholz, *Portrait of a Mother With Past Affixed Also* (1980–1981). Mixed media tableau. Collection of the Walker Art Center, Minneapolis; Walker Special Purchase Fund, 1985.

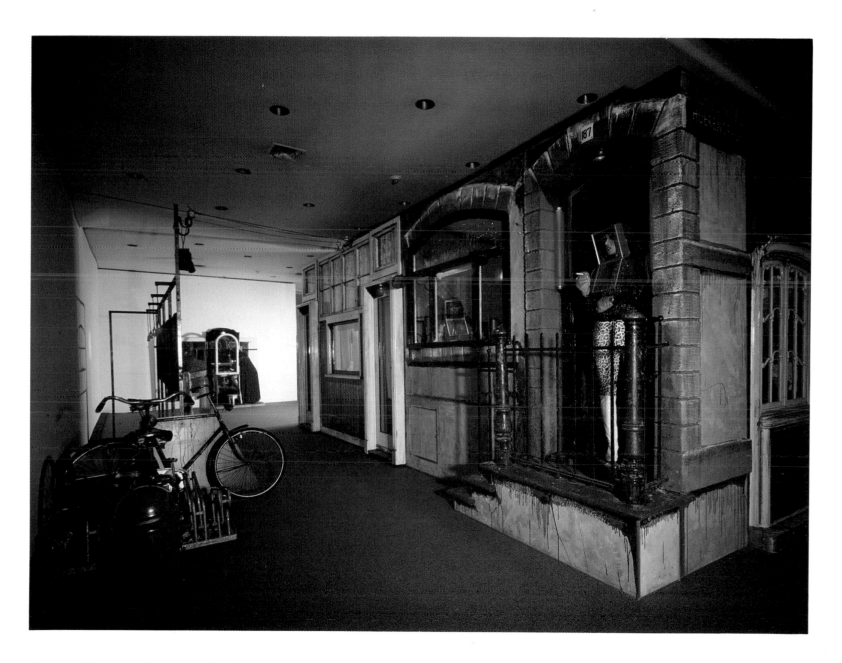

15. Edward Kienholz and Nancy Reddin Kienholz, Detail of *The Horengracht* (1984–1988). Mixed media tableau. Collection of the Daniel Templon Foundation, Paris. Photograph: Angelika Weidling.

16. (Next page) Edward Kienholz and Nancy Reddin Kienholz, *Holding the Dog* (1986). Mixed media tableau. Collection of Mandy and Cliff Einstein, Los Angeles.

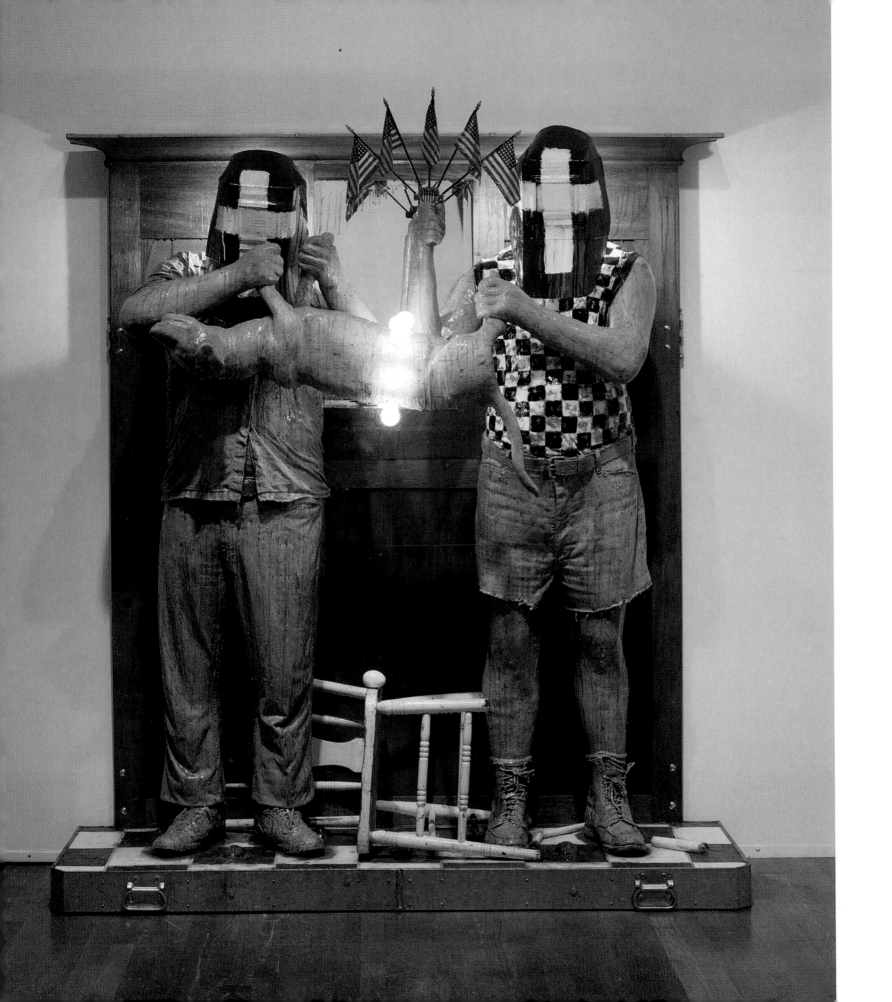

Five Car Stud was not based on any historical incident, but as with *Roxy's, The Back Seat Dodge '38,* and *The Beanery,* the chosen setting is explicitly American. Not only are the automobiles in this tableau of American origin, but there are little American flags on some of the cars. Morever, the model year of each car asserts that Kienholz wanted viewers to perceive this incident as contemporary, not historical. Its focus, then, links it with *The Eleventh Hour Final* and *The Portable War Memorial,* for it does not emanate from personal experience sifted through memory; instead, it originates with a social dilemma. The image, in *Five Car Stud,* does not have its origin in experience but a socially charged fantasy. Yet while the fantastical image of a tiny burned figure against a blank wall in *The Portable War Memorial* suggests that American society may destroy itself by warring with other societies, Kienholz's castration scene asserts that our culture may be destroying itself from within. Taken together, then, *The Portable War Memorial* and *Five Car Stud* offer a very bleak prophecy indeed for the future of America. "My scene is invented—the germane complexities within today's society are not," Kienholz asserts in his short essay at the outset of a privately published book documenting the production of *Five Car Stud.* Yet his fictional scene very strongly suggests that these complexities may have created an unsolvable dilemma; that blacks and other nonwhites may be constantly thwarted in their efforts to be equal partners in the creation of an American society. The license plates on the automobiles in this tableau read "State of Brotherhood," as if to remind us what has not been achieved. *Five Car Stud* is about failure, for there

is no element within the scene which suggests a transcendence of the social tragedy it represents. Perhaps there is, adapting a phrase of Gablik's to this context, an incurable disgrace in this instance.

The *Sawdy* (fig. 36) edition only affirmed our collective participation in this process of social castration. Named for Clarence Fred Sawdy, whose effects were found in the pickup truck used in the tableau, the edition consisted of fifty identical works. For each, Kienholz used the door of a Datsun pickup truck; it functioned as a large framing device for a representation of the scene of *Five Car Stud,* reproduced on a plate of glass. To view the image, however, one had to roll down an outer plate of mirrored glass engraved with its serial number within the edition. Thus, one's own reflection was the first of two images integral to the Sawdy wall sculpture; the viewer's face was the third image as well, since one presumably rolled the window back up. The viewer's role as detached voyeur was clearly undermined; he or she was an accomplice to this cruel action within the depicted scene.

The "masquerade" within *Five Car Stud* dramatized Kienholz's thwarted hopes for America; he perceived the state of American society to be tragic. In other words, this tableau concerns itself with betrayed ideals and gives us a scene depicting such betrayal. The struggle between good and evil, victims and their victimizers, which had consistently animated his tableaux of the 1960s, had become a victory for the victimizers in *Five Car Stud* and Kienholz's pageant of American life and death, at least one version of it, reached its climax in this tableau.

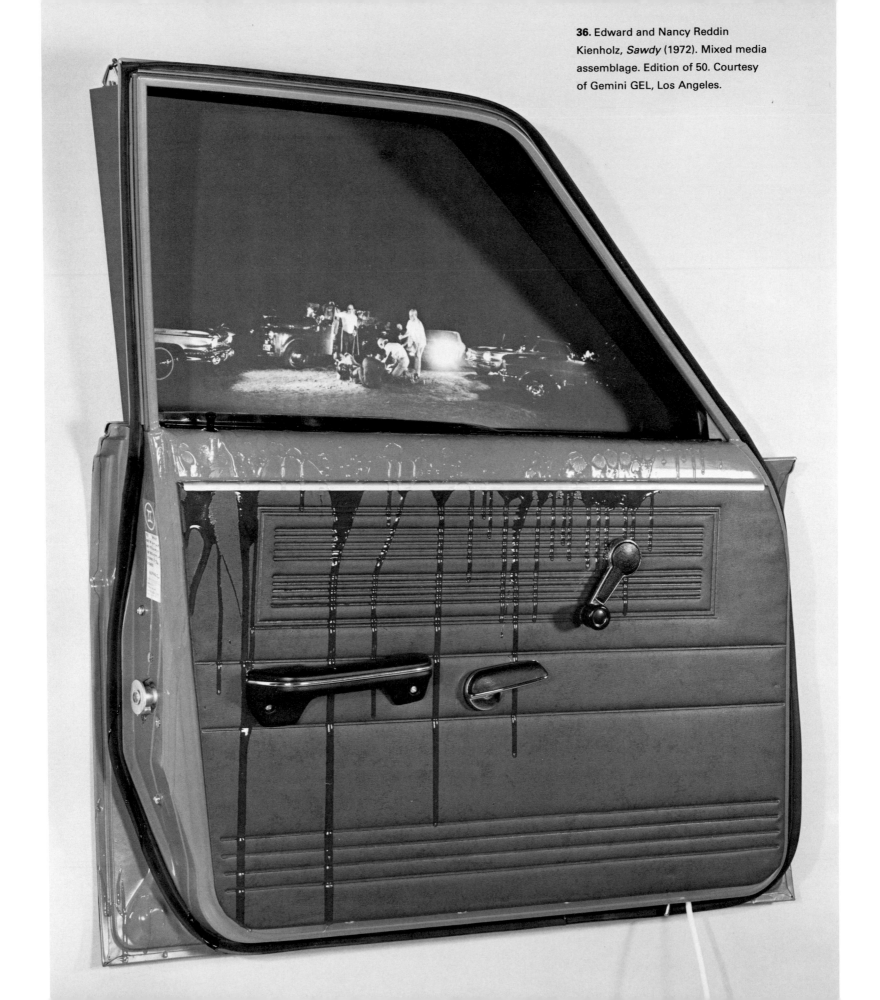

36. Edward and Nancy Reddin Kienholz, *Sawdy* (1972). Mixed media assemblage. Edition of 50. Courtesy of Gemini GEL, Los Angeles.

Five Car Stud never received a public showing in Los Angeles—or for that matter, anywhere else in the United States. For documentary purposes, it was installed in the parking lot of Gemini G.E.L. (the prints and edition studio that had commissioned the work) and photographed in 1971. And after it was exhibited at Documenta 5, *Five Car Stud* was purchased by a Japanese collector in 1973 or 1974.[2] Perhaps that is a poetically apt fate for this work, since like Kienholz himself, it left Los Angeles.

Yet as we can see in retrospect, it was only the Los Angeles version of his stop-action drama of American scenes which concluded with *Five Car Stud.* As I have suggested, Kienholz's "pageant" of American culture, during the 1960s and early 1970s, was governed by a bipolar vision that provoked the fury, both moral and emotional, that inspired his assemblages and tableaux: from *John Doe* to *Five Car Stud.* If the latter work gives us the vivid depiction of a failed dream of a democratic culture, the license plates on the tableau's automobiles, emblazoned with "State of Brotherhood," remind us of the sentiments that informed this work and so many others. Kienholz's anger emanated from betrayal—the betrayal of those same democratic ideals which animated eighteenth- and nineteenth-century American sensibilities. Not able, like a Barlow or a Whitman, to find solace in the articulation of a blessed American future, or able, like a Mount or a Bingham, to render genre scenes that envisioned a society governed by such ideals, Kienholz has given us scenes that reveal how far he believes we had strayed from them. His work expresses a "deep nostalgia," as Tillim has asserted, though not so much "for an existence uncomplicated by anxiety and ambition" as for a society of fulfilled selves, who possess the ability to conduct their lives in a democratic fashion (38).

Kienholz's achievement, in his work of this era, was to take assemblage and give it a shape that articulated this large social vision. As this vision took shape, so too did his formal approach evolve to provide this intense vision with a corresponding mode of presentation. Because of the powerful nature of his subject matter, the formal aspect of his achievement has been largely overlooked. He is, in fact, the one major American assemblagist of the 1950s and 1960s who did not change mediums, but expanded his approach to the use of found objects and environments instead. By the mid-1960s, Rauschenberg had shifted his emphasis from the combines to large pictures that employed photographic and printing techniques and Bruce Conner had forsaken assemblage and began making "assemblage" films from existing footage. Only George Herms, among the original Southern California assemblagists, remained committed to the genre, refining his two essential approaches to the genre: wall-mounted objects and box format works. But his oeuvre was never to undergo the dramatic sort of development that Kienholz's did.[3] In the passage from the Doe trilogy to *Five Car Stud,* Kienholz had demonstrated the variety of approaches one could take to the theatrically oriented sculptural environment or scene. The museum gallery could become a backdrop to an interior, as in *The Wait,* or a scene within the landscape, as in *The Back Seat Dodge '38,* whereas *The Beanery* and *The State Hospital* illustrate the alternative of a self-contained environment, whose

relationship to its exhibiting space was marginal. The use of cast figures, which began—as I noted in the second chapter—with *The Birthday,* proved instrumental to his theatrical approach to the tableau. For it removed the necessity of creating assemblage figures. Now sculptures could inhabit his prosaic settings, heightening the realism of the tableau enough to make the viewer's identification with the depicted subject unsettlingly intimate.

The *White Easel* series departed, in a decisive way, from this approach; for it consists of works that are cool and analytical. They are highly self-reflexive constructions, which contain a facsimile of the wood beam easel in the Kienholzes' Idaho studio. This object is, in turn, accompanied by materials—sheets of galvanized metal, a machine pistol, a wooden hand, a mannequin—which stimulate the raw materials of the more detailed and socially critical tableaux. Such arrangements simulate the notion that we have been transported into the studio and have come upon a work in progress. Yet this suggestion of incompletion remains just that—a suggestion—since these are completed works.

What is missing, of course, is the kind of social commentary one had come to expect from Kienholz. The overt emphasis in these tableaux is on the formal qualities of the materials themselves: a portion of an illuminated cinderblock wall half hidden by the foregrounded metal panel in *White Easel with Face* (1977) (fig. 37); or the glow of an upright steel panel under a bulb in *White Easel with Machine Pistol* (1979) (fig. 38). As critic Ron Glowen aptly remarked of *White Easel With Face* in a review of a 1979 exhibition, "They

[the found objects] and the pseudo-wall become a unified entity, like trompe l'oeil sculpture" (7).

Since the illusion of a real place is intrinsic to all of the tableaux, these works offer continuity as well as a rupture of the established socially critical vision of his earlier tableaux. What is decidedly different, however, is the very nature of the place the Kienholzes depict. In the *White Easel* series, that locale is the arena where they have created the tableaux; whereas, in his other tableaux, the depicted scene is that of a shared social arena.

If the narrative dimension of these works is more covert than in his earlier sculptural scenes and rooms, it is nevertheless present. For if we consider these works in the context of Kienholz's and the Kienholzes' oeuvre, they would appear to be not only about the beauty of common industrial forms and vernacular architecture but also about the very *absence* of social commentary. There are resonances of themes we would find in other tableaux: the gun quite obviously suggests violence, as does the isolated wooden hand; the face seen through a convex glass is a morbid sight. But here these themes are thwarted, since the works in this series are not concerned with creating narrative scenes that address socially or psychologically charged issues. The Kienholzes' focus, here, is on illuminating a vocabulary of forms, both for themselves and for the viewer—by manipulating the raw materials of the tableaux, as if set within the studio itself. These works, then, comprise a story of origins concerning the tableaux; they are ultimately tableaux about the composing process of their work: meta-tableaux, as it were.

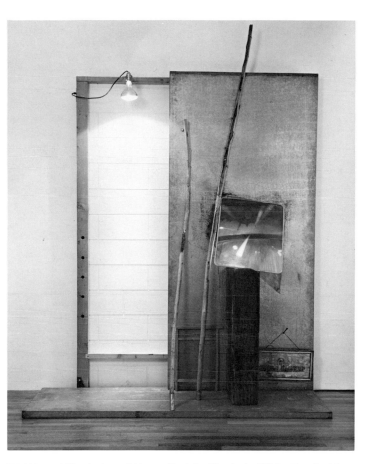

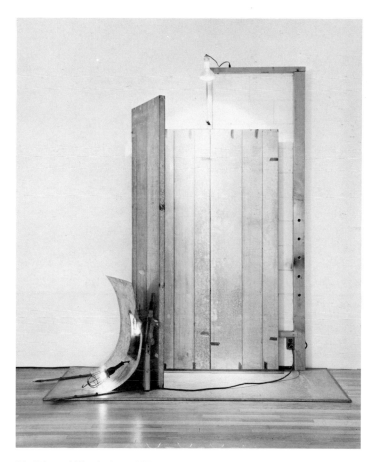

37. Edward Kienholz and Nancy Reddin Kienholz, *White Easel with Face* (1977). Mixed media tableau. Collection of the artists. Photograph: Thomas P. Vinetz.

38. Edward Kienholz and Nancy Reddin Kienholz, *White Easel with Machine Pistol* (1979). Mixed media tableau. Collection of the artists. Photograph: Thomas P. Vinetz.

The ability to work in this analytical fashion signaled a shift in their oeuvre as a whole. Anger was no longer imperative to each and every assemblage or tableau. Thus when they once again confronted the American societal arena, the fury that arose from conflicting ideals and actualities was less evident in the work itself; it had given way to a more presentational mode in the Spokane series and the tableau, as conceived by Kienholz and Reddin Kienholz, proved adaptable to such change. The image of the isolated individual, so grotesque in *The Wait* and *The Beanery*, had become less repulsive and more straightforwardly human. In place of the skulls or clocks for heads, there are framed photographs. Correspondingly, the moment within each tableau is more ordinary—arrested from the flow of life, rather than horrific or overtly theatrical. In *Sollie 17,* the centerpiece of the Spokane series, a casting of an older man—actually three figures of the same man—exist within an aged hotel room; *The Jesus Corner* (1982) contains a storefront window filled with objects that comprise a tableaux-like homage to Christianity, created by a one time janitor; *Night Clerk at the Young Hotel* (1982–1983) recreates a front desk, complete with signs and posters, adding only a cast figure; *The Pedicord Apts* (1982–1983) offers no figures at all—only a lobby, hallway, and sound which the viewer activates when he gets close enough to each of six closed doors. It would seem that Kienholz and Reddin Kienholz had simply preserved and transplanted chunks of a razed corner of the city, since much of the material in these four tableaux originated with one block that housed the Pedicord Hotel, the Young Hotel, and a few other buildings destroyed to make way for urban renewal in 1982.[4] Yet if the tone of these tableaux differs from those of the 1960s and early 1970s, the cast of characters does not. Once again, we are confronted with society's most marginal types—this time, within settings more "archaeological" as it were, than allegorical.

2 In their encounters with this group of buildings in Spokane, Kienholz and Reddin Kienholz had, in actuality, happened upon settings that offered a different means for presenting themes established by earlier tableaux. *Sollie 17* provided a companion piece to *The Wait;* but in this case it was an old man waiting for death rather than a woman. *Pedicord Apts* made the recurring voyeuristic motif in his art its central subject, for one could only listen at each door by moving very close to it. Yet this urban setting provoked a different sort of response, too: a desire to present us with nearly literal fragments of the urban environment. *Night Clerk at the Young Hotel* and *The Jesus Corner* declare that the represented prosaic scenes are rich with meaning; selection, reconstruction, subtle revision, and additions of the found environment are enough to create powerful tableaux.

The emphasis, in the Spokane series, is on poignant rather than horrific imagery. The collective tone of these tableaux resonates with pathos more than anger; moreover, they are surely the most openly sentimental work since that early Concept Tableau, *The World*. If the attention to detail and human-scale

environment is consistent with his earlier American tableaux, the figures are not. Rather than making them grotesque or repulsive, Kienholz and Reddin Kienholz rendered Sollie and the night clerk prosaically human— and they accomplished this shift by using framed photographs as heads. To repeat, Kienholz had employed this device once before for the figure in *The Wait*. But in that tableau, the vintage photograph of a pretty young woman was employed as a facade of youth, concealing the specter of death until the spectator looked at her profile and discovered that the picture hid a jar containing a deer's skull. Here, the photographic face is clearly the only face of Sollie; yet we gaze upon his face as if it existed in an album or propped upon a table. Thus, the look of the figures, in *Sollie 17* and *Night Clerk at the Young Hotel* are wholly appropriate to their settings: preserved, but wholly removed from the plane of the living. The figures as a whole, then, function much like photographic portraits themselves, which, as Roland Barthes once wrote, give us what he aptly termed "the return of the dead" (9). The subject, in Barthes view, is the target, who, once shot, is preserved in the picture for anyone to study, as his or her likeness is entombed in that picture.

Sollie 17 (see plate 11) reinforces this notion of the morbid quality of the photographic head, by making "Sollie" seem as if he is entombed in his one-room residence. The place he inhabits is a room sealed behind a wall of plexiglass. The door to his room is only slightly ajar and as the viewer peeks in, he also discovers that this wall keeps him from entering. This is, of course, an acutely voyeuristic way to view the interior of the tableau. Thus, even as the tableaux had

become more realist in the Spokane series, our viewing of them in turn becomes more self-conscious.

Like others among Kienholz's most powerful tableaux, *Sollie 17* had gestated in his memory for some time. In this case, it was fifteen years before he found the appropriate vehicle for a particular re-membrance; and it was his own voyeuristic experience of a down-and-out hotel dweller which endured and eventually triggered this work. As he was to recall in a brief essay published in the catalog for *Edward and Nancy Reddin Kienholz: Human Scale,* an exhibition mounted by the San Francisco Museum of Modern Art:

> In truth it started in the Green Hotel in Pasadena, California. The year was 1965. I was walking down the second floor corridor when I passed an open door. Inside was an old man sitting on the edge of his bed playing solitaire on a wooden chair that was facing him. The room was furnished in average, seedy hotel style, and the light was slanting in through the only window in a soft and pleasant way. The thing that struck me as I walked past was the conflicting signals I read from the scene. The strongest came from the man, "What the hell are you looking in here for? This is *my* place [Kienholz's italics] and you just keep your goddamn nose out of it." The lesser feeling was, "Oh, God, I'm so lonely, why don't you stop and talk a little bit?" (15)

The Kienholzes had actually begun constructing the tableau in their Hope studio before "excavating" materials from the Pedicord Hotel. "We constructed the room," Kienholz explained in the same catalog essay, "in three tapering sections which fit together and give

the illusion of perspective." But it was not until they journeyed to Spokane to amass materials for this environment that it acquired its convincing identity. The baseboards, electrical fixtures, furnishings, and bric-a-brac all originated with a single room at the hotel.

As realized, the tableau contains a loose narrative, since there are three versions of Sollie within the reconstructed version of this room. In each pose, he is wearing the same loose-fitting underwear. In one version, he is lying on the bed, his face toward the viewer's, reading a book whose title, *A Handful of Men,* obviously comments on his place in the larger social arena; as he reads, he is also playing with his genitals. In the second, he is sitting, shoulders slumped, staring straight ahead trance-like, his face a profile view portrait. In the third, he is staring out the only window in his room, his back to the viewer. Each of the black and white photographs that serve as heads are mounted so as to read in a formally continuous manner with the corresponding figure. (Sollie is actually a composite creation: the body castings were taken from one person, the photographs from another.) Superimposed upon the window is a shot of the nondescript portion of the Spokane skyline Reddin Kienholz took from the top floor of the Pedicord Hotel.

The presence of the three Sollies does not suggest a particular time frame; his movements could encompass a few minutes or perhaps an entire day. Yet the number of figures offers a palpable sense of his isolation and confinement within these cramped quarters. Indeed, the title itself, which echoes the phrase Stalag 17, points to both of these aspects of his

existence. Visually, the hallway outside his room introduces this theme, for it is stark, foreboding, and dimly lit (fig. 39). One approaches it from afar rather than as a corridor, however, since there is only a single wall and an extending floor, which function more like the front of a building than a hallway. On the left side is a closed door; on the right, light emanating from Sollie's partly open one. Between them, rests a single chair. Just to the right of Sollie's door is a pay telephone. The wall itself is fairly nondescript: wood paneling covers the lower portion; the upper part is painted white, now faded to a tawdry yellow. Graffiti, scattered profusely on the portion of the wall surrounding the telephone, gives the hall another patina of age and use; indeed, viewers have added to the existing phrases and words at the tableau's many showings.

In *Sollie 17,* Kienholz and Reddin Kienholz subtly but insistently assert that the poverty of the skid row hotel dweller imposes a form of incarceration upon him. The tableau does not try to suggest whether or not we, as a society, are responsible for his predicament; it merely provokes us to identify with him in some manner, to see him as some unacknowledged "other." As Lawrence Weschler perceptively observed in a short essay on the Spokane series, "Just as you're beginning to feel superior, you notice, almost unconsciously, how because of the way the door is blocked and angled, you are looking at him while standing in exactly his hunched posture. Kienholz has managed the trick of transmuting his own empathy to you" (*Human Scale,* 12). The receptive viewer does not merely see Sollie's existence, but physically

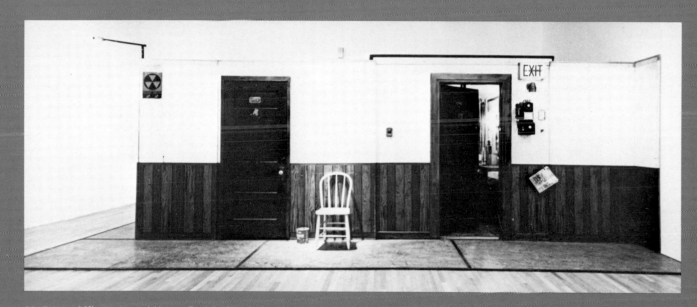

39. Edward Kienholz and Nancy Reddin Kienholz, Exterior of *Sollie 17*.

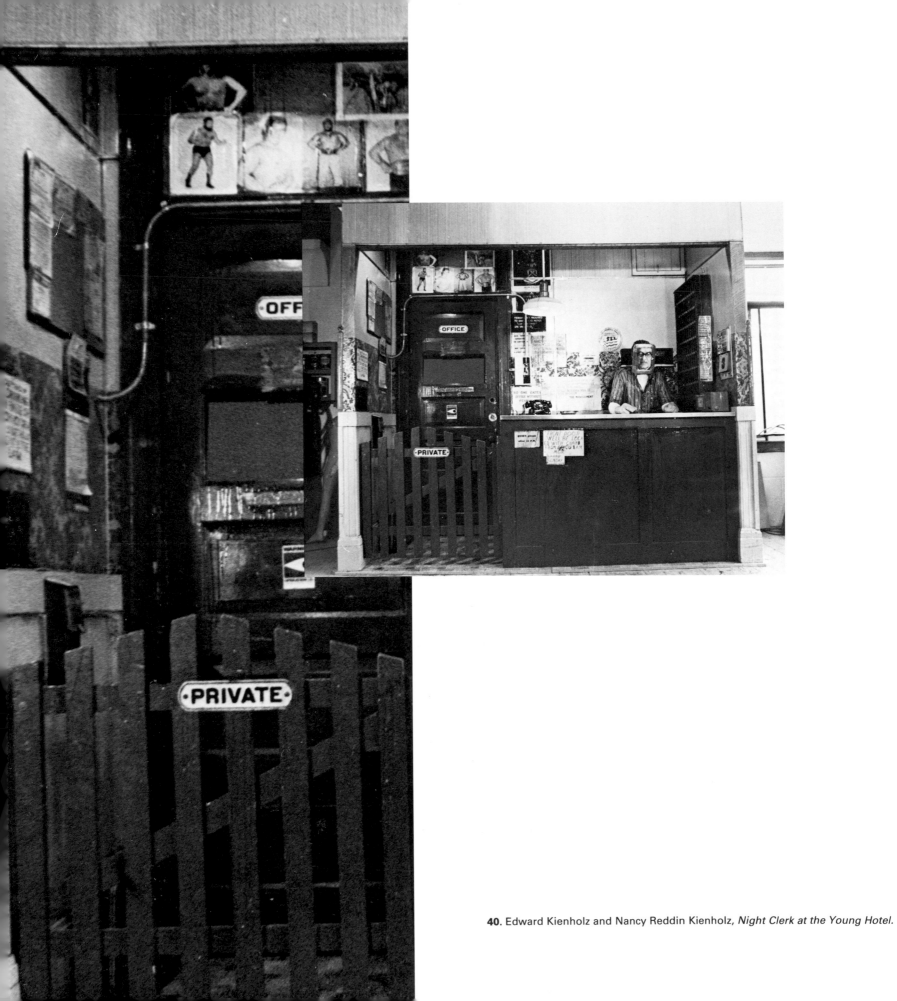

40. Edward Kienholz and Nancy Reddin Kienholz, *Night Clerk at the Young Hotel.*

experiences it in some fashion too. An arena of our culture which usually remains hidden is revealed to us, but not without the discomfort attached to voyeurism.

The Night Clerk at the Young Hotel (plate 12) is a haunting companion piece to *Sollie 17.* For if they are wholly separate tableaux, taken together, they nevertheless encourage viewers to imagine the unsettling scenario that we, too, are passing by the front desk before returning to our rooms down the hall from Sollie's. The scene depicted in this tableau is of decades past, as if, like *Sollie 17,* it has materialized from the world of the dead. On the walls surrounding the clerk hang aging photographs of men—wrestlers and boxers—striking heroic poses. There is an old Yellow Cab calendar on the wall; a clock/radio dating from the late 1940s or 1950s; and a profusion of ungrammatical signs stating the house rules. The radio is playing contemporary music, as in *The Back Seat Dodge '38,* creating the same eerie disjunction that exists in that earlier tableau, between the time of the depicted scene and that of the songs. But if this seems like a wry element in the earlier tableau, the sounds of the radio meshing with the representation of adolescent romance, in *Night Clerk at the Young Hotel* the music only intensifies the morbid aura of this scene. (It becomes evident that the name of the hotel in the title contrasts starkly with the mood of the tableau.)

The clerk himself is standing, his arms on the desk, reading a magazine; appropriate to the mood of the tableau, he is reading an article entitled "The Killer Who Made Love to a Corpse." For this seems to be a place of concealed horrors and hidden violence.

Kienholz has managed to evoke this aura without using grotesque forms or imagery; the clues are enough. We find them in the magazine story and in signs such as "Front Door Well Be Locked with Chain from 2 p.m. to 8 a.m. Mgr." The image of the clerk's face, too, resembles the door to some hidden chamber. Surrounded by a thick metal border, the photograph is attached to a three-dimensional head. The frame itself is actually a frame within a frame, with an attached handle that appears as if one could open the panel with a face to reveal something unknown within (fig. 40).

Pedicord Apts (plate 13), though it reveals affinities with both *Sollie 17* and *Night Clerk at the Young Hotel,* is more strongly linked to the former. For it manipulates one's physical position to intensify the notion of the viewer as voyeur. Voyeurism becomes the environment's central subject too, because only the viewer's curiosity can activate the sounds behind the doors in a reconstructed hallway.

One reads the title of the piece on a sign—in red letters on a white background—which sits just above the doorway. Inside, there is a lobby, true to everyday architectural scale, which leads into a hallway with a sealed up fireplace and a mirror with prominent resin drips (fig. 41). The hallway is an exercise in subtly distorted dimensions. It possesses three doors on each side and it, too, possesses realistic scale in the portion closest to the lobby. But this door-lined corridor gradually tapers as the viewer moves toward the far exit sign and window. As Kienholz has written, "The final effect is like being in a funhouse" (*Human Scale,* 16). Yet this is not a pleasurable or amusing sort of place, but a disturbing one, since the Kienholzes have

41. Edward Kienholz and Nancy Reddin Kienholz, Lobby of *The Pedicord Apts.*

managed to transform the viewer into the same sort of isolated figure as Sollie. During one's time in the environment, the viewer is stuck in the most non-descript sort of setting, with fake wood panel walls and tacky green carpet. All the doors are locked, but as one turns the knob he has stepped close enough to activate a small gadget that triggers human sounds. Thus, behind one door, the visitor would hear a marital spat; behind another, a blaring television set; behind still another, a sobbing woman. And in still another, one approaches a door and hears a dog lunging toward the door, reminding us of our suspect status as we skulk from apartment door to apartment door. There are no rooms behind these doors; that becomes clear enough when one scrutinizes the outside of *Pedicord Apts,* which resembles a giant unhinged shipping crate. But the use of sound creates strong enough illusions; people really seem to be on the other side of those doors, even though one exists apart from them in the disorienting hallway. (The body seems as if it is enlarging in the course of traversing this corridor.) This isolation is also central to the Kienholzes' purpose here, since it projects the role of the isolated pro-tagonist, customarily reserved for the figure, onto the viewer. This hallway is our cell or Stalag, as it were.

During the 1960s, Kienholz's Doe trilogy and tableaux had created an implicitly episodic chronicle of marginal types within American society. In the Spokane series, that episodic structure is in evidence too, but the explicit subject is narrowed to one small downtrodden section of society. The narrative relationship between *Sollie 17* and *Night Clerk at the Young Hotel,* as I have suggested, is evident. The

hallway of *Pedicord Apts,* though it has a slightly different look than Sollie's hallway, clearly houses people of the same strata in society as the declining hotel where he exists.

The Jesus Corner (fig. 42) takes us onto the street, outside these oppressive interiors, to a storefront whose window has become a makeshift shrine to Jesus. This tableau is not a devotional work; Kienholz is, as I have already noted, a self-proclaimed and quite strident atheist. Rather, it preserves and pays homage to the man who amassed and arranged this window full of old postcards, photographs, books, jars, and assorted bric-a-brac. As Kienholz recounts in his catalog essay for *Human Scale,* he and Reddin Kienholz had spent a good deal of time trying to locate the man who had lavished such attention on this window, after becoming fascinated with his efforts. Though they were never successful, they did learn his name (Roland Thurman) and a bit of his history: he was a former boxer, whose years in the ring had made him deaf, and he had worked for many years as a janitor at a nearby department store. Apparently, he had abandoned his rented storefront residence some time ago, for when notices went out that the building was to be salvaged, Thurman never laid claim to the product of his labors.[5]

Instead, Kienholz and Reddin Kienholz claimed it as art and it is a generously democratic sort of gesture. For it pays homage to the efforts of a wholly vernacular assemblagist by presenting them in their found condition, with the window and doorway of the former building intact. There is no evidence of condescension here; only a tribute of two artists to a very humble one.

42. Edward Kienholz and Nancy Reddin Kienholz, *The Jesus Corner* (1982). Collection of the artists. Photograph: Chris Sweat.

Though the devotional subject matter is of little interest to the Kienholzes, the evidence of Thurman's passionate labors clearly did fascinate them. He toiled to create this "shrine" with no other interest than his devotion to his religious beliefs. If Sollie is the archetypal man who exists on the fringe of society, Thurman is the archetypal marginal artist. He is Edward Kienholz's "other." Indeed, the connection between Thurman and Kienholz is deeper than one might presume. As Weschler writes in *Human Scale,* "As a child Ed starting out making creches with his mother and little dioramas celebrating all the standard Christian precepts" (13). Morever, after Kienholz created *Roxy's,* he had begun work on, but never completed a profane-looking version of *The Nativity.* Thus, his tableaux had begun in rebellion against the very concepts that Thurman celebrated. And ultimately, it is this outsider artist's devotion to his shrine—"the primitive perseverance, the seeing-it-through," as Kienholz once said of Thurman's window—to which *The Jesus Corner* pays tribute.

In the midst of creating this Spokane series of Kienholzes turned to another subject that he had confronted almost two decades before in *The Wait:* an older woman contemplating the course her life has taken (plate 14). It seems that in the return to American subjects with the Spokane series, they were also prompted to reexplore the theme of one of his most celebrated tableaux of the 1960s. But this is a much more intimate and autobiographical "portrait" than *The Wait,* for the woman pictured, in the photograph as face, is Kienholz's mother. The work never explicitly states this, though there are strong enough clues for one to draw this conclusion. The scaled down version of the front of her house displays a screen door with the letter "K," integrated prominently into its metalwork (fig. 43). And as the viewer opens the screen door, illuminating the interior of the tableau, he eventually locates a two-verse poem, signed by Ella Kienholz, which is positioned at approximately eye level on the far mirrored wall.

The poem itself, entitled "Resignation," speaks for the figure of a mother, who is holding a framed portrait of herself. As she contemplates a photograph of herself as a child, she is surely also meditating on the same subject of the poem: her mortality. The poem, written and typed many years ago by Ella Kienholz reads:

> When the trials of life assail us
> And the storm clouds gather low,
> In the blinding tears of heartache
> The flowers of understanding grow.
>
> For nothing is forever,
> And life is but a day.
> Though great the sorrow of the heart,
> Even this shall pass away. (*Human Scale,* 9)

The verses themselves are wholly undistinguished, and conventional, but their quality is beside the point here; they are simply one among many items that chronicle her life within this tableau. On a shelf are baby cups, both her son's and her own, as well as a vase painted by Kienholz when he was a child; on the table is some of her china and an artificial flower arrangement; and on the wall is a picture of his father as a young man. Elsewhere, there is a photograph of Lawrence Kienholz as an older man, sitting in a wheelchair and enfeebled

43. Edward Kienholz and Nancy Reddin Kienholz, Exterior of *Portrait of a Mother With Past Affixed Also.*

by a stroke, which can only be viewed through a magnifying and distorting (Fresnel) lens by twisting one's body into a decidedly awkward position.

Thus the years of this mother's life are compressed here into one scene. This tableau, then, is not a literal miniaturized version of her present home on Lake Pend Oreille, but a fusion of that house with Kienholz's own childhood abode in Fairfield, Washington. Thus the photograph superimposed on the exterior window is taken on Lake Pend Oreille looking toward the shore, but the photograph on an inner kitchen window depicts the wheat fields she once looked upon from the Fairfield farmhouse. Even the scene with this tableau is strangely metaphysical. The chairs and table are cut in half and butted up against the mirrored wall to create the illusion that each object is whole. But if this visual illusion is easy to locate, it suggests another that is more genuinely eerie. For a moment, it looks as if we too are in the room rather than outside it.

All of the objects in the tableau also function like projections of her thoughts, the Kienholzes "portrait" of "a mother" suggests. In the photograph, she is absorbed in reflection—so much so that she is looking away from the picture of herself that she holds in her hands, even as a pair of doll's arms attached to this photograph reach out to her. Youth beckons to her, as it were, but she is absorbed by other thoughts (of both death and an afterlife, "Resignation" suggests). Ultimately, it seems appropriate that his title reads "a mother" rather than "my mother," for the autobiographical elements of the tableau are outweighed by the archetypal ones. This is a portrait of any and every mother contemplating the passing of her life

before her mind's eye. Implicitly, the tableau is also about all of us: as mothers, fathers, sons, and daughters. We are all reflected in the mirror on the facing wall; we are not merely spectators to this scene, but participants by virtue of our mortality, our roles as parents and offspring. We are, in effect, inside the room as we study our reflections, even if we cannot enter it physically.

 With the opening of the exhibition *Edward and Nancy Reddin Kienholz: Human Scale* at the San Francisco Museum of Modern Art in 1984, the return to America was complete. Eighteen years after the last major retrospective of Kienholz's work, tableaux of American scenes by the Kienholzes were exhibited in four cities.

The timing seemed right for such a return; the critical climate was much more hospitable to their work in 1984 than a decade earlier. The practice of social criticism in art had become almost commonplace by that time—and we can see Kienholz's tableaux of the 1960s and 1970s as a vital precedent for much of this work, even if there is no direct link. For it helped to cultivate a climate in which such art could arise. I am thinking, here, of a wide range of work; notable examples are Leon Golub's paintings of unfeeling mercenaries and torturers whose gaze meets ours, creating a situation where, as in Kienholz's work, the viewer becomes an uncomfortable voyeur; Neil Jenney's paintings, in word and image, which function as cautionary tales about our destruction of the environment; and Barbara Kruger's mix of borrowed

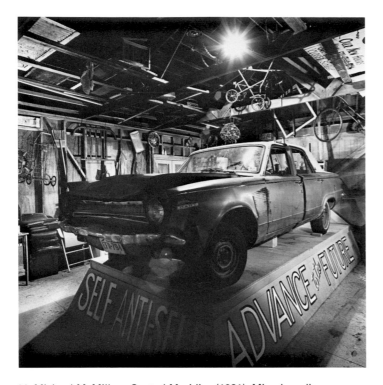

44. Michael McMillen, *Central Meridian* (1981). Mixed media environment. Collection of the Los Angeles County Museum of Art. Photograph: Robbert Flick.

and altered mass media imagery and confrontational slogan-like texts. Only Hans Haacke, among Kienholz's contemporaries during the 1960s and early 1970s, has been equally instrumental in creating a favorable climate, in the United States, for socially critical art.[6]

The creation of narrative tableaux has become such a frequently employed device in contemporary art that it is hard to imagine a time when it was not an available option. This essay has attempted to demonstrate, in a vivid way, that the contribution that Kienholz's tableaux made to this genre was enormous. That legacy is clear in the work of a host of artists younger than Kienholz himself; prominent among them are Terry Allen, Chris Burden, and Michael McMillen—highly different sensibilities who each, nonetheless, have made significant use of the tableau. Consider Allen's *Billingsgate (A Motel)* (1982), an environment containing props and text which narrates the experiences, both prosaic and bizarre, of a man whiling away his days in this Montana town; Burden's expansive miniature scale landscape, *A Tale of Two Cities* (1981–1988), dense with toy soldiers and weapons, which created a three-dimensional picture of a militarized future; or McMillen's human-scale environment, *Central Meridian* (1981) (fig. 44), a garage setting filled with appropriate bric-a-brac, mystical sign-boards, and a split car on an elevated, text-covered pedestal that creates a curiously affecting variety of suburban surrealism. Such work is largely unimaginable without the precedent established by Kienholz's early tableau.

Writing of the *Human Scale* exhibition in *Art in America,* art historian Robert Silberman pointed to the

Kienholzes' impact on the art of our era. Commenting on his tableaux of the 1960s, Silberman wrote:

> These works stand out because of their audacity, their horrific but often darkly humorous view of the world. . . . If in today's art world, they don't appear quite as exceptional as when they first appeared, that is a testimonial of sorts to the success of Kienholz—and other artists—in extending the boundaries of art. But if the art world has changed, so has the artist. (138)

The boundaries of art did indeed have to be expanded to allow for a socially critical art, a narrative and theatrical genre such as the tableau. In our decade, such work has been legitimized in a way that would have seemed improbable in the 1950s and 1960s, when formalist standards of taste dominated. As Clement Greenberg, the most influential proponent of such critical standards had it, sculpture was destined to follow the same path as painting. "A modernist work of art," he asserted, "must try, in principle, to avoid dependence upon any order of experience not given in the most essentially construed nature of its medium" (139). The artist, in Greenberg's view, was to attempt to discover those truths inherent in the three-dimensional bulk of steel or wood just as the painter was to reveal the essential flatness of the picture plane. This was the logic embedded in art history, according to Greenberg.

Viewed from this theoretical perspective, the tableaux of Kienholz and the Kienholzes are an aberration. But the art of the last two decades has, of course, undermined formalist logic and the mixed media work of Kaprow, Rauschenberg, and Kienholz and others adumbrated its demise. As I have re-

counted, they advocated an impure field, where the high and low cultural forms could meet, where the viewer was as important as the work itself.

This field, as envisioned by Kienholz and Reddin Kienholz, has offered—and continues to offer—a rich array of possibilities. A survey of their work of the past decade, *Edward and Nancy Kienholz: 1980's,* organized by the Kunsthalle Düsseldorf, is vivid testimony to this fact.[7] They have indeed changed, as Silberman suggested, while also remaining committed to the themes that made the earlier tableaux such significant works.

In *The Hoerengracht* (1984–1988) (plate 15), one of their most ambitious tableaux to date, the Kienholzes offer a provocative interpretation of a subject introduced a quarter century ago—in *Roxy's.* The inspiration here is the red light district of Amsterdam, rendered as an entire street with eleven figures: nine situated (standing or sitting) in illuminated windows; one leaning in a staircase; another standing by the side of the road. ("Hoerengracht" is Dutch for whore's canal, although the name of the city's red light district is actually "herengracht," which translates as men's canal.) In this tableau, the "women" are generally attractive rather than grotesque, consisting of cast bodies and mannequin faces. Yet like Sollie, they seem caged, prisoners of their own fate. And unlike the figures in other tableaux, whose photographic faces provide them with character, these seem devoid of genuine personality. They are, in a metaphorical sense, faceless; and it is we, as a culture, who have rendered them so.

In this decade, the Kienholzes have also created

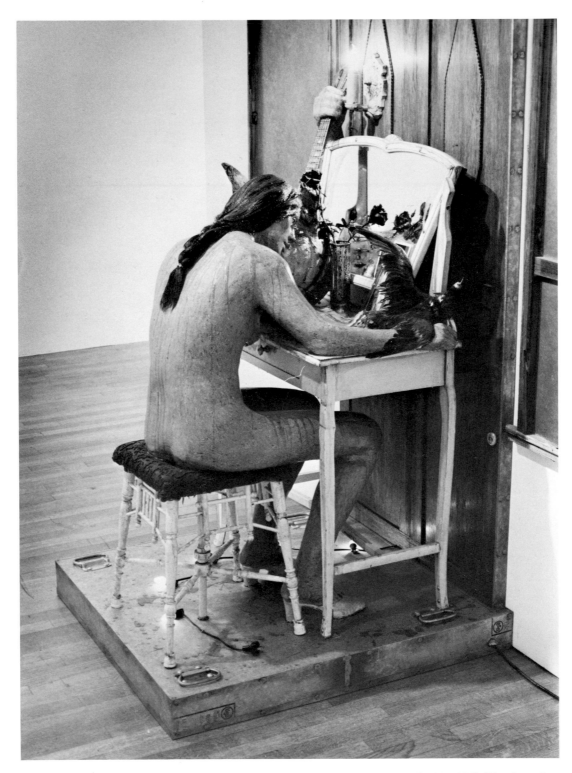

45. Edward Kienholz and Nancy Reddin Kienholz, *The Gray Window Becoming* (1983–1984). Mixed media tableau. Collection of the artists.

a number of compelling smaller scale tableaux to complement larger works such as those of the Spokane Cycle and *The Hoerengracht.* The environmental setting is sparer, more economical in details, but equally persuasive.

The Gray Window Becoming (1983–1984) (figs. 45, 46), one of the strongest of these modestly sized tableau, harkens back to *Jane Doe* in its exploration of the theme of thwarted female identity. A casting of a nude woman sits at a dressing table with an upright mirror, a family Bible resting open on its surface. The central theme is suggested by a gathering of symbolically resonant objects. One of the woman's hands rests on a replica of the pig's head (a meat market display item), attached to the neck of banjo which, in turn, is gripped by a disembodied masculine hand. She is gently resting her head on that of the pig—clearly the surrogate male—as if listening for the music he might offer. Yet the blank look in the pig's eyes offers little or no sign of empathy, no hope of welcome music.

Other props, too, suggest an air of futility; a headless, stuffed bird rests atop her other hand; and a photograph of a woman's face gazes sadly at the seated figure's face, like a second and more revealing reflection. To her right, within a window frame, is a surface of galvanized steel, creating an image of enclosure, blankness, and confinement. Most un-settling of all is a gun resting next to the Bible. Is she considering suicide? One inevitably wonders. Contem-plating death, the woman in this tableau becomes the youthful counterpart to the figures in *The Wait* and *Portrait of a Mother with Past Affixed Also* as well.

The word "becoming," in this context, has an ironic relationship to what we see. For as the figure here reflects on the condition of her existence, there is no view to an outside world—only the neutral grey surfaces of the windows that flank her dressing table.

Holding the Dog (1986) (plate 16), among the compact human-scale works, is equally engaging. Like *Five Car Stud* before it, this work confronts the specter of racism. Yet its approach differs markedly from that of the earlier tableau; it is presentational more than shocking. A dog becomes a surrogate for the human victim, its taxidermied and coated form is held aloft, upside down, by two imposing figures, each wearing a welding mask with a white cross painted on it. These crosses are clearly emblematic of the burning crosses that Ku Klux Klan members and other white power groups employ as a symbol of terror; they are also reminders of how they cloak their racist and cowardly acts in the rhetoric of religion.

Analogously, the composition of this tableau points up, in a precise and dramatic way, the cowardice and absurdity of white supremacism. The "trophy" that the two male figures hold aloft is wholly pathetic. Yet *Holding the Dog* suggests that the extreme racism of those such as the Klan does not exist in isolation. Tiny human faces in lead, which adorn the tiles of the floor beneath the feet of the male figures, connote the anonymous numbers who approve of such bigotry without actively engaging in racist acts. Directly in the center of the wall behind them is a mirror that places the viewer's reflected face squarely between the covered heads of the figures within the tableau. Thus we are confronted with an

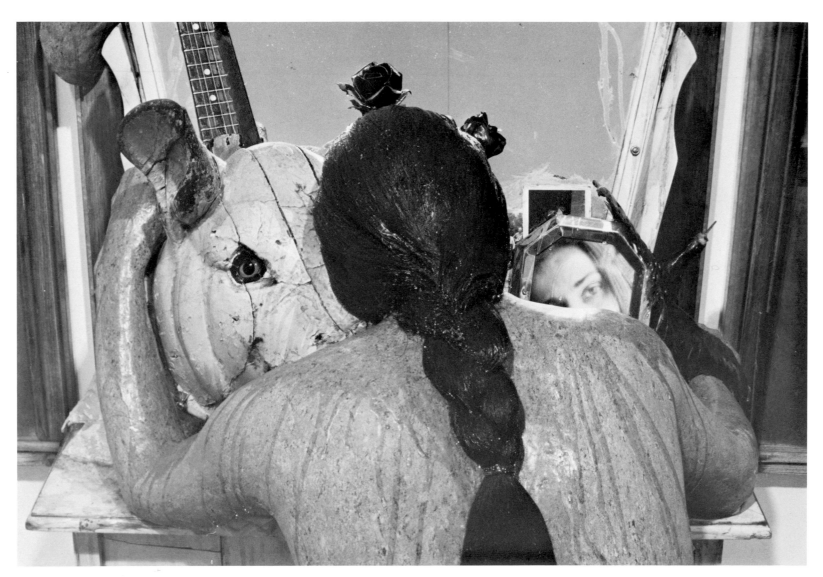

46. Edward Kienholz and Nancy Reddin Kienholz, Detail of *The Gray Window Becoming* (1983–1984).

unhappy question: are we, too, participants in the survival of such bigotry?

These three tableaux, like so much of the Kienholzes work of the 1980s, ultimately place continuity above change but offer no signs of a decline in the quality or depth of the oeuvre. For like earlier assemblages and tableaux, the more recent creations are deeply receptive to the tragic circumstances of society's victims, of its marginal citizens. The Kienholzes have made their circumstances palpable in ways that other contemporary artists have not been able to duplicate. The loneliness of the aging, isolated individual is embodied by the costumed skeleton in *The Wait* or the three figures of a man entombed in the recreated skid row hotel room of *Sollie 17.* No one who peers inside the barred window of *The State Hospital* seems able to forget its interior scene of two emaciated figures, with fish bowls for heads, naked and shackled to bunk beds; it is an almost unbearable image of human degradation. And never was the notion of killing time given a more vivid interpretation than in *The Beanery,* where the frozen clocks that serve as the heads of figures are emblematic of the mood the entire environment projects. The everyday world is entombed in Kienholz's and the Kienholzes assemblages and tableaux in such a way that we experience the places they have constructed as if they were places we have actually visited at some point in our own lives. They are not comfortable places, since it is the covert, unsettling, and often horrific aspects of a scene that are revealed and intensified. But they are seemingly as familiar as those troubling images from our own lives many of us try to forget or obliterate. These kinds of

scenes resurface in their tableaux, persuading us that we should confront their difficult implications; that we neglect them at supreme cost to our fate as individuals and as a culture. This, it would seem, is the paramount accomplishment of their art.

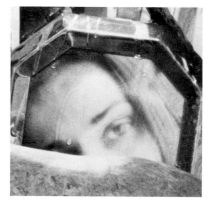

CHRONOLOGY

1927

Edward Kienholz born to Lawrence and Ella Eaton Kienholz in the rural eastern Washington town of Fairfield. From his father, he learns carpentry and other practical skills he will use in his art. In high school, he becomes interested in architecture, but decides his math skills are not good enough to pursue it as a career.

1943

Nancy Reddin born to Thomas and Betty Parsons Reddin in Los Angeles. Attends the University of Southern California for a brief period. Works as a court reporter, emergency room attendant, medical assistant and holds other odd jobs.

Late 1940's

Kienholz attends Eastern Washington College of Education in Cheney and Whitworth College in Spokane. Holds an assortment of jobs in Northwest, West and Southwest: manages a dance band, sells used cars, serves as an attendant in a state-run mental facility, builds apartments and so forth.

1952 or 1953

Moves to Los Angeles.

1954

Begins making wall pieces with plywood relief surfaces. He paints them with a broom to make them "as ugly as possible." ("If I could really make them ugly," he remarked in our interview of September 12, 1987, "I could understand what beauty was about.")

1956

Remodels a building that housed a theater and opens the Now Gallery. Meets Walter Hopps; they co-organize the All-City Art Festival. Kienholz exhibits his constructions at the Syndell Studio, of which Hopps is one of the owners.

1957

Kienholz and Hopps open the Ferus Gallery on La Cienega Boulevard. Kienholz maintains a studio in the back.

1958

Sells his share of the gallery to Hopps. Buys a house in Laurel Canyon and builds a studio there.

1959

Begins making freestanding constructions. First exhibits some of them, such as *John Doe,* at the Ferus Gallery.

1960–1961

Constructs his first tableau, *Roxy's,* an environmental recreation of a brothel.

1962

Roxy's has its first showing at the Ferus Gallery.

1966

Retrospective at the Los Angeles County Museum of Art, curated by the museum's curator of modern art, Maurice Tuchman. Two Los Angeles county supervisors, Warren Dorn and Kenneth Hahn, spark controversy by labeling *Roxy's* pornographic and trying to pressure museum officials—unsuccessfully—into closing the exhibition. Begins spending summers in northern Idaho town of Hope.

1966–1967

Devotes himself to *Concept Tableaux,* a series of works begun in 1963. Presented as written descriptions and title plaques; will only be constructed if patron pays artist's wages and materials.

1968

Roxy's presented at Documenta 4 in Kassel, West Germany; introduces Kienholz's work to a European audience.

1969

Exhibits *Watercolors* at the Eugenia Butler Gallery in Los Angeles.

1970–1972

11 + 11 Tableaux exhibition opens at the Moderna Museet in Stockholm. Travels to five other European museums. Meets Nancy Reddin, they begin working together, and are married.

1973

Under the auspices of the Deutscher Academiikischer Austauschdienst (DAAD), the Kienholzes establish a studio in Berlin. Begin spending winters in Berlin and summers in Hope.

1975

Creation of *Volksempfangers* series, focusing on the Nazis' use of the radio for propaganda purposes.

1977

Guggenheim fellowship used to establish the Faith and Charity in Hope Gallery in Idaho; its purpose: to bring significant art to the surrounding communities. *The Art Show* first shown in Berlin and appears at the Centre Georges Pompidou in Paris. They begin work on the White Easel series in Hope.

1979–1983

They construct the Spokane series of tableaux in Hope.

1981

Kienholz declares, in writing, that all work, retroactive to 1972, will be co-signed by Nancy Reddin Kienholz. Joint solo exhibition at L.A. Louver Gallery is also his first solo show in commercial space in Los Angeles in twelve years.

1984

The entire Spokane series and other works open at the San Francisco Museum of Modern Art, in exhibition entitled *Edward and Nancy Reddin Kienholz: Human Scale.* Travels to four cities in the United States.

1986

Assemblages and small tableaux of past three years shown at L.A. Louver Gallery. First exhibition of *The Art Show* in Southern California: at the Santa Barbara Contemporary Arts Forum. *The Back Seat Dodge '38* enters the collection of the Los Angeles County Museum of Art and goes on view in the new Robert O. Anderson building for twentieth-century art.

1989

Survey of their work of the 1980s opens in Düsseldorf in March; travels to Vienna in September. First solo exhibition in New York since 1967 opens in October; it provides the debut show for Louver Gallery, New York.

1991

Completion of *Mine Camp* at Walla Walla Foundry in southeastern Washington, an outdoor tableau requiring the casting of more than 2,000 objects in bronze. The piece is installed in Hope. Artists establish third studio and residence in Houston, Texas.

1992

Large environmental work begun in 1988, *The Merry-Go-World or Begat by Chance and the Wonder Horse Trigger* is completed and premieres at the L.A. Louver Gallery in Venice, Ca.

1993–94

The Merry-Go-World or Begat by Chance and the Wonder Horse Trigger is exhibited at the Minneapolis Institute of Arts and Museum of Fine Arts in Houston and embarks on tour of Japan, Asia and Europe. *The Hoerengracht* is the subject of a show at the Museum of Contemporary Art, San Diego.

NOTES

Preface

1. The decision to give equal credit to Nancy Reddin Kienholz for work created since 1972 was retroactive. Edward Kienholz made the collaboration official in a statement included in a catalog published in 1981 by the Galerie Maeght, Zurich, Switzerland, which accompanied an exhibition entitled *The Kienholz Women.* However, they had begun cosigning works, concurrent with the completion of them, in 1979.
2. Owens's essay is collected in Brian Wallis, ed. *Art After Modernism: Rethinking Representation* (New York: The New Museum of Contemporary Art, in conjunction with David R. Godine, Boston, 1984): 203–235; the sentence I am alluding to reads: "Appropriation, site specificity, impermanence, accumulation, discursivity, hybridization—these diverse strategies characterize much of the art of the present and distinguish it from its modernist predecessors."

Introduction

1. For information on vernacular sources of Kienholz's tableau, see K. G. P. Hulten, *11 + 11 Tableaux* (Stockholm: Moderna Museet, 1970), n. p.; for Kienholz's memories that triggered *Roxy's,* see Lawrence Weschler, ed., *Edward Kienholz,* 2 vols., part of *Los Angeles Art Community: Group Portrait* (Los Angeles: University of California, Los Angeles Art History Program, 1977): 231–233, where the artist painfully recalls: "I went back in memory to going to Kellogg, Idaho, to whorehouses when I was a kid, and just being appalled by the whole situation—not being able to perform because it was just a really crummy experience of old women with sagging breasts that were supposed to turn you on, and like I say, it just didn't work."
2. The most accurate and concise history of the development of New York assemblage, environments, and happenings during these years is in Barbara Haskell, *Blam! The Explosion of Pop, Minimalism and Performance 1958–1964* (New York: Whitney Museum of American Art, in association with W. W. Norton & Company, 1984); for information on Kaprow's first environments and Rauschenberg's combines in his 1958 exhibition at the Leo Castelli Gallery, see Haskell's chapter, "The Aesthetics of Junk," 15–19.
3. Underlying my argument in the introduction—and elsewhere in this book—is the notion that the work of Berman provided a precedent, but one that Kienholz quickly assimilated and transcended. Subsequently, his work took a decidedly different direction than Berman's, Conner's, or Herms's. For a general, if somewhat factually flawed, discussion of West Coast assemblage, see the chapter "Assemblage Line" in Peter Plagens, *The Sunshine Muse* (New York: Praeger Publishers, 1974): 74–95; for an extended chronology/oral history of the era, see "Assemblage Art in California : A Collective Memoir, 1940–1969," in Sandra Leonard Starr, *Lost and Found in California: Four Decades of Assemblage Art* (Los Angeles: James Corcoran Gallery in conjunction with Shoshana Wayne Gallery and Pence Gallery, 1988): 53–119; for the best documentation of Berman's career, see Hal Glicksman, ed., *Wallace Berman Retrospective* (Los Angeles: Otis Art Institute Gallery, 1978); for the most thorough account of Herms's life and work through the 1970s, see Thomas Garver, ed., *The Prometheus Archives: A Retrospective Exhibition of the Works of George Herms* (Newport Beach, Calif.: Harbor Art Museum, 1979); there is no substantial scholarly catalog to date on Conner's oeuvre.
4. For a contemporaneous critical response to Kienholz's work of the early to mid-1960s, see Michael Benedikt's group of reviews, "Sculpture as Architecture: New York Letter, 1966–67," in Gregory Battock, ed., *Minimal Art: A Critical Anthology* (New York: E. P. Dutton and Co., 1968): 82–85; writing of such artists as Claes Oldenburg and Robert Hudson in the context of The Whitney Annual of 1966, he asserts, "[C]ertainly Edward Kienholz, with the disgusting pillows and pots and currettes and lamp of *The Illegal Operation* (all blood stained) belongs among the eccentrics too. . . . " In *American Art Since 1900* (New York: Holt, Rinehart and Winston, 1965): 265–266, Barbara Rose praised Kienholz as one of three major American assemblagists, but placed him on the periphery of contemporary concerns when she characterized his work as "a specifically American reaction—a kind of negative puritanism and extreme form of local eccentricity—to the American scene."
5. Substantial American writing on Kienholz's art is infrequent. The best American catalog is still Maurice Tuchman, *Edward Kienholz* (Los Angeles: County Museum of Art, 1966); the most recent one of note is *Edward Kienholz and Nancy Reddin Kienholz: Human Scale* (San Francisco: The San Francisco Museum of Modern Art, 1984), published for an exhibition that subsequently traveled to four museums; it documents many of their recent American

112 tableaux. Also see Anne Ayres, "Berman and Kienholz: Progenitors of Los Angeles Assemblage" in Maurice Tuchman, *Art in Los Angeles: Seventeen Artists in the Sixties* (Los Angeles: Los Angeles County Museum of Art, 1981); and among recent articles see my "An Ode and an Odious for Neo-Dada: Edward Kienholz's Assemblages and Tableaux, 1959–65," *Images and Issues* Fall 1981: 53–55; and Robert Silberman, "Imitation of Life," *Art in America* March 1986: 138–143.

Interchapter One

1. Ginsberg is renamed Alvah Goldbook and "Howl" is retitled "Wail," but the locale of the reading, Gallery Six, remains the same; see Jack Kerouac, *The Dharma Bums* (1st ed., 1959; 2d ed., New York: Signet Books, 1969): 13.

Chapter One

1. Personal interview with Edward Kienholz, 20–24 August 1982, conducted at the artist's home in Hope, Idaho. Hereafter, statements from these sessions will be parenthetically referred to as "Personal interview, 1982" within the text. This will distinguish it from quoted comments obtained during a second interview, held 11–14 September 1987, parenthetically referred to as "Personal interview, 1987."

2. My choice of texts here does not represent the full range of the Beat sensibility, of course; perhaps conspicuous in their absence are Jack Kerouac's novels and Gary Snyder's poetry. It is my view that in the writings of both Kerouac and Snyder the transcendent or beatific impulse of this sensibility is dominant, whereas, to varying degrees, the chosen texts by Burroughs, Mailer, and Ginsberg give voice to a darker vision. The latter group of writers illuminate the other dimension of the term Beat: the notion of being beaten down or suppressed by social forces. (Of course Mailer's work, in general, is only loosely related to that of the Beats, but I think it is valid to include "The White Negro" in this context.) Both impulses are repeatedly voiced in Ginsberg's poetry and statements, although not reconciled anymore than they are in "Howl," where his last section in the poem, "Footnote," proclaims everything to be holy, as if such a proclamation were an after-thought to the rest of the poem. The value of Richard Chase's assertion about the American imagination (see epigraph to this chapter) becomes apparent here. For a good representation of the Beat sensibility, in all its contradictory variety, see Thomas Parkinson, ed., *Casebook on the Beats* (New York: Thomas Y. Crowell Co., 1961).

3. There would be nine issues of *Semina* in all; they were published irregularly from 1955 to 1964. For a full chronology of Berman's career, see *Wallace Berman: A Retrospective Exhibition*.

4. Telephone interview with David Meltzer, 20 April 1986; Kienholz raised objections to Meltzer's assertion in our interviews of September 1987.

5. See Northrop Frye, *The Anatomy of Criticism* (Princeton, N.J.: Princeton University Press, 1957): 223.

6. Since 1961, when Kienholz created an assemblage entitled *The Big Eye,* the oeuvre has included a steady stream of works that both adopt the form of and comment upon television. Most of them have been produced in editions at Gemini G.E.L. in Los Angeles. A small brochure, with photographs of all the television editions to date, was published by Gemini G.E.L. in 1984. The text of that publication is a revealing letter from Kienholz to the owner of Gemini, Sidney Felsen, explaining his continuing fascination with the television as a motif for sculptures. In it, the artist writes: "You may have guessed that I have long had a love/hate relationship with American T.V. I sit dummy style in front of that marvelous communication tool and find my years slipping by and my mind turning to slush from the 95% trash being beamed my way. To try and understand my ongoing stupidity and perhaps to express some kind of critical objectivity I find that I keep making T.V. sets out of anything that vaguely resembles a T.V. apparatus (oil containers, blocks of concrete, surplus jerry cans etc.)." Since 1984, the Kienholzes have produced still other works that employ the television format: *The Newses* (1986), a witty trio of satirical pieces on news broadcasting; *Alls Quiet* (1986), an antiwar piece; and *Double Cross* (1988), the collective title for a series of television objects, produced at Gemini G.E.L., on television's role in the promotion of both religion and war.

7. The written versions of the *Concept Tableaux,* including *The World,* are reproduced in K. G. P. Hulten, *11 + 11 Tableaux* (Stockholm: Moderna Museet, 1970); they are discussed at greater length in chapter 3.

Interchapter Two

1. Included in *Three Tableaux* were *Back Seat Dodge '38, The Birthday,* and *While Visions of Sugarplums Danced In Their Heads.*

2. A little more than a year after Kienholz's exhibition closed at the Los Angeles County Museum of Art, the artist published an affectionate tribute to Tuchman. Describing the curator's conduct while the museum was under attack, Kienholz waxed enthusiastic: "He was unshakable; he stood like a rock; he was a master politician; he prevailed at press conferences; he was karate chops of effectiveness and fresh air, and in the end, the show opened on schedule and intact." See "Maurice Tuchman: Bronx Cowboy and Super Curator," *West* 4 June 1967: 44–46.

3. I am indebted to the unpublished scrapbooks of the Kienholzes for much of the information concerning the chronology of exhibitions at the Ferus and Dwan galleries. The sequence of events surrounding Kienholz's retrospective at the Los Angeles County Museum of Art was gleaned from clippings in both the artist's scrapbooks and a volume of the same in the library of the Los Angeles County Museum of Art; there were literally hundreds of articles published during the six-week run of the show—in the *Los Angeles Times,* the *Los Angeles Herald-Examiner,* smaller newspapers as well as national publications.

Chapter Two

1. See Gerald Nordland, "Neo-Dada Goes West," *Arts* May–June 1962: 102; my account of the Kienholz-Tinguely-Saint Phalle collaborative construction is derived from Nordland's article as well. A year earlier, Dore Ashton, in an important and perceptive review, was already referring to Kienholz's work as an example of neo-Dada; see her "Constructions at the Ferus Gallery in Los Angeles," *Studio International* March 1961: 7–8.

2. I am referring here to a passage from Sontag's essay, "America, Seen Through Photographs Darkly," where she asserts, "In the mansions of pre-democratic culture, someone who gets photographed is a celebrity. In the open fields of American experience, as catalogued with passion by Whitman and as sized up with a shrug by Warhol, everybody is a celebrity." Although her explicit subject is photography, and its power of demystification, the implicit concern of her essay, is the failure of Whitman's prophecies for a democratic culture; see *On Photography* (New York: Farrar, Straus and Giroux, 1977): 27–48.

3. Claes Oldenburg, *Store Days,* as excerpted in Adrian Henri, *Total Art: Environments, Happenings and Performance* (New York: Praeger Publishers, 1974): 86. Henri also discusses Kienholz's "total environments"; see pp. 44–54.

4. Writing in the *11 + 11 Tableaux* catalog on *The Birthday* Hulten explained, "With this piece, Kienholz had completed a transition in style from experimental assemblage to one of defining and working out a total preconceived idea in large sculptural terms." Kienholz credits George Segal with introducing him to the hydrocal plaster and the casting technique that he employed in the tableaux intermittently beginning with *The Birthday*—and that he and Reddin Kienholz continue to employ. At the same time, Kienholz observes, Segal was strongly influenced by the full scale environment that *Roxy's* offered. "There were ideas worked out in his work that can be traced back to mine," Kienholz commented. They met and exchanged ideas, as he recalls, on Segal's trip to California in 1963 and Kienholz's regard for him and his work was—and remains—high. Edward Kienholz and Nancy Reddin Kienholz, personal interview, 12 September 1987.

5. Silk's article provides a good comparison of the two tableaux, concluding that "The visual links between the *Dodge* and the *Taxi,* and the use of mannequins and a penchant for sometimes macabre or scatological themes, suggest that both artists, in certain and restricted ways, share related ideas." Though Silk offers some observations on the development of assemblage in general and Kienholz's work in particular, his real focus is on the origins and iconography of *The Back Seat Dodge '38.* Taking a larger perspective one needs to add that for Dali, the tableaux was a minor episode in his oeuvre whereas for Kienholz it is the major mode in which he has worked.

6. At the first showing of *The Beanery,* there was an event that demonstrates just how vividly this tableau conveys its theme of the bar as a place for killing time. As Kienholz recalls the episode, "Lavonne Regehr [a friend of the artist] came out of there crying. I said, 'Geez, Lavonne, what's the matter?' She said, 'I saw myself in there.' She was sobbing. She said, 'You know, I saw myself. I'm wasting my life. . . . I don't need to drink to live.' And she had this big trauma because she'd seen some figure in there she just assumed was her." See Weschler, pp. 373–374. Her assumption is precisely the one that Kienholz strives to have all viewers make, of course; it is a major source of the tableaux's emotional power.

Interchapter Three

1. This statement is derived from a remark Kienholz made in a lengthy tape interview with Pontus Hulten; no date for the session is provided, though Hulten recalls that it took place in early 1969.

2. See Kienholz, "Maurice Tuchman: Bronx Cowboy and Super Curator."

3. Here I am referring to Croce's notion of aesthetic intuition as something potentially separate from concrete notions of spatiality. "Some limit intuition to the sole category of spatiality," he writes, "maintaining that even time can only be intuited in terms of space. Others abandon the three dimensions of space as not philosophically necessary, and conceive the function of spatiality as void of all particular spatial determination. But what could such a spatial function be, a simple arrangement that should arrange even time? It represents, surely, all that criticism and refutation have left standing—the bare demand for the affirmation of some intuitive activity in general. And is not this activity truly determined, when one single function is attributed to it, not spatializing or temporalizing, but characterizing"; see Croce, "Aesthetic," *Critical Theory Since Plato,* ed. Hazard Adams (New York: Harcourt Brace Jovanovich, 1971): 728. Kienholz's presentation of a Concept Tableau fulfills this notion of an intuition characterized.

4. Pontus Hulten, personal interview, 13 March 1983; hereafter referred to parenthetically as "Personal interview, 1983."

Chapter Three

1. In this context, we should recall the most telling of Kienholz's remarks, already quoted at the outset of chapter 1; questioned about the aesthetic validity of *The Beanery,* he exclaimed: "I don't know if it's art, but I don't give a damn."

2. The contract for the *Concept Tableaux* also appeared in the catalog for the *11 + 11 Tableaux* exhibition.

3. The short essay on the *Watercolors* in the Finnish catalog, *Kienholz* (Helsinki: Galerie Christel, 1974) is one of the best examples of Kienholz's wryly pragmatic and partly tongue-in-cheek approach to a theoretically oriented project. Though this series is clearly a spoof on the whole idea of market values for art, Kienholz never reveals that to be one of his purposes. He asserts: "What I have done, in effect, is to issue a kind of currency which is not dependant [sic] on the normal monetary system." He is right; but we know that this "money" can only exist as a symbolic gesture that momentarily subverts the power of genuine currency.

4. The function of words as a surrogate for images is, of course, a prime characteristic of Conceptual Art. See, for example, Ursula Meyer, *Conceptual Art* (New York: E. P. Dutton, 1972), which documents work by a representative cross-section of artists, both American and European; aside from Kosuth and Baldessari, we find artists such as the British Art-Language group (Terry Atkinson, Michael Baldwin, and others), Douglas Huebler, and Gregory Battcock using words as the stuff of their art in the early 1970s. A substantial history of Conceptual Art remains to be written.

5. For a general history of Earthworks or Earth art, which includes discussion of Heizer's seminal works, see John Beardsley, *Earthworks and Beyond: Contemporary Art in the Landscape* (New York: Abbeville Press, 1984). Interestingly, Kienholz's concepts for *After The Ball Is Over #1, The Cement Store #1 and #2,* and *The Office Building* anticipate the placement of architectural constructions within the landscape that characterizes work dating from the 1970s by such artists as Siah Armajani, Alice Aycock, Mary Miss, Andrew Leiceister, and Alan Wood. However, there is also a decided difference between his *Concept Tableaux* and their works, since Kienholz proposed using found buildings while these artists design and construct works that emphasize a visionary approach to architecture. Even the Kienholzes most elaborate use of exterior facades, in the expansive, masterful, and recently completed tableau, *The Hoerengracht* (1984–1988), tries to adhere closely to the architecture of its source, the red light district in Amsterdam, though as in so many tableaux, the artists take many liberties in detail and scale.

6. For Kienholz's account of his casting of Ed Born for *The State Hospital,* see Weschler, pp. 402–404.

7. The catalog entry for *The Portable War Memorial* in the *11 + 11 Tableaux* exhibition catalog, consists chiefly of a lengthy excerpt from this published letter; I have quoted from this version of the letter.

8. While Baer mentions the sentimental strain in Kienholz's tableaux and includes it as one of the four central characteristics of his art in her "summary," she is unspecific about its role in the works she discusses. Baer is much better on their gritty realism, offering catalogues of their many small and sometimes hidden details. See "Edward Kienholz; The Sentimental Journeyman," *Art*

International (April 1968), 45–49.

9. In addition to Kienholz's earlier quoted statement on sculpture as three dimensional painting, taken from Weschler's interview, there is this remark from an essay by Kienholz in the *Kienholz* catalog of 1974: "As time went on the relief structures got more and more intricate and protruded further and further into the room until they finally demanded floor space and I guess I became a sculptor (1958–60) although I still think of myself as a painter" (no page).

10. My account of Segal's early development derives from two major sources on his work. See Graham W. J. Beal and Martin Friedman, *George Segal: Sculptures* (Minneapolis: Walker Art Center, 1978), 9/28, 59–79; and Phyllis Tuchman, *George Segal* (New York: Abbeville Press, 1983), 23–68. Also refer to note four of chapter two for Kienholz's comments on the sharing of ideas between him and Segal.

Interchapter Four

1. Nancy Reddin Kienholz, personal interview, 23 August 1982.

2. Photographs as faces have become a frequently employed device in the Kienholzes work of the 1980s, beginning with *Sollie 17*. See *Edward and Nancy Kienholz: Werk aus den 80er Jahren* (Dusseldorf: Kunsthalle Dusseldorf, in conjunction with Museum Moderner Kunst, 1989); the text, which includes essays by Jurgen Harten, Dieter Ronte, and Hans Werner-Schmidt, and my entries on forty-four works, appears in both German and English.

Chapter Four

1. See *Documentation Book: Five Car Stud and Sawdy* (Los Angeles: Gemini G.E.L., 1972). This volume, published in an edition of seventy-five, contains an introductory essay by the artist, and provides a pictorial chronicle of the construction of both the tableau and the edition of sculpture that accompanied it. Kienholz credits *Los Angeles Times* columnist Art Seidenbaum with the title of the tableau.

2. This information is derived from Nancy Reddin Kienholz, 1 February 1987. Letter to the author.

3. My underlying point here is that the resurgence of assemblage in the United States, in its most vital phase, was chiefly limited to the late 1950s and early 1960s. It was during this time that Robert Rauschenberg concentrated on his "combine" paintings and that Berman, Herms, and Kienholz established themselves as the major figures of West Coast assemblage. See Seitz, *The Art of Assemblage*; Plagens, "Assemblage Line" in *The Sunshine Muse*; Anne Ayres, "Los Angeles Modernism and the Assemblage Tradition, 1948–1962," Ph.D. diss., University of Southern California, 1983; and two of Ayres's essays: "Berman and Kienholz: Progenitors of Los Angeles Assemblage," in Tuchman, *Art in Los Angeles: Seventeen Artists in the Sixties,* and "Directions in California Assemblage," in *Forty Years of Assemblage* (Los Angeles: Wight Art Gallery, University of California, Los Angeles, 1989).

4. See Edward Kienholz, untitled essay in *Edward and Nancy Reddin Kienholz: Human Scale.*

5. See Edward Kienholz, untitled essay in *Edward and Nancy Reddin Kienholz: Human Scale.*

6. Haacke's career, as a socially critical artist, began in 1969, when he used exhibitions as occasions to poll viewers on their political views. By 1971, Haacke had clarified his particular approach and had begun to practice what Fredric Jameson characterizes as "institutional analysis." Using maps with highlighted locales and a series of photographs accompanied by caption-like text, Haacke documented the immense holdings in Manhattan—"as of May 1, 1971"—of the partnership of Sol Goldman and Alex DiLorenzo (in one work) and those of the Harry Shapolsky family (in another). This sort of work proved too much for the Guggenheim Museum's director, Thomas Messer, and its Board of Trustees, which had scheduled an exhibition of the artist's work and abruptly canceled it. Curator Edward Fry resigned in protest. Like Kienholz's 1966 exhibition at the Los Angeles County Museum of Art, this one has become part of the lore of recent art history. And like Kienholz's work, Haacke's has periodically proved controversial. See Jack Burnham, "Hans Haacke's Cancelled Show at the Guggenheim," *Artforum* June 1971, as reprinted in Amy Baker Sandback, ed. *Looking Critically: 21 Years of Artforum Magazine* (Ann Arbor: UMI Research Press, 1984); for a more detailed account, see Leo Steinberg, "Some of Hans Haacke's Works Considered as Fine Art," and Rosalyn Deutsche, "Property Values: Hans Haacke, Real Estate, and the Museums," *Hans Haacke: Unfinished Business,* ed. Brian Wallis (New York: The New Museum of Contemporary Art, 1986); Fredric Jameson's characterization of Haacke's art as "institutional analysis" is described in an essay "Hans Haacke and the Cultural Logic of Postmodernism," which is contained in this

116 same exhibition catalog. Interestingly, both Haacke and Kienholz were included in an exhibition entitled, *No! Contemporary American Dada,* mounted by the Henry Art Gallery of the University of Washington and accompanied by an extensive catalog; see Joseph N. Newland, ed. *No! Contemporary American DADA* (Seattle: University of Washington, 1985).

7. *Edward and Nancy Kienholz: 1980's* appeared at the Kunsthalle Düsseldorf from March 23 to May 28, 1989 and at the Museum Moderner Kunst in Vienna from September 29 to December 11, 1989.

BIBLIOGRAPHY

Arce, Hector. "Eleventh Hour," *Home Furnishings Daily* 9 May 1968: n. p.

Ashton, Dore. "Constructions at the Ferus Gallery in Los Angeles," *Studio International* March 1961: 7–8.

Ayres, Anne. "Directions in California Assemblage," *Forty Years of California Assemblage*. Los Angeles: Wight Art Gallery, University of California, Los Angeles, 1989, 49–64.

———. "Kienholz and Berman: Progenitors of Los Angeles Assemblage," *Art in Los Angeles: Seventeen Artists in the Sixties*. Los Angeles: Los Angeles County Museum of Art, 1981: 11–18.

———. "Los Angeles Modernism and the Assemblage Tradition, 1948–1962." Ph.D. diss., University of Southern California, 1983.

Baer, Jo. "Edward Kienholz: The Sentimental Journeyman," *Art International* April 1968: 45–49.

Barthes, Roland. *Camera Lucida: Reflections on Photography*. Trans Richard Howard. New York: Hill and Wang, 1981.

Battcock, Gregory, ed. *Idea Art: A Critical Anthology*. New York: E. P. Dutton & Co., 1972.

———, ed. *Minimal Art: A Critical Anthology*. New York: E. P. Dutton and Co., 1968.

Beal, Graham, W. J., and Martin Friedman. *George Segal: Sculptures*. Minneapolis: Walker Art Center, 1978.

Beardsley, John. *Earthworks and Beyond: Contemporary Art in the Landscape*. New York: Abbeville Press, 1984.

Burnham, Jack. "Hans Haacke's Cancelled Show at the Guggenheim," *Looking Critically: 21 Years of Artforum Magazine*. Ed. Amy Baker Sandback. Ann Arbor: UMI Research Press, 1984: 105–109.

Burroughs, William. *Naked Lunch*. 1959. New York: Grove Press [Black Cat Edition], 1966.

———. *The Soft Machine, Nova Express, The Wild Boys: Three Novels*. New York: Grove Press, 1980.

Calas, Elena, and Nicolas Calas. *Icons and Images of the Sixties*. New York: E. P. Dutton & Co., 1971.

Carey, Martin. *The New American Realism*. Worcester: Worcester Art Museum, 1965.

Chase, Richard. *The Democratic Vista: A Dialogue on Life and Letters in Contemporary America*. New York: Doubleday, 1958.

Clemens, Samuel Langhorne. *Adventures of Huckleberry Finn*. Ed. Leo Marx. Indianapolis: The Bobbs-Merrill Co., 1967.

de Crevecoeur, J. Hector St. John. *Letters from an American Farmer*. New York: E. P. Dutton & Co., 1957.

Croce, Benedetto. "Aesthetic," *Critical Theory Since Plato*. Ed. Hazard Adams. New York: Harcourt Brace Jovanovich, 1971: 727–735.

Eliot, T. S. *Collected Poems, 1909–1962*. New York, Harcourt, Brace & World, 1970.

Frye, Northrop. *The Anatomy of Criticism*. 1957. Princeton: Princeton University Press, 1971.

Garver, Thomas, ed. *The Prometheus Archives: A Retrospective Exhibition of the Works of George Herms*. Newport Beach: Newport Harbor Art Museum, 1979.

Ginsberg, Allen. *Howl and Other Poems*. San Francisco: City Lights Books, 1959.

Glicksman, Hal, ed. *Wallace Berman: A Retrospective Exhibition*. Los Angeles: Otis Art Institute, 1978.

Glowen, Ron. "Kienholz's New Formalism: Sculpture 1976–79," *Artweek* 1 December 1979: 7.

Greenberg, Clement. *Art and Culture*. Boston: Beacon Press, 1961.

Haskell, Barbara. *Blam! The Explosion of Pop, Minimalism, and Performance 1958–64*. New York: Whitney Museum of American Art; New York: W. W. Norton & Co., 1984.

Henri, Adrian. *Total Art: Environments, Happenings and Performance*. New York: Praeger Publishers, 1974.

Hopps, Walter. *Works from the 1960's by Edward Kienholz*. Washington, D.C.: Washington Gallery of Modern Art, 1967.

Hulten, K. G. P. *11 + 11 Tableaux*. Stockholm: Moderna Museet, 1970.

———. Interview with Edward Kienholz. Cassette. 1969.

———. Personal interview. 13 March 1983.

———. "A Salute to Kienholz's Piece Sollie," Unpublished essay, 1982.

Kaprow, Allan. *Assemblage, Environments and Happenings*. New York: Harry N. Abrams, 1966.

Kerouac, Jack. *The Dharma Bums*. 1959. New York: Signet Books, 1969.

Kienholz, Edward. *Documentation Book: Five Car Stud and Sawdy*. Los Angeles: Gemini G. E. L., 1972.

———. *Kienholz*. Helsinki: Galerie Christel, 1974.

———. "Maurice Tuchman: Bronx Cowboy and Super Curator," *West* 4 June 1967: 44–46.

———. Personal interview. 20–24 August 1982.

———. Personal interview. 11–14 September 1987.

118　Kienholz, Edward, and Nancy Reddin Kienholz. *The Kienholz Women.* Zurich: Galerie Maeght, 1981.

———. *Edward and Nancy Reddin Kienholz: Human Scale.* San Francisco: San Francisco Museum of Modern Art, 1984.

———. *Edward und Nancy Kienholz: Werke aus den 80er Jahren (Edward and Nancy Kienholz: 1980's).* Düsseldorf: Kunsthalle Dusseldorf, 1989.

Kronick, William, dir. Film: *Story of an Artist.* With Edward Kienholz. Prod. David Wolper. 1961.

Lieder, Philip. "Kienholz," *Frontier* November 1964: 25.

———. Review of *Boxes* exhibition. *Artforum* October 1964: 49.

Mailer, Norman. *Advertisements for Myself.* 1959. New York: G. P. Putnam's Sons [Berkeley Medallion Edition], 1966.

Martin, Ann Ray. Review of *The Beanery,* by Edward Kienholz. *Newsweek* 20 December 1965: 103.

Meyer, Ursula. *Conceptual Art.* E. P. Dutton & Co., 1972.

Miller-Keller, Andrea, and John B. Ravenal. *From the Collection of Sol LeWitt.* New York: Independent Curators Incorporated; Hartford: Wadsworth Atheneum, 1984.

Mukarovsky, Jan. "The Essence of the Visual Arts," *Semiotics of Art.* Ed. Ladislav Matejka and Irwin R. Titunik. 1976. Cambridge: The MIT Press, 1984: 229–224.

Newland, Joseph N., ed. *No! Contemporary American Dada.* Seattle: University of Washington Press, 1985.

Nordland, Gerald. "Kienholz Happy in Affirmative New Pasadena Art Show," *Los Angeles Mirror* 24 May 1961: D17.

———. "Neo-Dada Goes West," *Arts Magazine* May–June 1962: 102–103.

Parkinson, Thomas, ed. *A Casebook on the Beats.* New York: Thomas Y. Crowell Co., 1961.

Pearce, Roy Harvey. *The Continuity of American Poetry.* 1961. Princeton: Princeton University Press, 1977.

Pincus, Robert. "An Ode and an 'Odious' for Neo-Dada," *Images and Issues* 2.2 (1981): 53–55.

Plagens, Peter. *The Sunshine Muse.* New York: Praeger Publishers, 1974.

Owens, Craig. "The Allegorical Impulse: Toward a Theory of Postmodernism," *Art After Modernism: Rethinking Representation.* Ed. Brian Wallis. New York: The New Museum of Contemporary Art; Boston: David R. Godine, 1984: 203–235.

Reddin Kienholz, Nancy. Personal interview. 23 August 1982.

———. Personal interview. 11–14 September 1987.

Rose, Barbara. *American Art Since 1900.* 1967. New York: Holt, Rinehart and Winston, 1975.

———. "New York Letter," *Art International* 25 March 1963: 65–68.

———, ed. *Readings in American Art 1900–1975.* 1968. New York: Holt, Rinehart and Winston, 1975.

Rosenberg, Harold. *The Tradition of the New.* New York: Horizon Press, 1959.

———. *The De-definition of Art.* 1972. New York: Collier Books, 1973.

Russell, John, and Suzi Gablik, eds. *Pop Art Redefined.* New York: Praeger Publishers, 1969.

Scott, David. *Edward Kienholz: Tableaux 1961–1979.* Dublin: The Douglas Hyde Gallery, Trinity College, 1981.

Secunda, Arthur. "John Bernhardt, Charles Frazier, Edward Kienholz," *Artforum* November 1962: 30–34.

Seitz, William. *The Art of Assemblage.* New York: The Museum of Modern Art, 1961.

Seldis, Henry. "Kienholz Artistry Deeply Pessimistic," *Los Angeles Times* 2 October 1964: D5.

Silberman, Robert. "Imitation of Life," *Art in America* March 1986: 138–143.

Silk, Gerald. "Ed Kienholz's 'Back Seat Dodge '38,'" *Arts Magazine* January 1978: 112–118.

Sontag, Susan. *On Photography.* New York: Farrar, Straus and Giroux, 1977.

Starr, Sandra Leonard. *Lost and Found in California: Four Decades of Assemblage Art.* Los Angeles: James Corcoran Gallery; Pence Gallery; Shoshana Wayne Gallery, 1988.

Tillim, Sidney. "The Underground Pre-Raphaelitism of Edward Kienholz," *Artforum* April 1966: 38–40.

Tomkins, Calvin. *Off The Wall: Robert Rauschenberg and the Art World of Our Time.* 1975. New York: Penguin Books, 1977.

Tuchman, Maurice. *Edward Kienholz.* Los Angeles: Los Angeles County Museum of Art, 1966.

Tuchman, Phyllis. *George Segal.* New York: Abbeville Press, 1983.

Turnbull, Betty. *The Last Time I Saw Ferus.* Newport Beach: Newport Harbor Art Museum, 1976.

Wallis, Brian, ed. *Hans Haacke: Unfinished Business.* New York: The New Museum of Contemporary Art, 1986.

Weschler, Lawrence, ed. *Edward Kienholz.* 2 vols. Los Angeles: University of California, Los Angeles Oral History Program, 1977.

Whitman, Walt. *Complete Poetry and Selected Prose.* Ed. James E. Miller, Jr. Boston: Houghton Mifflin Co., 1959.

INDEX

Designer: Robert Ross
Compositor: Prestige Typography
Text: Univers 55
Display: Univers 65
Printer: Malloy Lithographing, Inc.
Binder: John H. Dekker & Sons